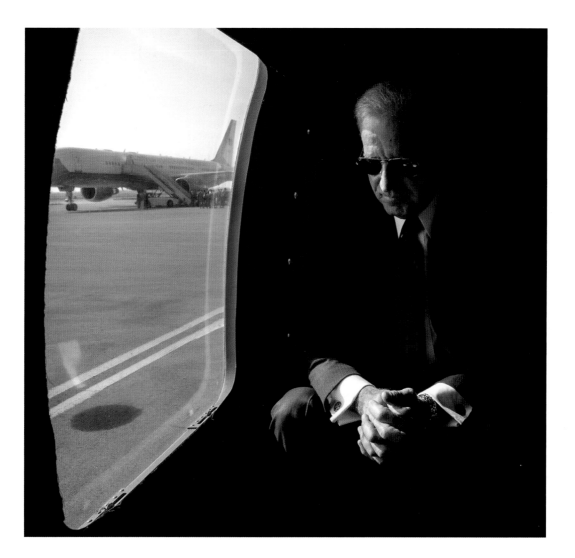

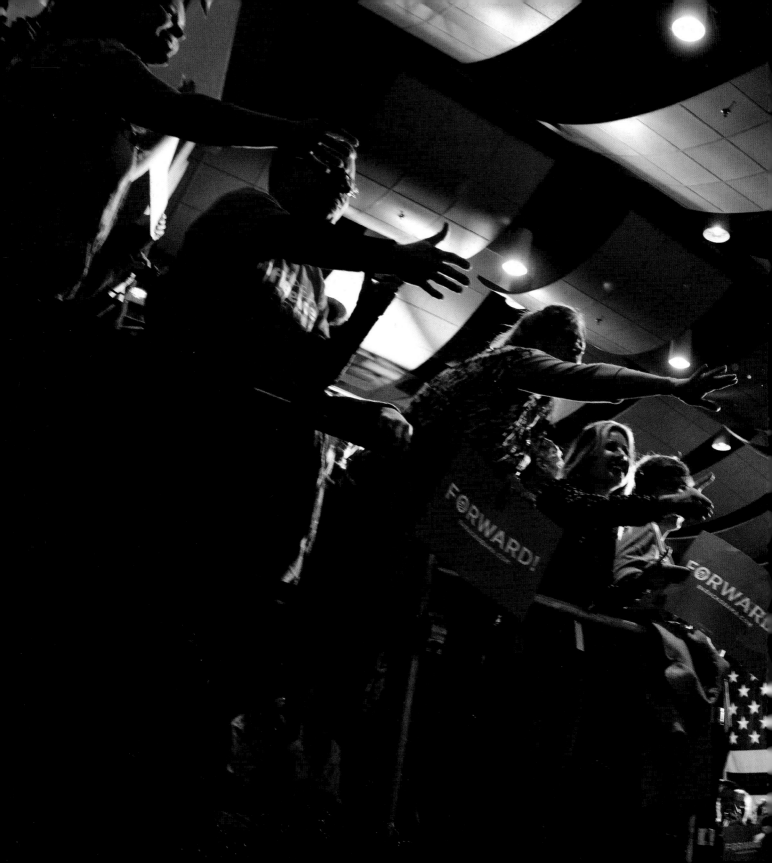

BIDEN

THE OBAMA YEARS AND THE BATTLE FOR THE SOUL OF AMERICA

DAVID LIENEMANN

VORACIOUS

Little, Brown and Company
New York Boston London

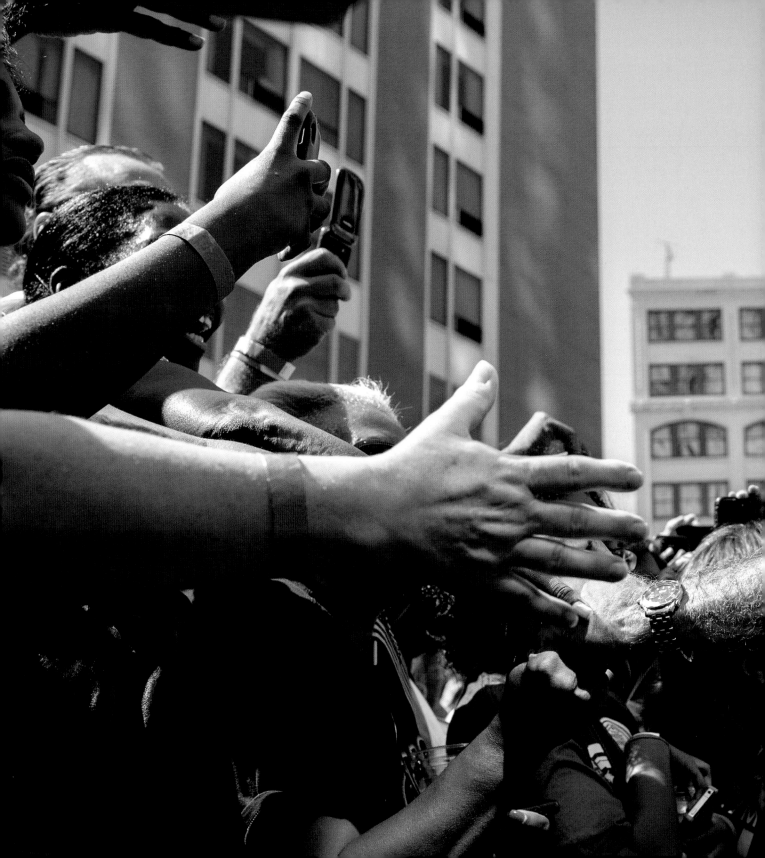

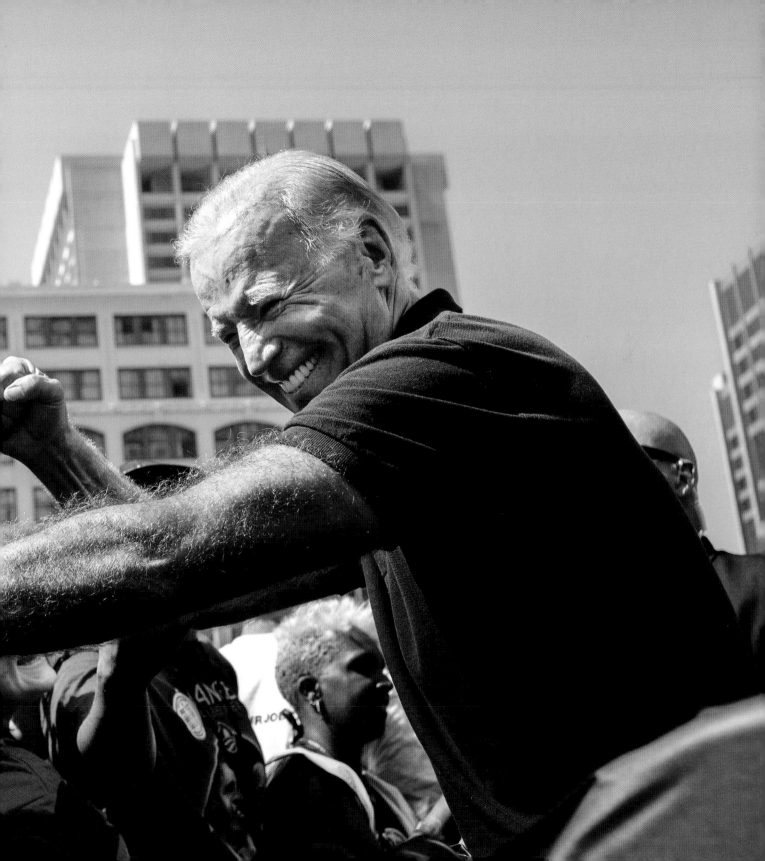

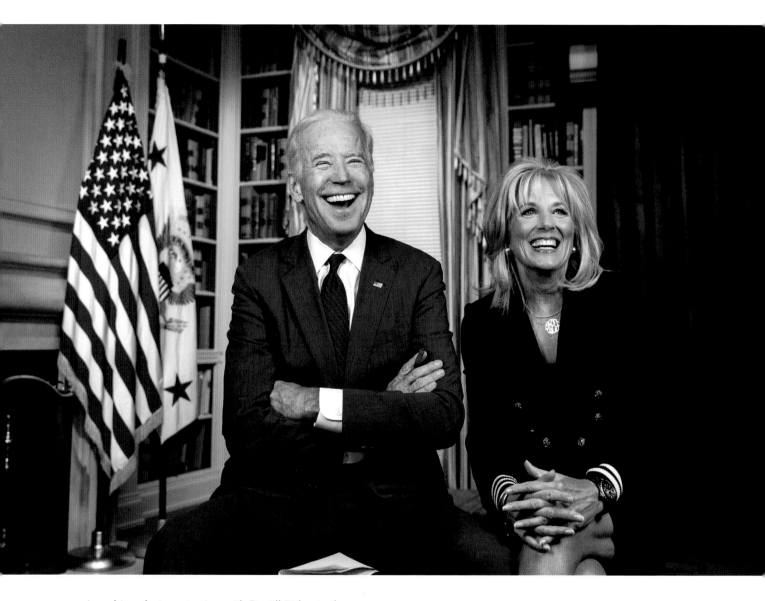

Laughing during a taping with Dr. Jill Biden in the
Eisenhower Executive Office Building, March 30, 2016.

FOREWORD

JILL BIDEN

It is sometimes hard to believe that Joe took office as Vice President of the United States over a decade ago. Even after his 36 years of service in the Senate, our move from Wilmington, Delaware, to Washington, D.C., was a drastic change. We were suddenly surrounded by so many new faces. The staff who came to work with us at the White House were driven by the hope to change the world. That was David Lienemann: young and idealistic. We watched them grow up by our sides as we traveled the world, greeting U.S. military service members in Iraq, my fellow teachers in North Carolina, and Americans across the country whose lives were improved by the passage of the Affordable Care Act. Over the years, we watched these men and women grow into accomplished advocates, strategists, and experts.

A good photographer goes unnoticed, capturing scenes without being part of them, finding his way into the most intimate of circumstances without disrupting the fragile moment. In the eight years that David documented Joe's work, he met that bar with skill and grace. As David seamlessly wove himself into the day-to-day of Joe's life, he became something more than just a photographer — he became one of Joe's most honest advisors. Our friend.

Serving alongside President Barack Obama and First Lady Michelle Obama was a tremendous honor — an opportunity to make real change to our country in ways that would improve lives. For me, that meant finding a new school to continue my 30-year teaching career, but also learning to use my voice outside of the classroom, advocating for the students and military families I cared about so deeply. For Joe, it meant a bigger stage from which to fight for people like the ones he grew up with in Scranton, Pennsylvania.

Looking at David's photographs, I am filled with deep pride. He captured it all: the hours of work, the questions and negotiations, the emotions that spanned from such incredible highs to such heartbreaking lows, every hard-fought battle. His lens memorialized the big moments, when we hardly understood the magnitude from the middle of it all, and the small moments, when we realized that the world had shifted forever. David captured Joe's character, the joy he finds in our grandchildren, the purpose he finds when he meets with others: taking a selfie with an elevator operator, meeting students at a Boys and Girls Club, or consoling those grieving the loss of a loved one.

During times of trouble and strife, as we see so much heartache around us and so much work left to do, I am bolstered by remembering what President Barack Obama and Vice President Joe Biden were able to accomplish during those years. I know the hope I see in David's pictures is not gone. It is alive, and its power will continue to transform our nation for the better. We did the impossible before, and with courage, grit, and determination, we will do it again. These photographs invigorate me for the challenges ahead, and I hope they do the same for you.

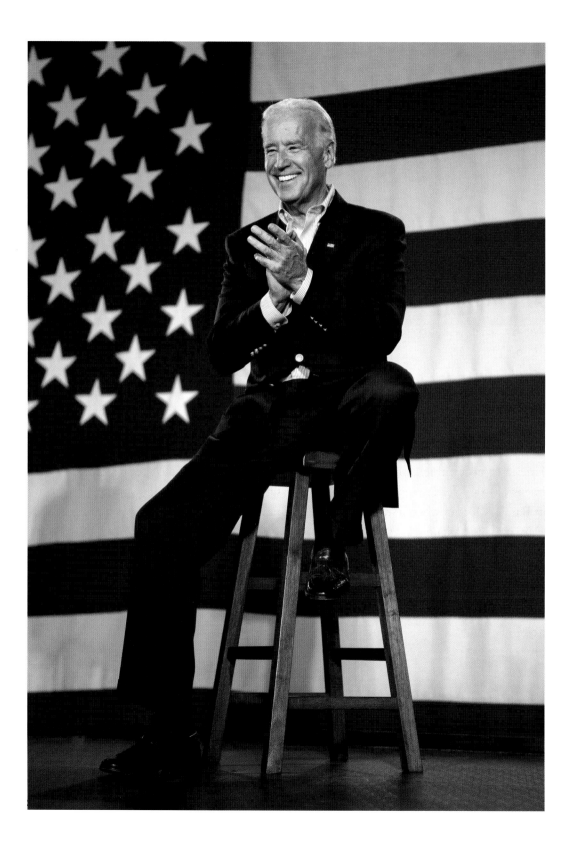

INTRODUCTION

As Joe Biden's Official White House Photographer, I was privileged to document all eight of his years in the White House, capturing his transformation from respected Senator to world leader in his own right. It was an incredible window into history as it happened. It was also an opportunity to document one of America's most influential leaders in every dimension—as a leader and partner to President Barack Obama, of course, but also as a father, husband, and friend. I made more than 900,000 photographs during those years, capturing moments of intense effort, heartbreaking tragedy, and glorious triumph. This book is an attempt to show you the story of Joe Biden in the White House and his role in shaping our nation and to reveal the essential values that motivate his work as a public servant.

I first met Joe Biden in 2007. I was a freelance photographer in Iowa, working for the *New York Times* and other news organizations. I had just graduated from college and was fresh off a few local newspaper internships before heading off to cover the Iowa Caucus. Covering politics in Iowa in the lead-up to their first-in-the-nation caucus meant frantically crisscrossing the state to photograph all sixteen Democratic and Republican Presidential candidates as they fought for each voter in all 99 counties. Over those grueling months covering then-Senator Biden, I saw up close and in person what he was made of. I was impressed by the goodness I saw in his interactions with people. Anyone who has attended an event with him knows what I'm talking about. He connects with people because he truly cares

(**OPPOSITE**) At a rally at the United Auto Workers Local 12, in Toledo, Ohio, October 31, 2010.

about them—their lives, their health, their jobs, their problems. It's what makes him a great politician, but more importantly, it's what makes him a great civil servant.

When President Obama was sworn in and the full White House staff was being assembled, I called everyone I knew connected with the administration. I wanted to be Vice President Biden's photographer. Thanks to a combination of irritating persistence and dumb luck, I found myself leaving my home in New Mexico in March 2009 with a new suit, a passport, and very little idea what to expect in the days ahead.

For the next eight years, I traveled the world with Vice President Biden and his family, spending almost every day documenting their lives and work. I saw the Vice President experience the triumph of passing the Affordable Care Act, the safe return of his son after a year of service in Iraq, and the wedding of his daughter. I witnessed the heartbreaking loss of his son to cancer, his consolation of families who lost their children to school shootings, and the administration's ultimately unsuccessful fight to make Congress finally act on gun violence. Throughout my years in the White House, Vice President Biden never lost the spark of goodness and caring that I saw when I covered him in Iowa, a sense of optimism that America's best days are ahead

of us, and that, when we work together, there is a brighter, more equitable future for our country.

The administration had begun in crisis, inheriting an economy in free fall, losing nearly two million jobs in the four months before they were sworn in. The impacts of the Great Recession hit close to home for Vice President Biden. He remembered all the folks he'd met on the campaign trail who were struggling to make ends meet and worrying about their next paychecks. The stories he heard were not so different from his own middle-class roots, and they drove him to fight for these Americans every day.

As I write this in the summer of 2020, the United States is again embroiled in crisis: a pandemic that has cost the lives of more than 100,000 Americans, a crippling economic collapse with tens of millions of people losing their jobs, and the urgent nationwide demand for racial justice accompanied by protests in every state.

As I watch so many people concerned about the future, I think back to a story Joe Biden tells about his own father: Upon losing his job, he reminded his young son that a job is about a lot more than a paycheck. It's about the dignity of a day's work, and every person, regardless of race or where they are from or who they love, deserves that dignity.

Biden never forgot that. It is at the core of what he believes. After the assassination of Dr. Martin Luther King Jr., he was moved to leave his job at a prestigious law firm to work as a public defender. He came to understand the economic, environmental, and health impacts that result from systemic racism. In the White House I observed as he pursued policies to make America fairer and more just and to make room at the table where policies are shaped for those who have lived the experience of injustice.

My photos of the Vice President present a man who knows America—its people and its promise. A man deeply and authentically engaged in crafting a policy to rebuild America—this time, bringing everyone along.

Documenting Vice President Biden's mark on the White House and the nation for history has been a great honor. I hope these photographs will offer you deeper insight into the man I know: his humor, his kindness, his decency, and his quest to restore true American values to our nation's highest office.

(P. 1) Leaning forward into the light as the helicopter spins down next to *Air Force Two,* in Pristina, Kosovo, en route to Beirut, Lebanon, May 22, 2009.

(PP. 2-3) Taking the stage at an Obama for America rally in Superior, Wisconsin, November 2, 2012.

(PP. 4-5) Working the rope line at a Labor Day rally in Detroit, Michigan, September 3, 2012.

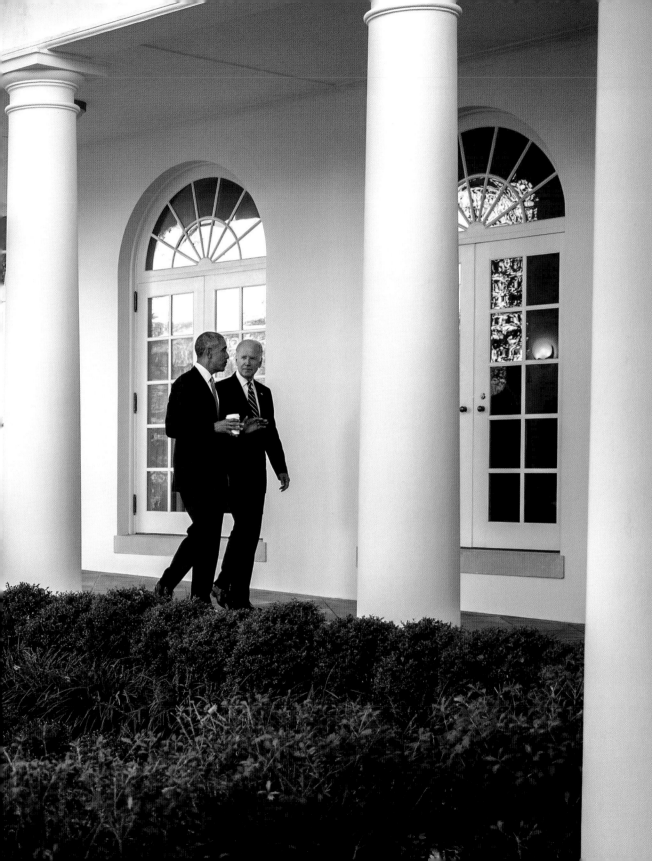

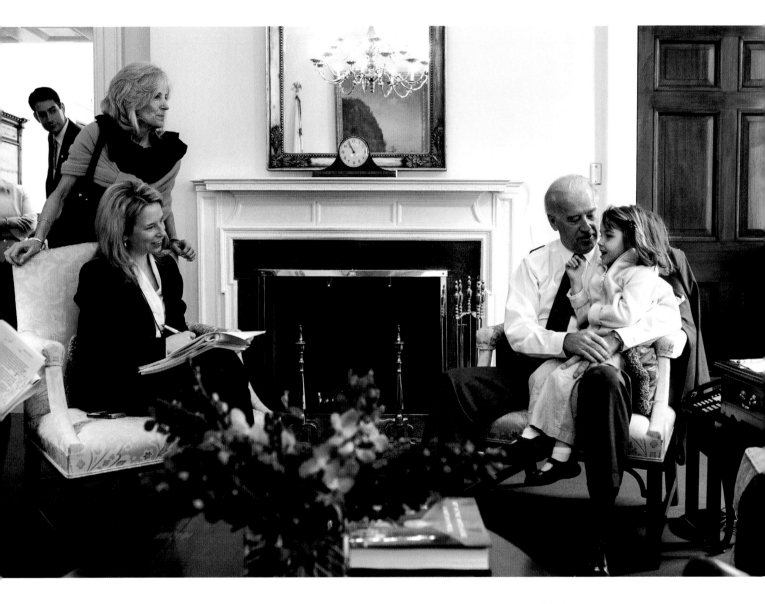

(PREVIOUS) Walking down the Colonnade with President Barack Obama, October 12, 2016.

(ABOVE) Pausing a meeting to check out granddaughter Natalie's missing tooth, with Dr. Jill Biden and policy director Terrell McSweeny, March 18, 2009.

2009-2010

BLUE SKIES
The New Administration

After a historic election with national support for a hopeful
new agenda, Vice President Biden eagerly embraced his new
role in the Obama administration. He worked to improve an
economy imperiled by recession while making connections
with Americans at home and military personnel and allies
abroad. This time was full of firsts—first ride on *Air Force Two,*
first trip to Iraq, first pitch at a Baltimore Orioles game—and
the themes of hope and change that drove the election
campaign. During these early days in the White House, Biden
and President Obama built on their partnership as the new
administration made its first strides in health care, marriage
equality, and gun violence.

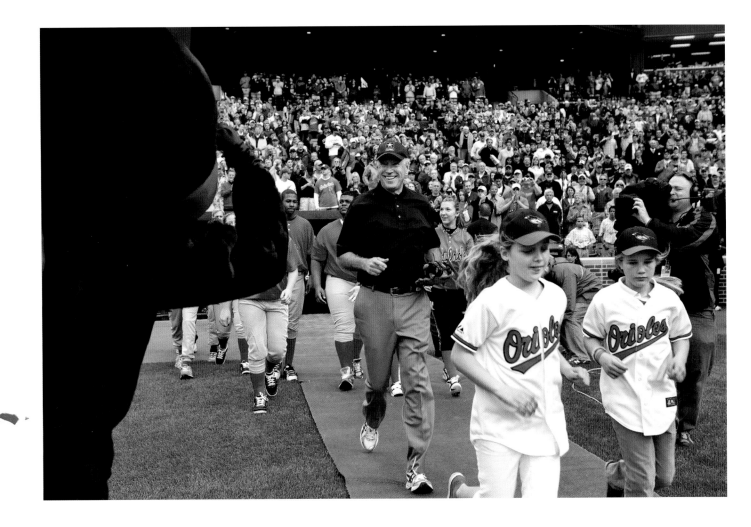

Taking the field for the Baltimore Orioles season
opener with granddaughters Finnegan and Maisy
Biden, at Camden Yards in Baltimore, Maryland,
Monday, April 6, 2009. That day, the Orioles beat
the Yankees 10-5, even though the Yankees would
go on to win the World Series that year.

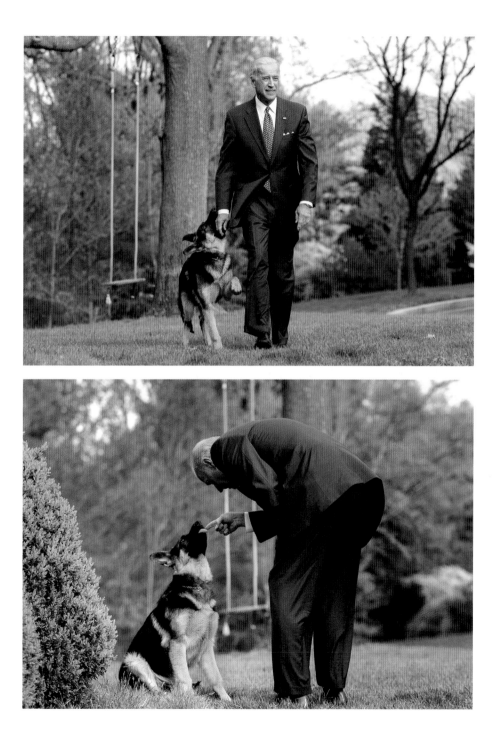

There's a time and a place for everything: The Vice President has a word with his German shepherd puppy, Champ, after a playful nip outside the Naval Observatory Residence, Washington, D.C., March 22, 2009.

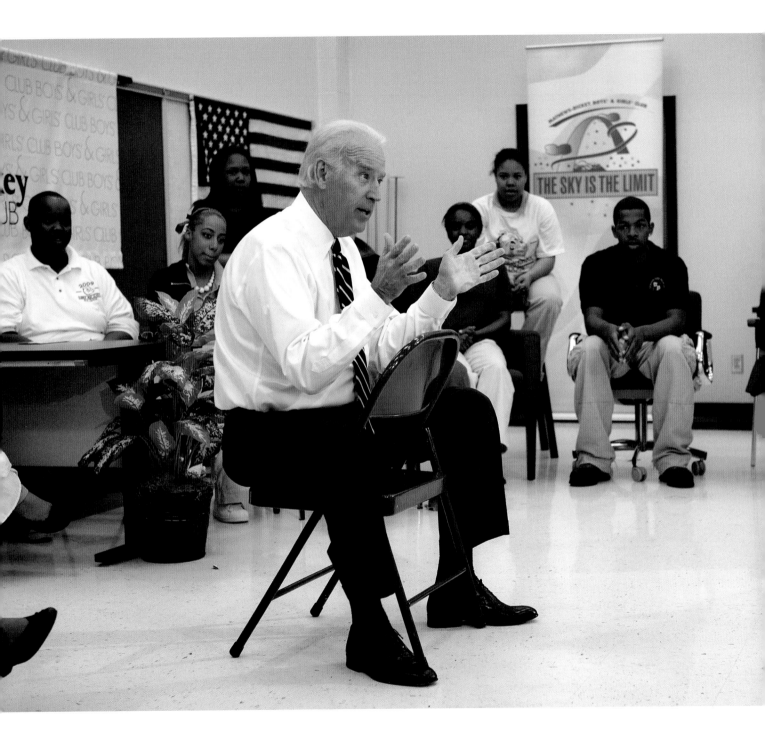

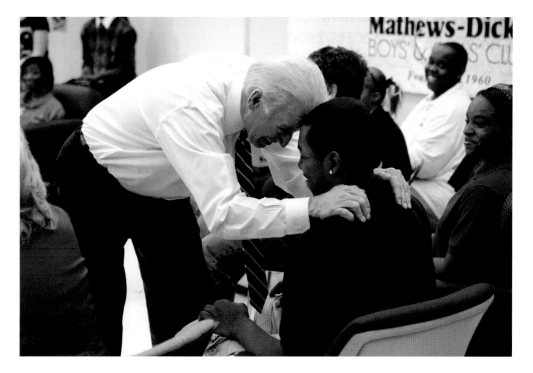

With Dr. Jill Biden, having a discussion with
St. Louis area high school students at the Boys
and Girls Club, in St. Louis, Missouri, April 17, 2009.

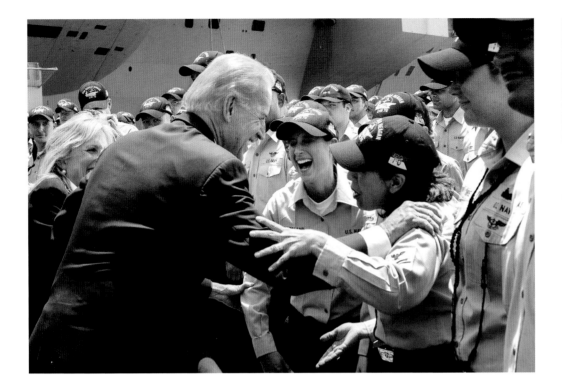

(ABOVE) Greeting sailors outside the USS *Ronald Reagan* aircraft carrier before their deployment to the Western Pacific and Indian Oceans, in Coronado, California, May 14, 2009.

(RIGHT) Talking with SEAL trainees, at the Naval Special Warfare Center, in Coronado, California, May 14, 2009.

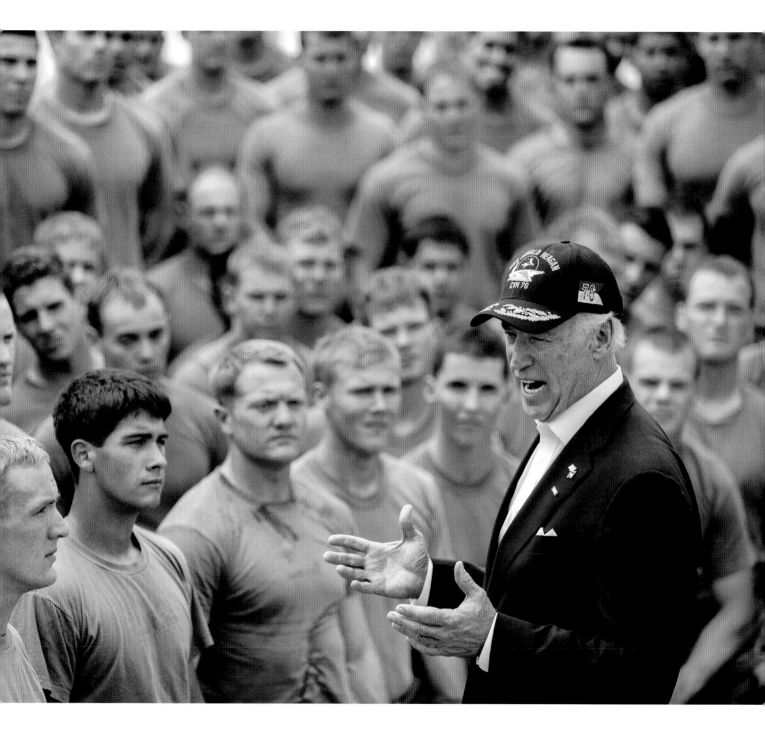

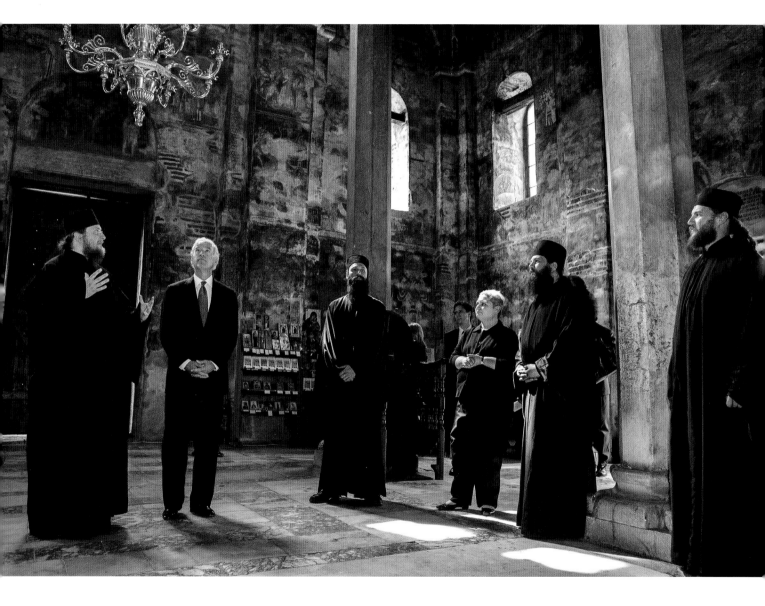

A VISIT TO THE BALKANS

I JOINED THE VICE PRESIDENT'S team in March 2019 and was immediately thrown into a new and exciting world. I was a Washington outsider, and while I'd worked as a journalist for several years, covering campaigns in Iowa was different than working at the White House. Vice President Biden kept a busy, often international, travel schedule. We traveled to Belgium on *Air Force Two* my third day on the job for meetings at NATO, and a few weeks later the Vice President flew to Chile to meet with Latin American heads of state. But it was on this trip, a four-country trip to meet with leaders in Bosnia, Serbia, Kosovo, and Lebanon, that I started to feel like I was hitting my stride. Making photographs became more than just snapping a photo of what was happening in front of me, and became an attempt to capture the character and meaning of a place or event. The Serbian Orthodox Dečani Monastery, a historic UNESCO World Heritage Site, is located just a few miles from the Kosovo-Albanian border. During the war in Kosovo, the monks at the monastery sheltered refugees of all ethnicities, and the site is still protected by international peacekeepers. It is a remarkable place, and for one of the first times, I felt that my work as a photographer conveyed the feeling of what it was like to be there with the Vice President.

INTERNAL MEMOS

THIRTY-SEVEN YEARS BEFORE he was sworn in as Vice President, Joe Biden lost his first wife, Neilia Hunter, and his daughter Naomi in a car accident. It was only six weeks after he had been elected to the U.S. Senate at 29. His sons, Hunter and Beau, were also in the car and survived the crash. Biden was sworn in alongside their hospital beds. The tragedy would define the rest of his career. From then on, Senator Biden took the train home every night from Washington, D.C., to Delaware, to be with his boys. For him, there is nothing more important than family, and he carried those values into the White House.

Whether his granddaughter Natalie was dropping by the office to show him she'd lost a tooth (page 14), or one of the older grandchildren was calling during the day to talk about a school report or to see if they could come over to the house to swim in the pool, or there was a grandkid's basketball or lacrosse game on the weekend, family always came first. When Beau was deployed to Camp Victory, outside Baghdad, Iraq, Beau's kids, Natalie and Hunter, sometimes came to Washington for a sleepover at their grandparents' house. In the morning they would drop into the West Wing, as they did on this morning, June 9, 2009.

With their son deployed overseas, the Bidens understood this could be a scary and overwhelming time for the whole family, and especially Beau's kids. Visits from the grandkids brought the Vice President and Dr. Biden tremendous joy and a sense of stability even as their lives grew more hectic in their new roles. Here Natalie and Hunter sit at the Vice President's desk and write him notes while he attends a meeting with the President just down the hall in the Oval Office.

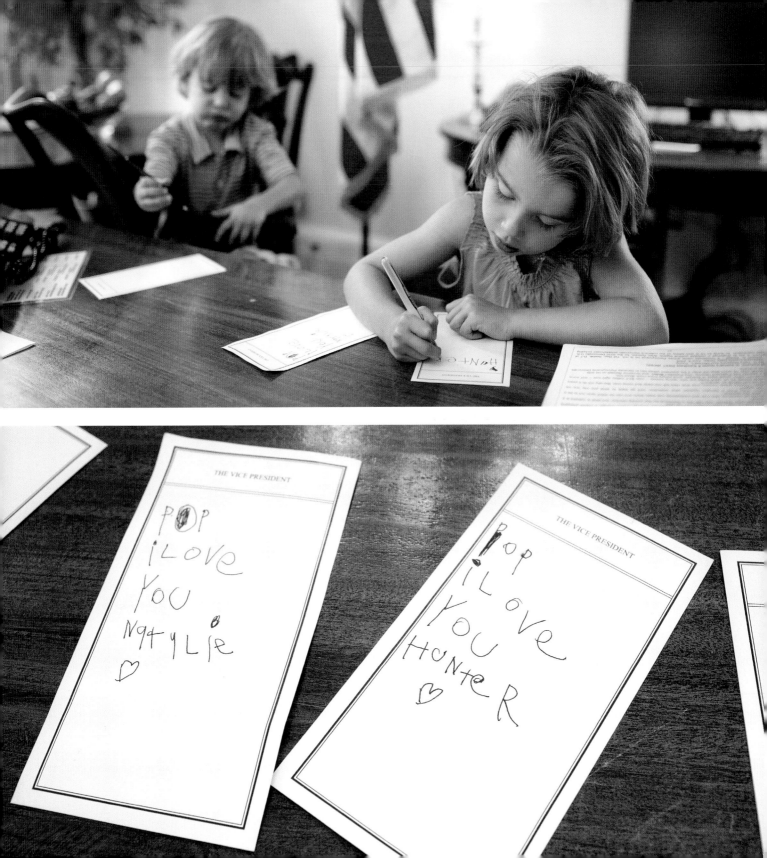

A chance run-in with President Obama while showing the 2009 NCAA Champion Syracuse University Lacrosse team around the White House grounds, June 24, 2009.

Visiting with families of Congress members during
the annual congressional picnic on the South Lawn
of the White House, June 25, 2009.

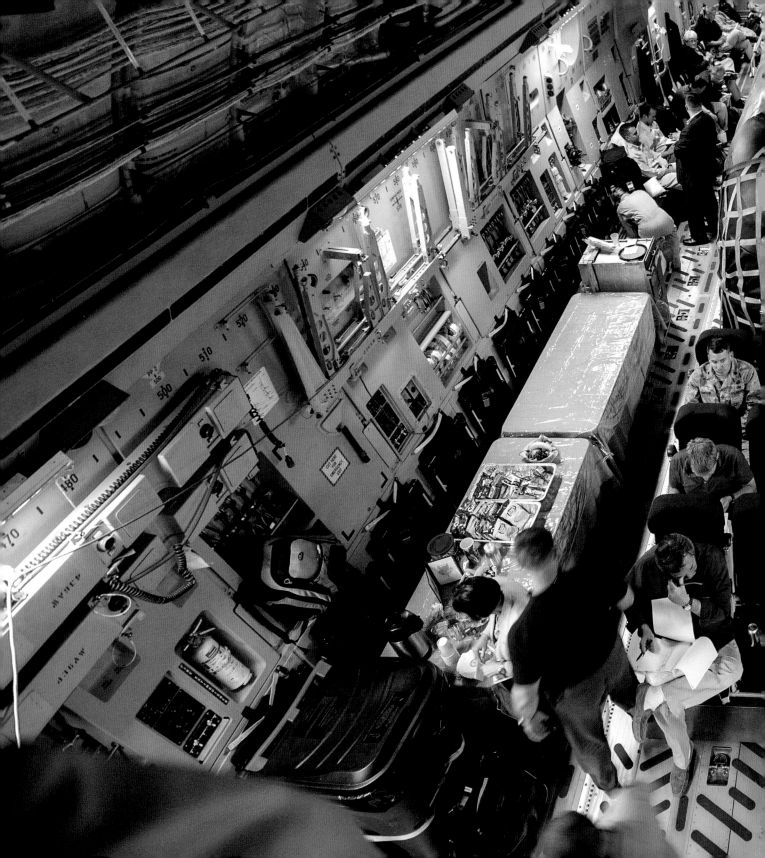

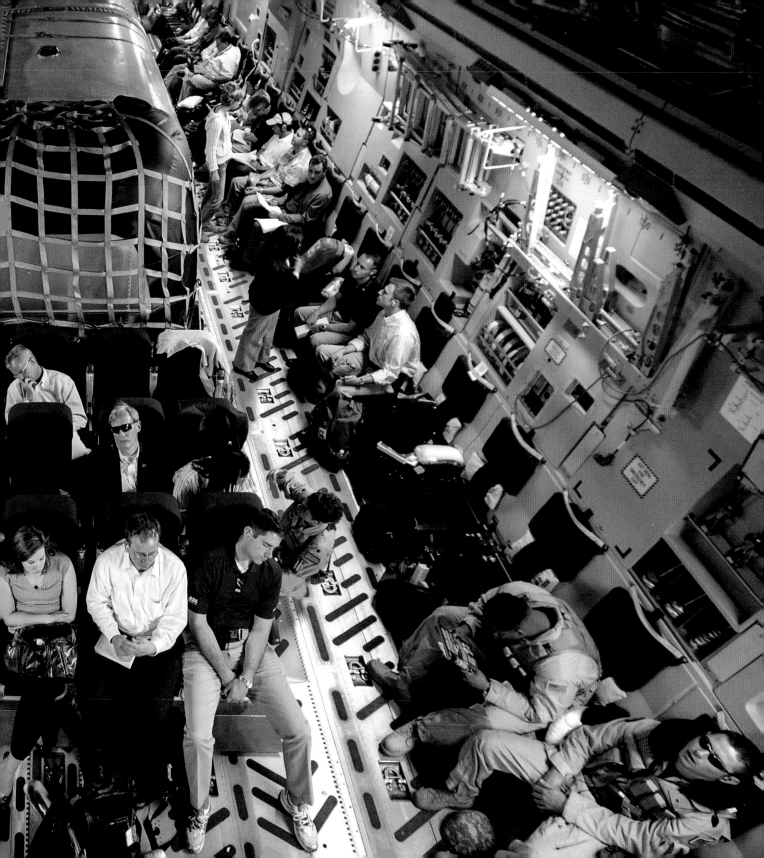

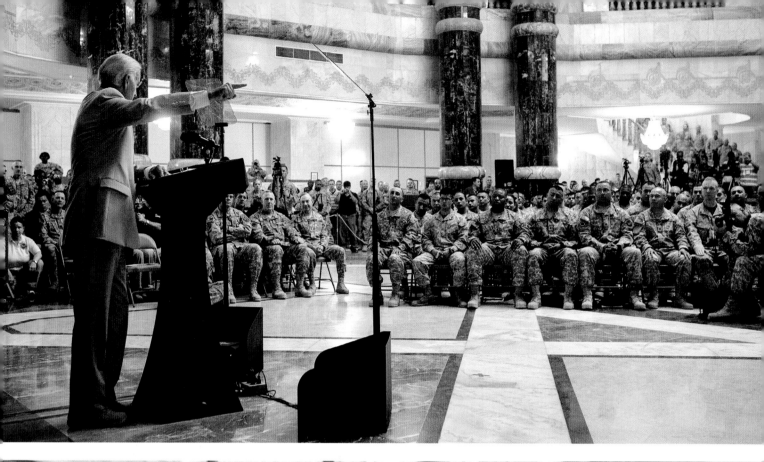
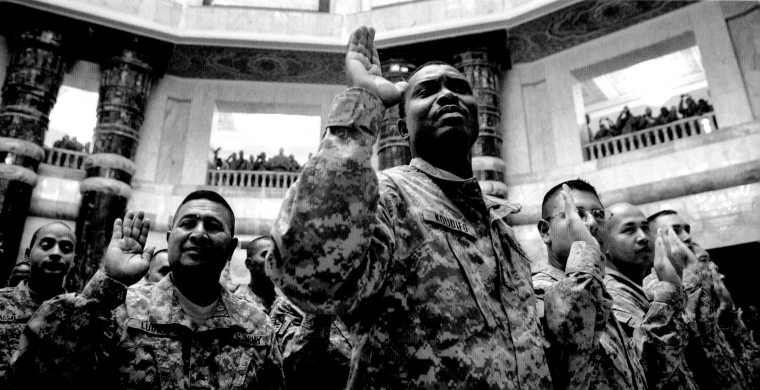

C-17 TO BAGHDAD

LIKE MOST HIGH-LEVEL VISITS to Iraq at the time, our first trip to Baghdad was kept a secret until we arrived. We departed Andrews Air Force Base late at night on *Air Force Two* and transferred in England to a C-17 cargo plane for security. Seemingly nondescript, like any other cargo plane traveling into Baghdad, inside it was decked out with a modified Airstream trailer for secure communications (and quieter sleeping). The staff, press, and Secret Service buckled into the sides of the plane for the five-and-a-half-hour long, disorienting, and nausea-inducing flight.

The landing in Baghdad was a rapid descent full of hard turns to evade any attempts to fire at the plane. Since there were no windows, we didn't know what to expect on the ground. As the door opened, the hot summer air poured into the plane. It was pitch black outside. A sandstorm was raging, grounding helicopters and forcing us to drive through Baghdad to the Green Zone for the Vice President's meeting with Iraqi leaders.

Everyone wore body armor outside, traffic was held back by military vehicles, and giant concrete walls topped with coils of razor wire surrounded buildings to protect them from car bombs, making streets feel like narrow alleyways. The sky-darkening sandstorm left an eerie tint in my photographs, which was accentuated by the thick ballistic windows of the vehicles we rode in.

In 2009, there were 148,000 U.S. troops serving in Iraq. Just before our visit, those troops pulled back from the urban centers, handing over control to the Iraqi military and police. Vice President Biden was there to meet with the Iraqi leadership and to promise continued American support. He also greeted and thanked the diplomatic staff who deployed far from their families to do the essential work of building Iraq's tenuous security and peace. For many of us, though, the most rewarding part of the trip was the morning of July 4th. We traveled to one of Saddam Hussein's old palaces and it was there, surrounded by the opulence and extravagance of a home built on corruption, exploitation, and tyranny, that the Vice President spoke at a naturalization ceremony where U.S. servicemen and women from 59 countries were sworn in as American citizens.

Taking a knee to converse with an attendee after a
Middle-Class Task Force meeting on health care, in
Alexandria, Virginia, June 16, 2009.

Breaking a sweat with his son Captain
Beau Biden in the gym at Camp Victory, Iraq,
September 17, 2009.

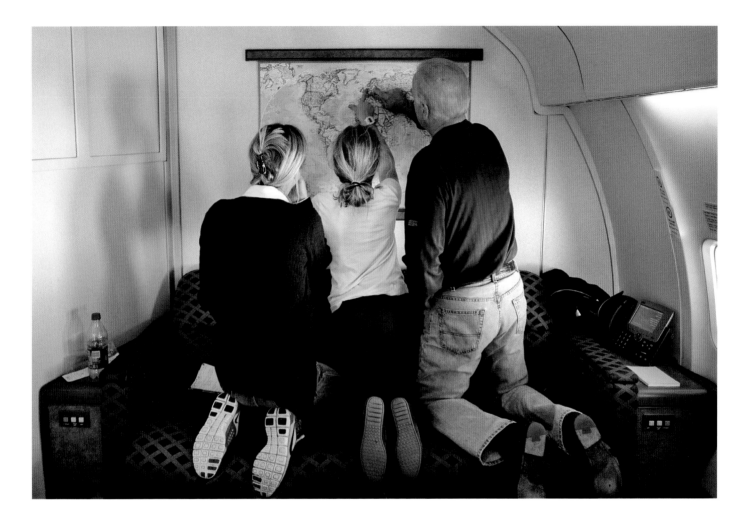

A midflight geography lesson aboard *Air Force Two*, with daughter-in-law Kathleen and granddaughter Finnegan, on the way to Warsaw, Poland, October 20, 2009.

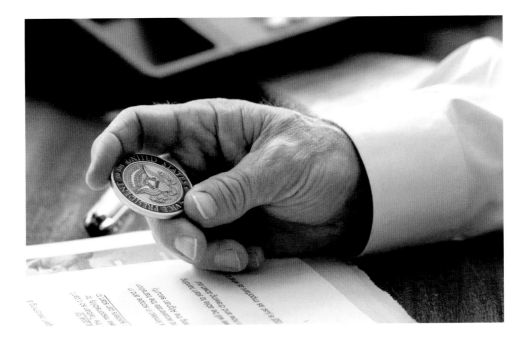

CHALLENGE COIN

HISTORICALLY, MILITARY COMMANDERS have presented challenge coins to their teams in recognition of special achievement. Today they are presented and collected by all branches of the armed services, as well as by firefighters, police officers, and politicians.

Here, Vice President Biden examines one while on the phone with allies explaining that the United States would be sending more troops into Afghanistan. These calls and the decision to put more Americans in harm's way weighed upon him, but he knew it was essential to the mission, and that it was important to maintain a strong international coalition with our allies. The additional troops, President Obama said later that evening at West Point, "will increase our ability to train competent Afghan security forces and to partner with them so that more Afghans can get into the fight. And they will help create the conditions for the United States to transfer responsibility to the Afghans."

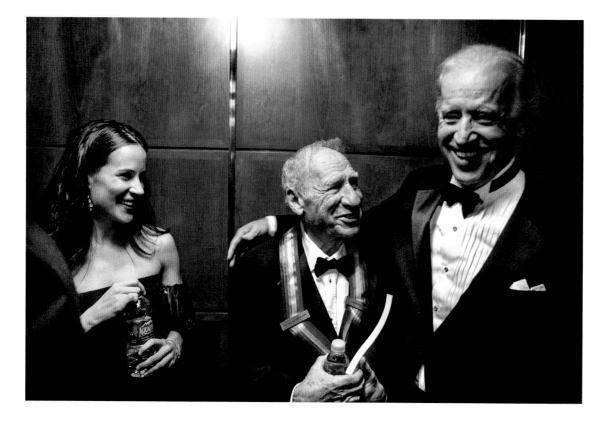

Sharing the elevator at the Kennedy Center Honors
with his daughter Ashley and honoree Mel Brooks,
December 6, 2009.

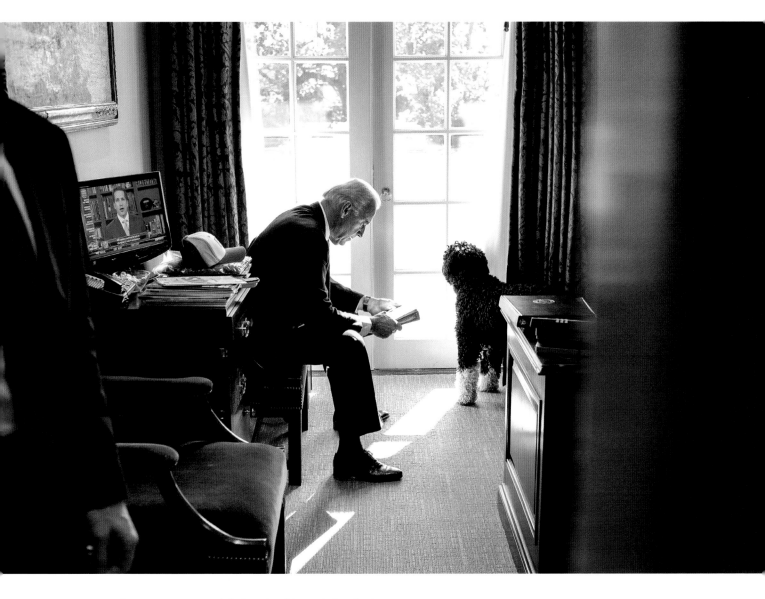

Reviewing notes while Bo, the Obama's family dog,
looks out the door before the President's Daily
Briefing in the outer Oval Office, March 19, 2009.

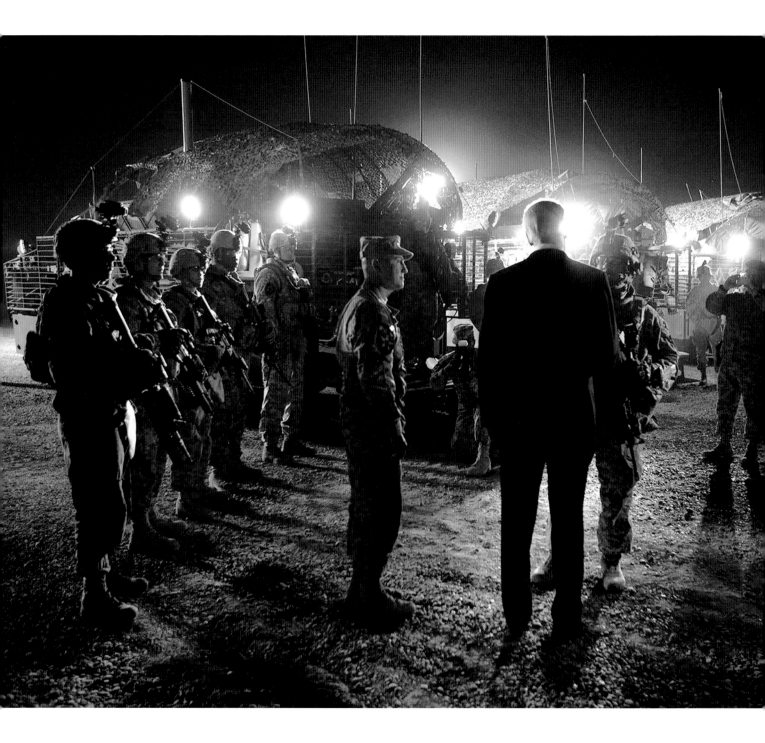

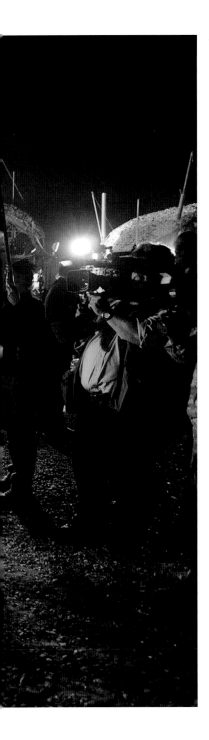

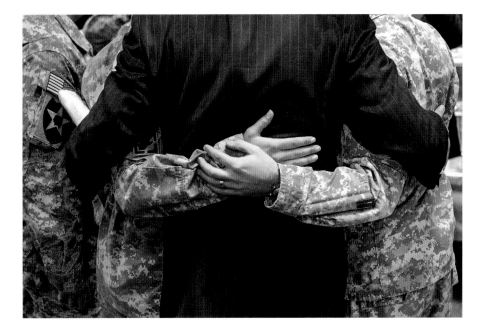

(ABOVE) Surrounded by U.S. troops for a photo commemorating a visit to Baghdad, Iraq, January 23, 2010.

(LEFT) Talking with 4-2 Stryker troops during a trip to Camp Victory, Baghdad, Iraq, January 23, 2010.

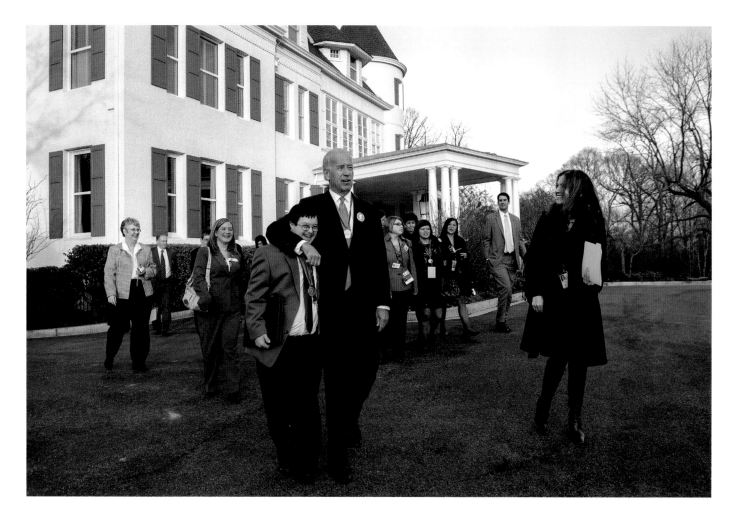

Walking with Special Olympians and coaches,
outside the Naval Observatory Residence,
January 27, 2010.

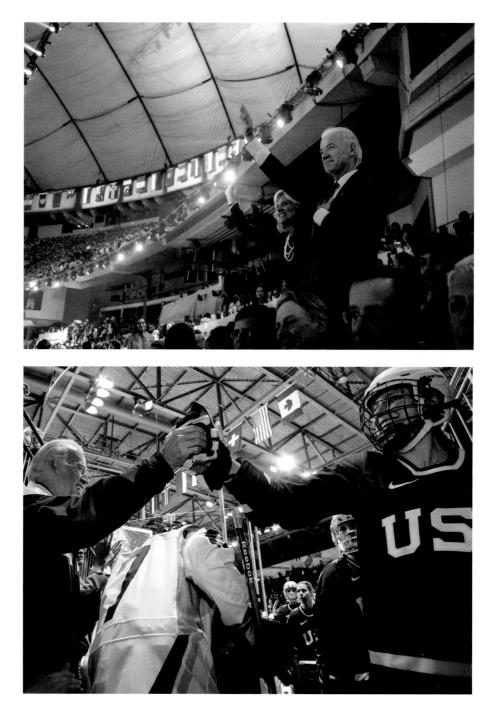

Saluting the U.S. Olympic team from the stands during the opening ceremonies processional of the 2010 Winter Olympics, in Vancouver, Canada, February 12, 2010.

Greeting the U.S. Women's National Hockey Team after their 12–1 victory over the Chinese team, in Vancouver, Canada, February 14, 2010.

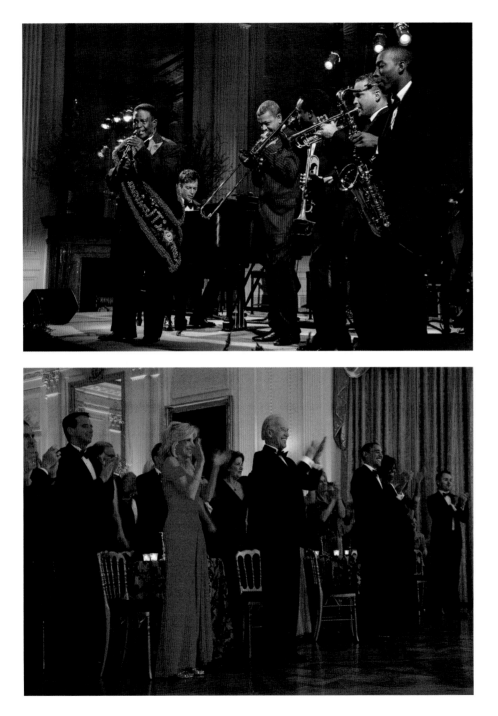

Harry Connick Jr. performs at the Governors' Ball in the East Room of the White House, February 21, 2010.

Giving Harry Connick Jr. a standing ovation at the Governors' Ball, alongside Dr. Jill Biden, the President, and the First Lady in the East Room of the White House, February 21, 2010.

Giving a pep talk to granddaughter Maisy Biden during a break in her basketball game in Chevy Chase, Maryland, Saturday, February 27, 2010.

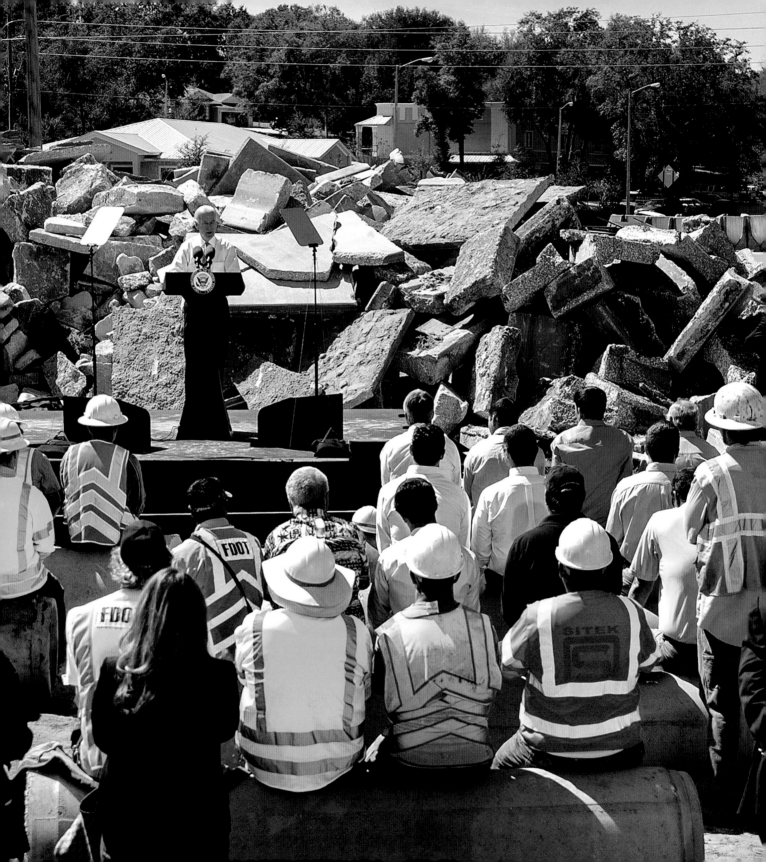

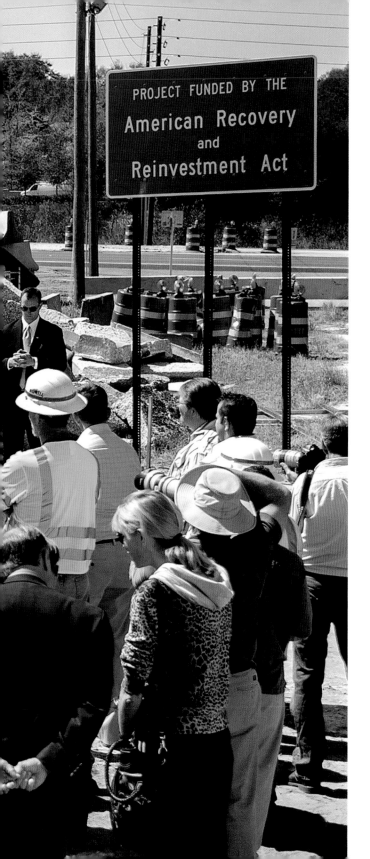

REBUILDING AMERICA

WHEN TOURING RECOVERY Act–funded projects like this one in Clermont, Florida, the VP often thought back to his father telling him that a job is about a lot more than a paycheck, it's about dignity and respect. As the administration began at the depths of the Great Recession, millions were struggling with unemployment and wondered if jobs like theirs would come back at all. Vice President Biden took charge of the American Recovery and Reinvestment Act on behalf of President Obama, stewarding the $831 billion investment in projects to reduce unemployment across the country, from this road construction project in Clermont, Florida, to improvements to municipal wastewater treatment plants, broadband and wireless internet access, and energy efficiency and renewable energy research and investment. At its peak, the Recovery Act increased employment by nearly 2.5 million jobs and prevented millions of Americans from falling into poverty — more than 5 million in 2010 alone.

With President Barack Obama as he addresses the nation after the House passed the Affordable Care Act, East Room of the White House, March 21, 2010.

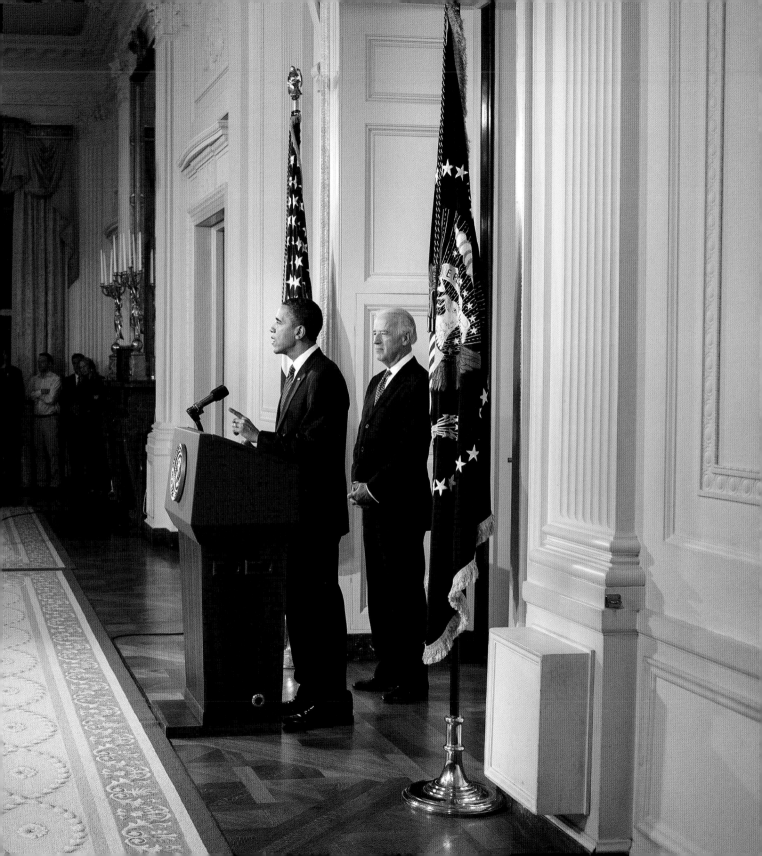

THE RIGHT TO HEALTH CARE

DECADES IN THE MAKING and 15 months into the Obama-Biden administration, Congress passed the Affordable Care Act, for the first time making health care a right and not a privilege for millions of Americans. It broadly expanded Americans' access to health care and pushed the rate of uninsured people to historic lows, with nearly 20 million fewer uninsured people by the end of the administration. It also ensured that people with preexisting conditions wouldn't be denied care or have unaffordable insurance premiums. In the months leading up to the final votes, President Obama and Vice President Biden spent many hours with members of Congress, hosted town halls to answer questions, and painstakingly reviewed and rewrote the bill. I remember these days as being filled with hope. This was more than a policy victory—it was an important step in affirming our highest ideals.

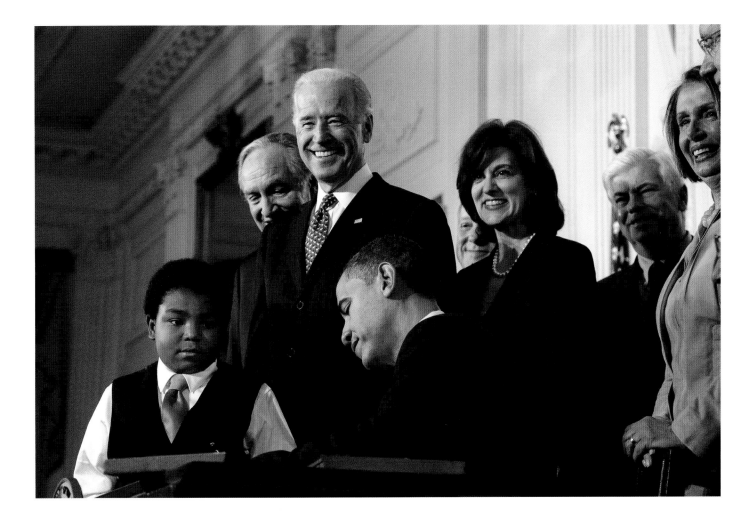

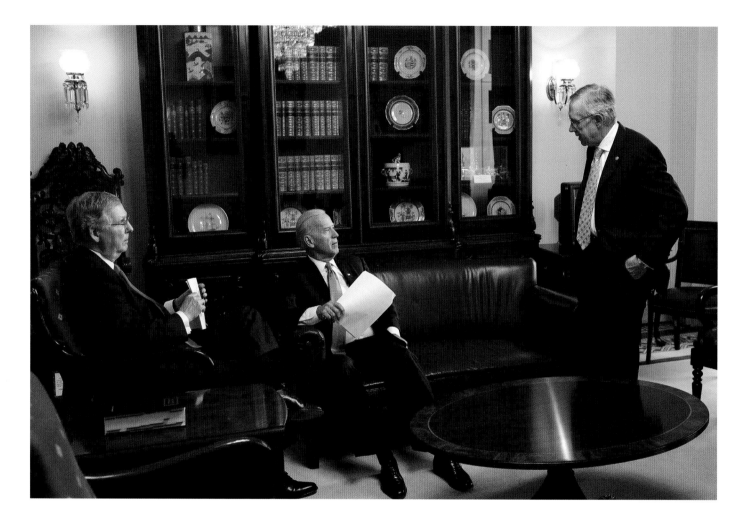

Meeting with Senate Majority Leader Harry Reid
and Minority Leader Mitch McConnell, in his Senate
office at the U.S. Capitol, April 22, 2010.

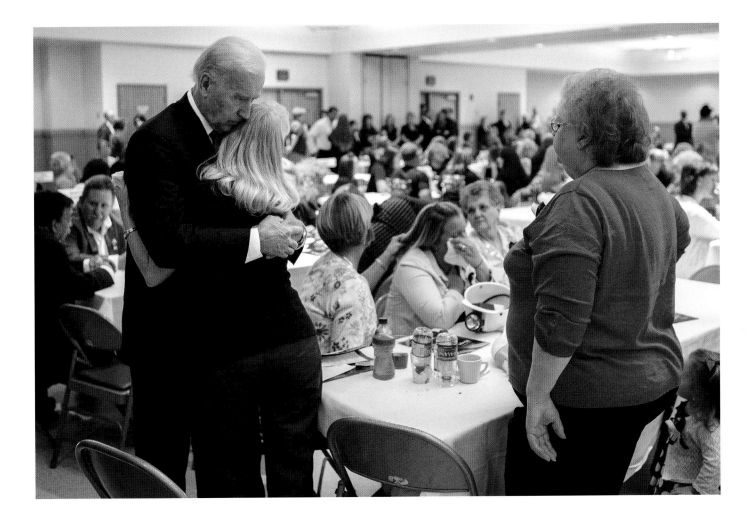

Consoling families of the 29 victims of the Upper
Big Branch Mine disaster before a memorial service
in Beckley, West Virginia, April 25, 2010.

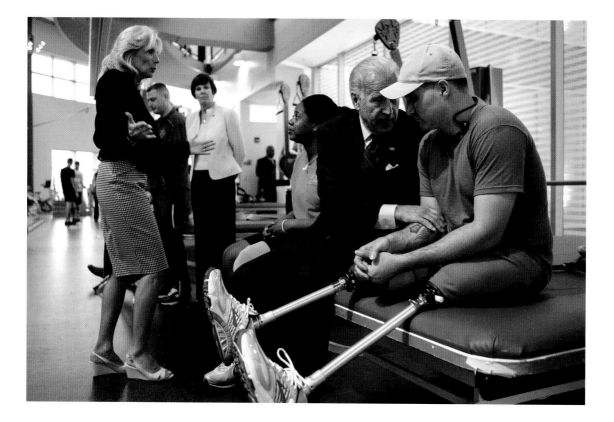

Visiting patients with Dr. Jill Biden, at Brooke
Army Medical Center, in San Antonio, Texas,
April 7, 2010.

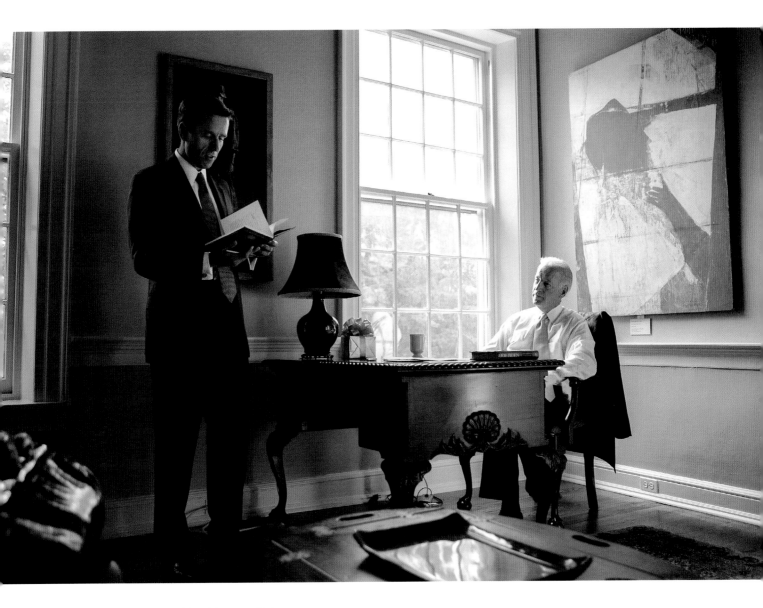

Listening to his older son, Delaware attorney general Beau Biden, before an event in Dover, Delaware, May 3, 2010.

MEMORIAL DAY

ON MEMORIAL DAY 2010, Vice President Biden traveled across the Potomac river to Arlington National Cemetery to pay tribute to fallen service members. With his son Beau recently returned from a year serving in Iraq with the Army National Guard, he keenly felt the weight carried by families who had lost a loved one. He would often visit Section 60, where veterans of the Afghanistan and Iraq Wars are buried. There, he met the family of Army Captain Brian Matthew Bunting, who had been killed in Kandahar the previous February, while his wife was pregnant with their second child.

Both as the Vice President, and as the father of a soldier, the loss of these young men and women in Section 60 was deeply personal to Biden. Only months earlier, he and President Obama had made the decision to send more troops into Afghanistan, believing that it would be impossible to secure the country and ensure peace for the Afghan people without U.S. troops to force back the Taliban—who had for so long harbored terrorists, committed atrocities, and created a dangerous breeding ground of anti-American sentiment in the region.

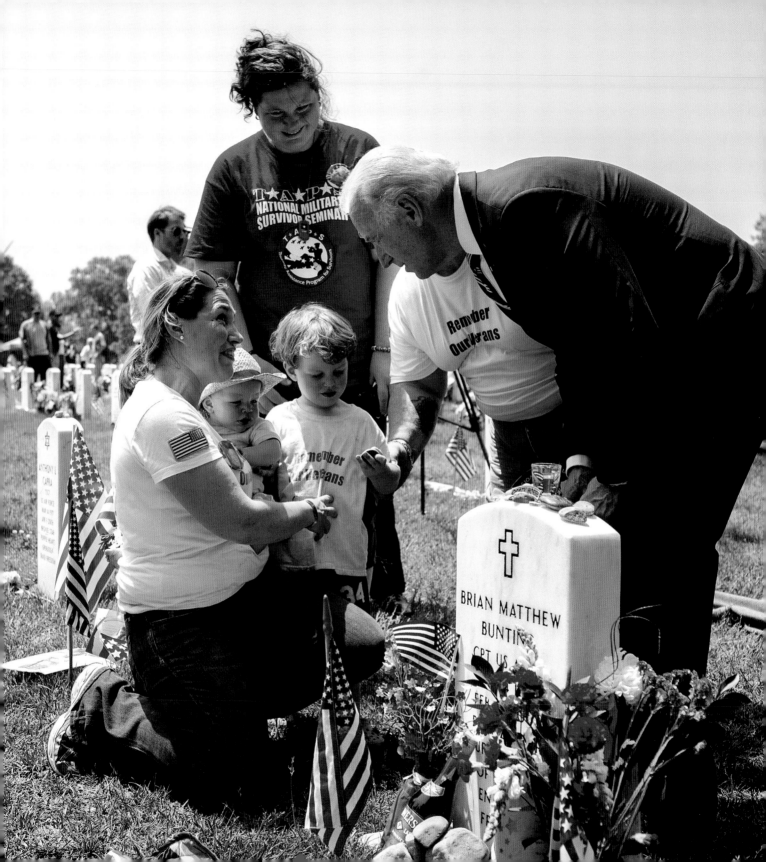

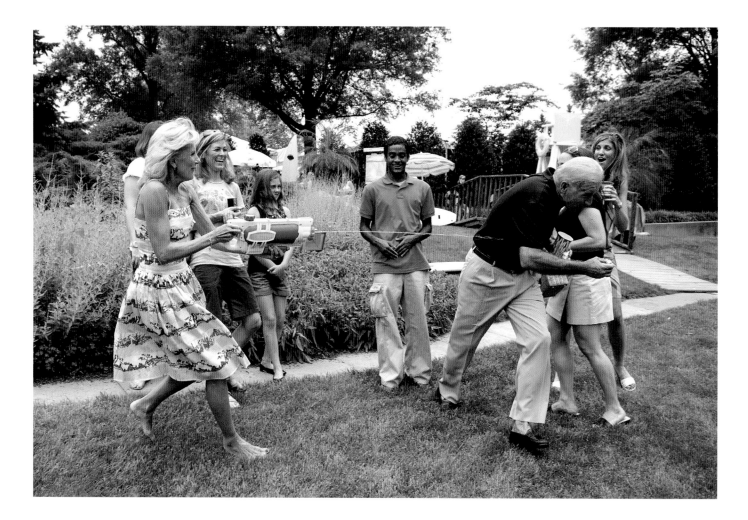

Ambushed by Dr. Jill Biden during a picnic for
White House press and their families, at the Naval
Observatory Residence, June 5, 2010.

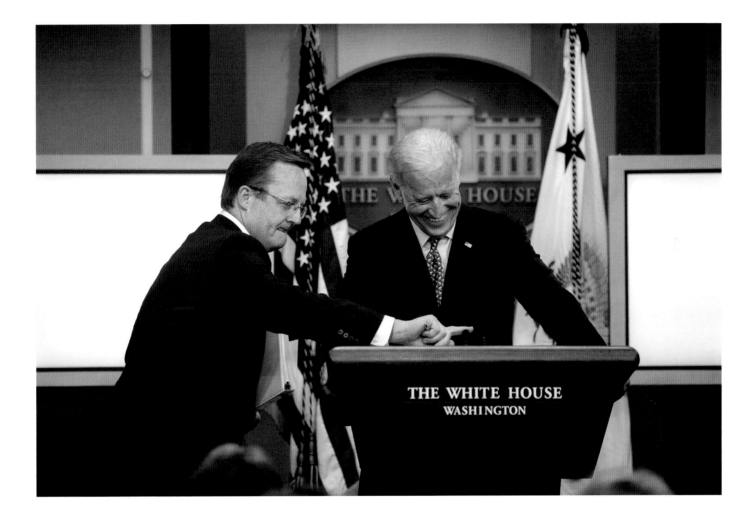

Laughing as press secretary Robert Gibbs does a soundcheck before speaking to the White House press corps in the James Brady Press Briefing Room, June 17, 2010.

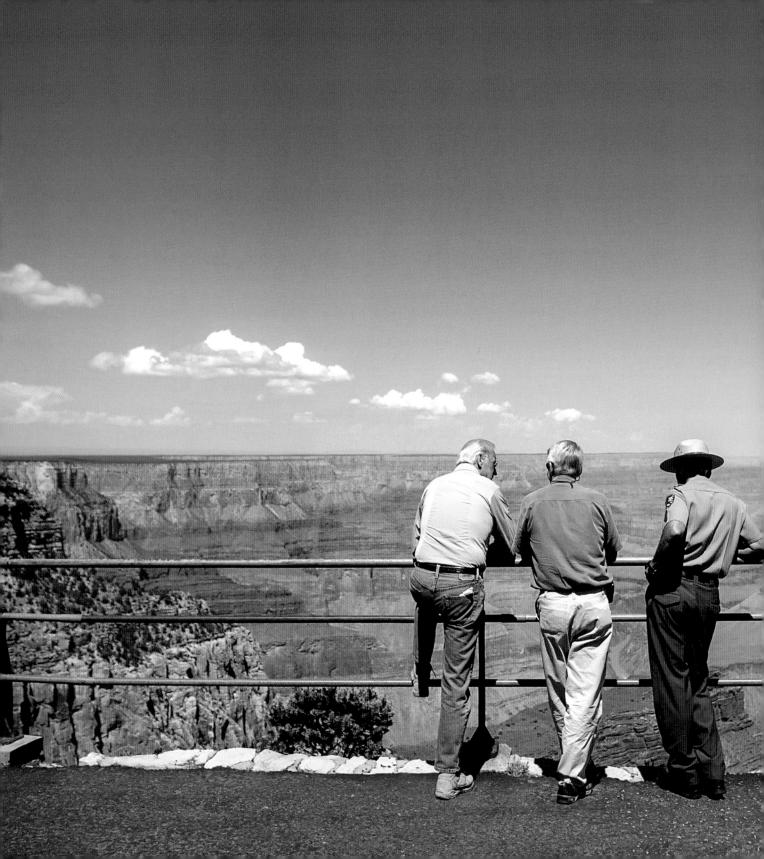

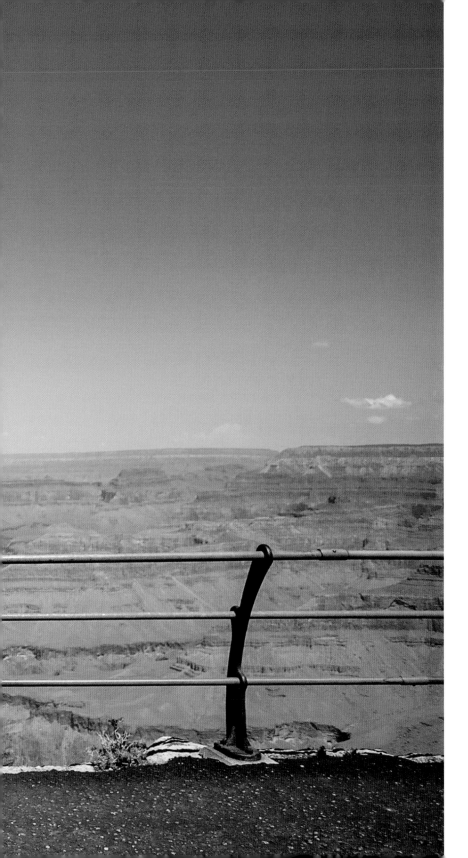

Touring Hopi Point at the Grand Canyon with National Park Service Director Jon Jarvis and Grand Canyon National Park Superintendent Steve Martin, July 27, 2010.

With President Obama at a campaign rally in
Philadelphia, Pennsylvania, October 10, 2010.

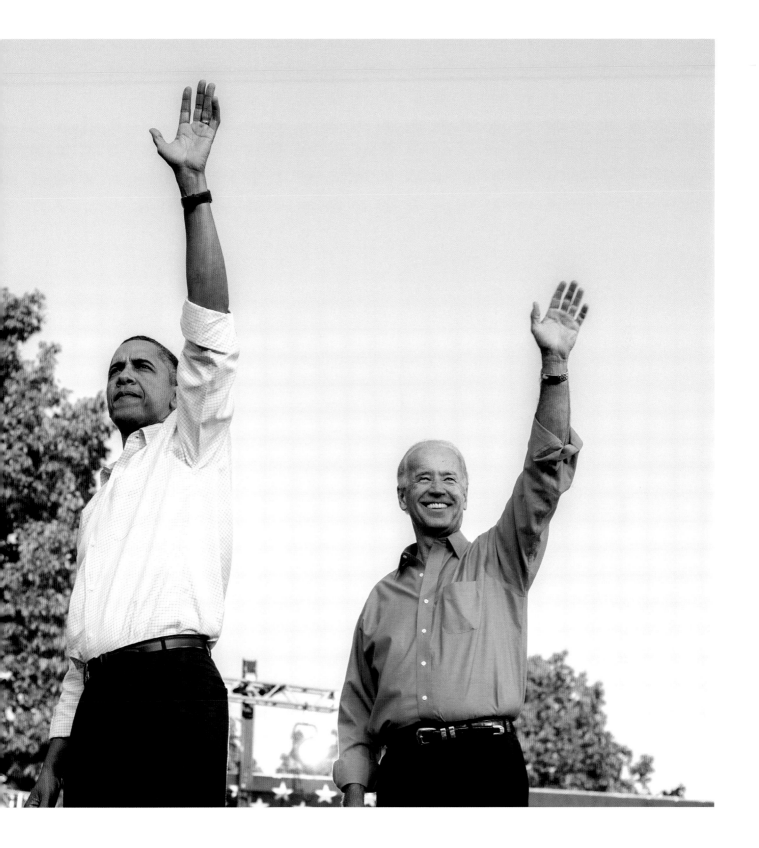

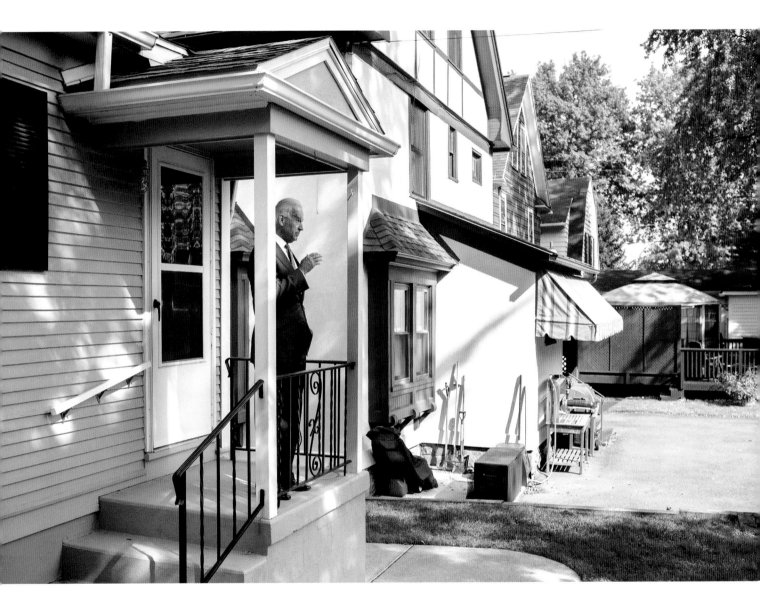

SCRANTON

VICE PRESIDENT BIDEN speaks often about his childhood in Scranton, Pennsylvania, as the son of an "automobile man." Those times were occasionally idyllic and at times tumultuous. A relative or two often came to live with them, crowding a home that already contained four children. To overcome the stutter the Vice President had growing up, an uncle suggested he learn to recite poetry, so long hours were spent in front of a mirror reciting works by Irish poets. Financial uncertainty was familiar to the Bidens. Joe Biden Sr. struggled to maintain a job as the economy of the region—and indeed the entire nation—changed, so he relocated the Biden family to Delaware where he found a better job.

Joe Biden's experience growing up in Scranton is much more than a well-known political talking point. His working-class upbringing shaped his view of the world and pervades his every action as a leader. The power of this place in his personal history is evident in this photo of his first visit back to Scranton after being sworn in as Vice President. He stopped by his childhood home and asked the current owners, who he's kept in touch with, if he could show us around. After touring the house, he paused on the back step, for a brief moment all alone, looking out over the backyard where he'd played as a boy. He then turned around and stepped back inside, returning to a team of aides and security and a packed schedule of events.

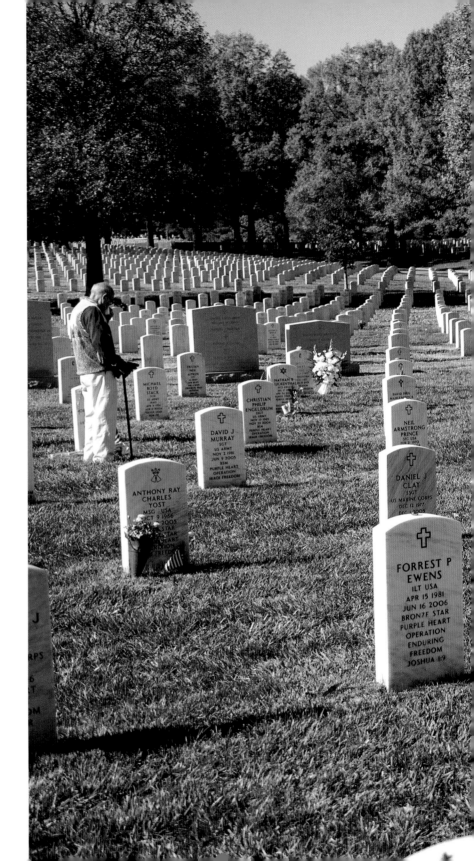

Visiting with families in Section 60, where many veterans of the Afghanistan and Iraq wars are buried, on Veterans Day, at Arlington National Cemetery in Arlington, Virginia, November 11, 2010.

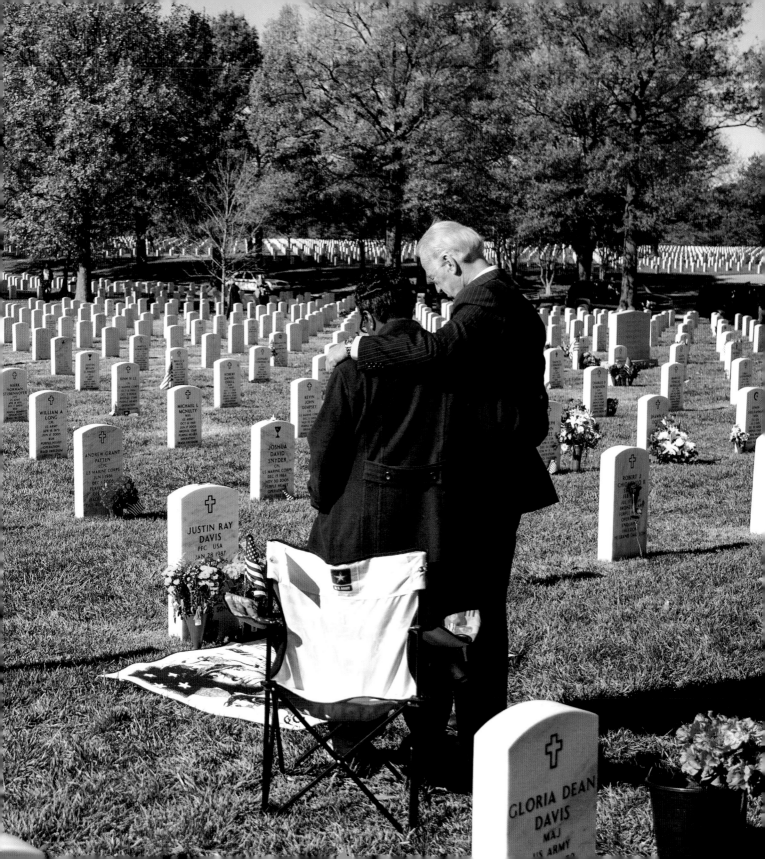

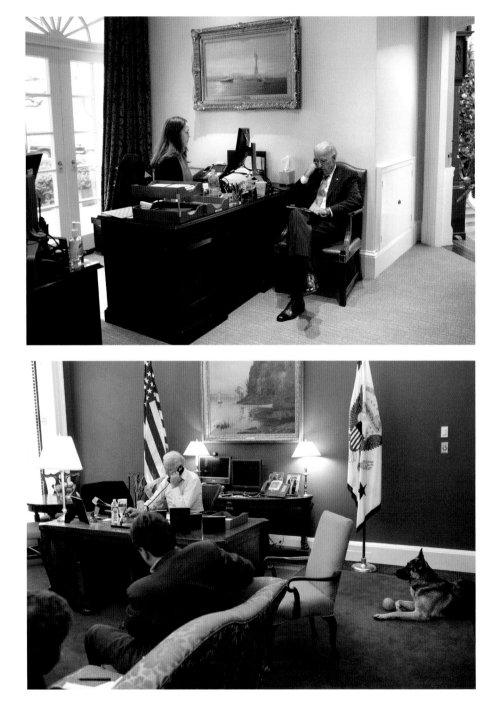

Making a call from President Obama's personal secretary Katie Johnson's phone, in the outer Oval Office, December 2, 2010.

Champ, the German shepherd, looks on as the Vice President makes a phone call during a discussion on the tax cut compromise during the lame-duck session of the 111th Congress, December 5, 2010.

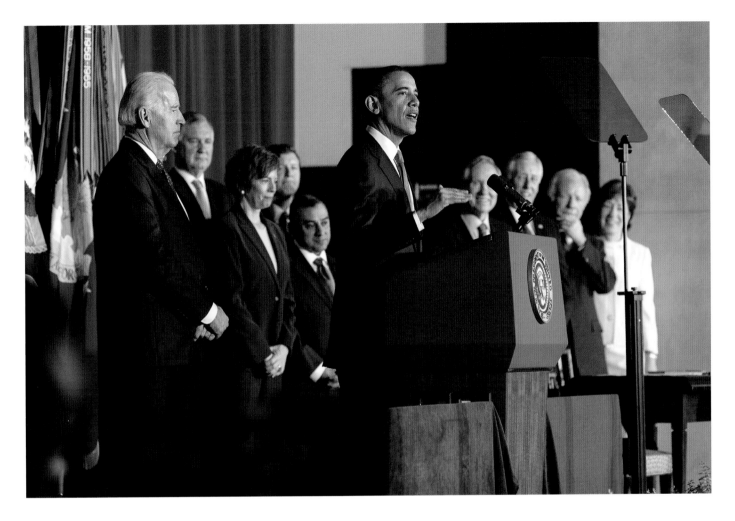

Listening to President Obama speak about the repeal of the military's Don't Ask, Don't Tell policy, during the bill signing at the Department of the Interior, December 22, 2010.

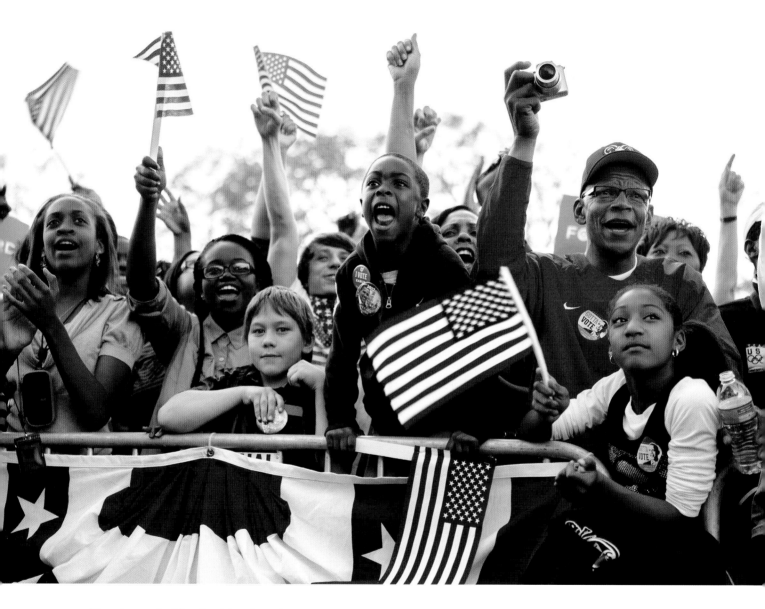

Cheering as the Vice President introduces
President Barack Obama, in Dayton, Ohio,
October 23, 2012.

A PERFECT STORM

The Campaign for Reelection

With the first years in the White House behind them, the Obama-Biden administration had delivered results, strengthening the economy while the Vice President continued to build on his foreign-policy expertise and expand his reach in international circles. In 2011, Navy SEALs brought Osama bin Laden to justice in a daring special operations raid. By 2012, the "Forward" reelection campaign was in full swing, blazing a trail across America. It was a time to rejoice personally and professionally as the Bidens celebrated their daughter's wedding and rode a wave of loyalty and enthusiasm into a second term.

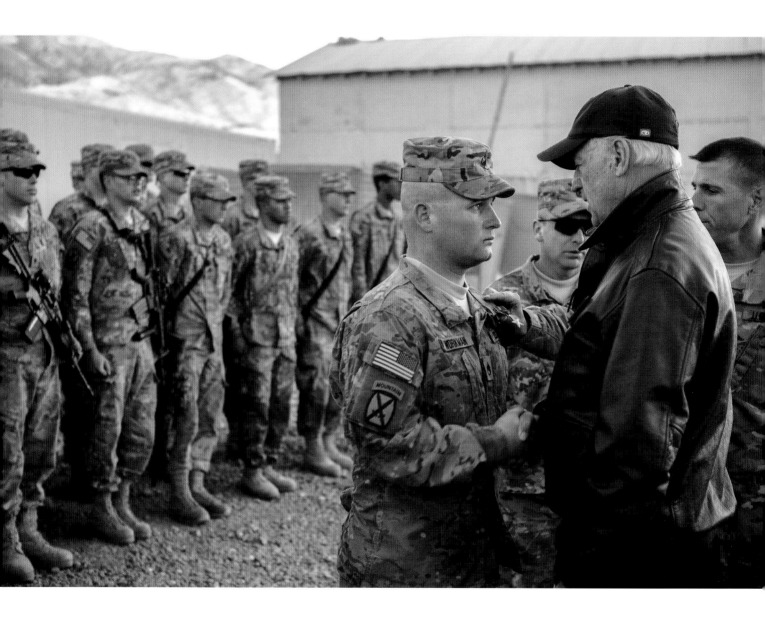

BRONZE STAR

VICE PRESIDENT BIDEN made an unannounced trip to Afghanistan to meet with Afghan leaders and U.S. service members. The agenda included a side trip to Forward Operating Base Airborne in Wardak Province, just southwest of Kabul, to present the Bronze Star to Staff Sergeant Chad Workman.

Workman later recounted the story of the meeting to the *Washington Post*. The Bronze Star is given for heroic achievement in a combat zone. In this particular act of heroism, Workman ran into a burning vehicle in an attempt to save a trapped friend. By the time he was able to remove the burning door, it was too late. Workman told the Vice President he didn't want the medal.

As the *Post* reported:

"I know you don't," Biden replied softly. Eight years later, Workman still remembers how Biden looked at him. "He has that look where his eyes can see into your eyes," Workman said. "I felt like he really understood."

Boarding *Air Force Two,* at
Joint Base Andrews, Prince
George's County, Maryland,
February 11, 2011.

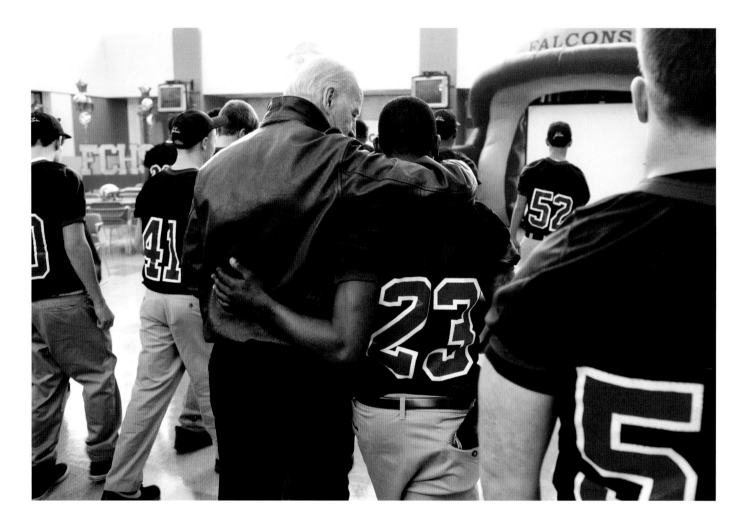

Embracing a player from the Fort Campbell Falcons football team, at Fort Campbell, Kentucky, February 11, 2011.

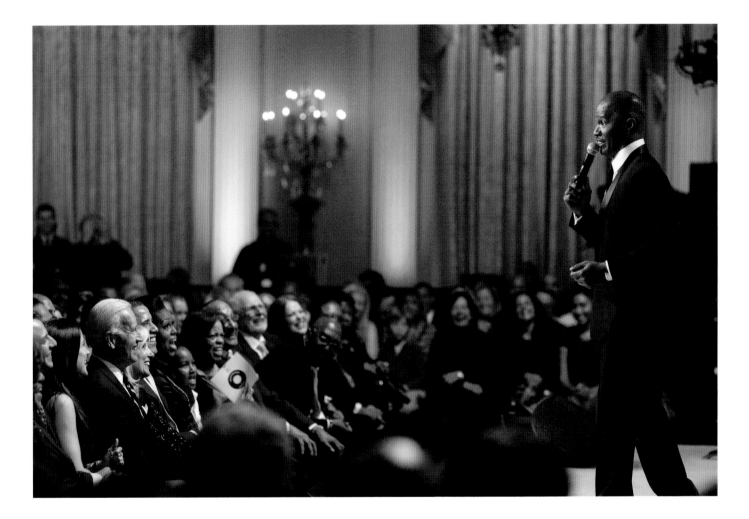

(ABOVE) Laughter erupts as Jamie Foxx performs at the Motown Sound event in the East Room of the White House, February 24, 2011.

(FOLLOWING SPREAD) Talking with President Obama after the White House St. Patrick's Day Reception in the White House Residence, March 17, 2011.

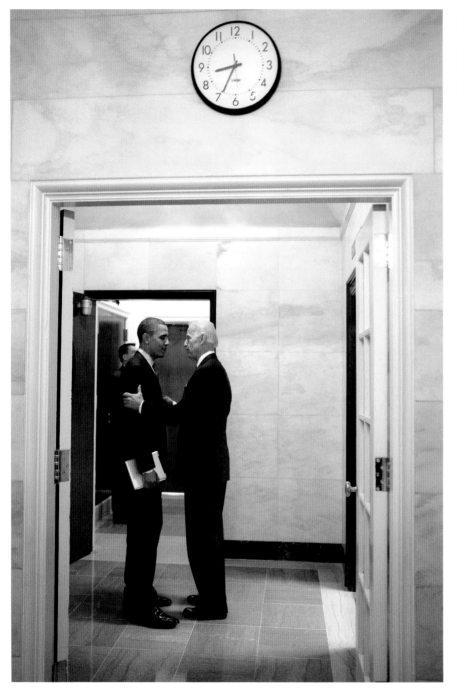
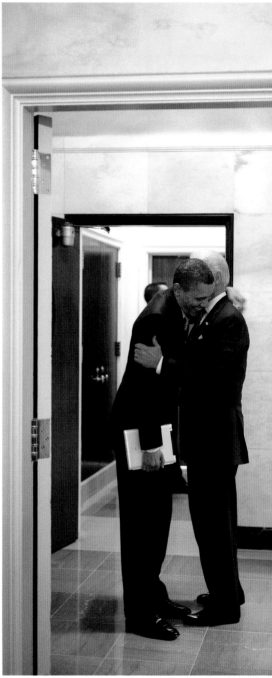

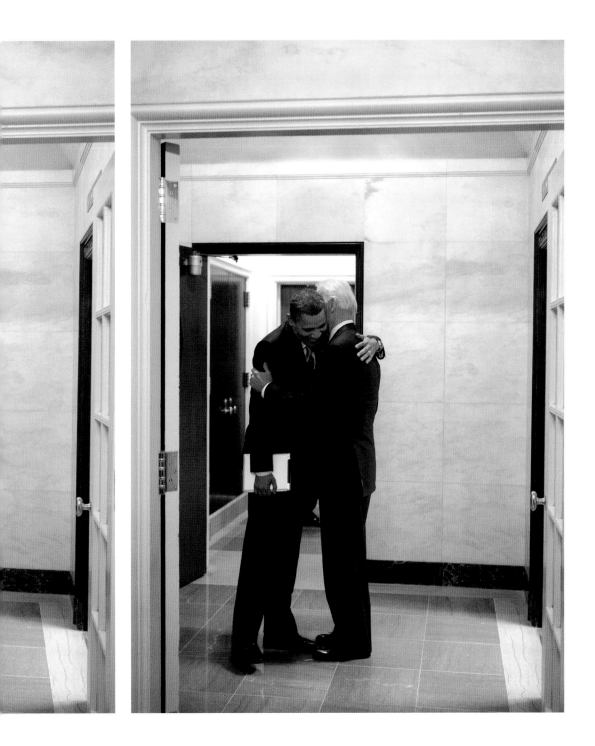

CAPABLE WARRIORS

ON MAY 1, 2011, Osama bin Laden was brought to justice in a highly risky special operations raid deep inside Pakistan by a team of Navy SEALs and U.S. Army Night Stalkers. That night, President Obama marked the mission's success with a speech to the nation from the East Room of the White House. He then traveled to New York City to pay his respects at Ground Zero before having lunch at Engine 54 firehouse in Midtown, which lost fifteen firefighters on 9/11.

Five days later, on May 6, the President and Vice President traveled to Fort Campbell, Kentucky, to personally meet and thank SEAL Team Six, which led the raid. After that private meeting, both leaders took the opportunity to thank the 101st Airborne Division, many of whom had done repeated deployments to Afghanistan and Iraq, for their service in the global war on terror. Vice President Biden told them this: "You are the capable warriors, let me say this without any fear of contradiction, you are the most capable warriors in the history of the world, there has never, never, never, never been a fighting force as capable as you are."

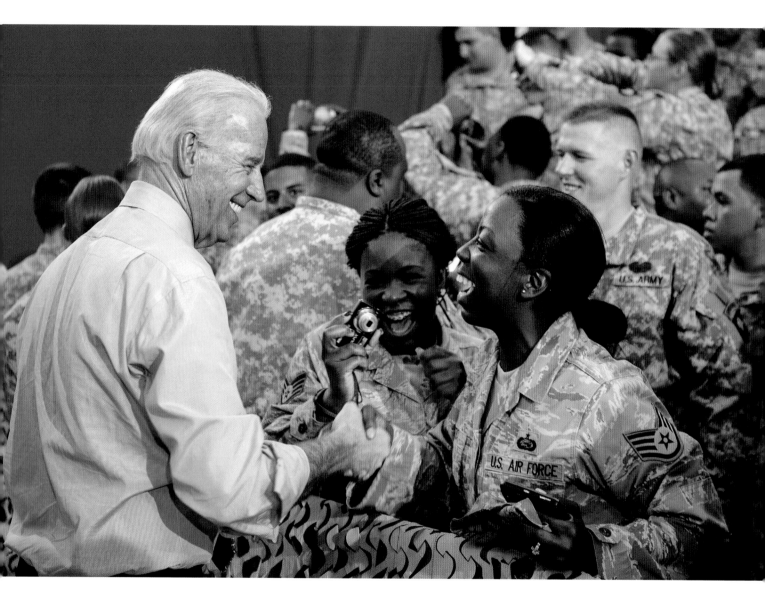

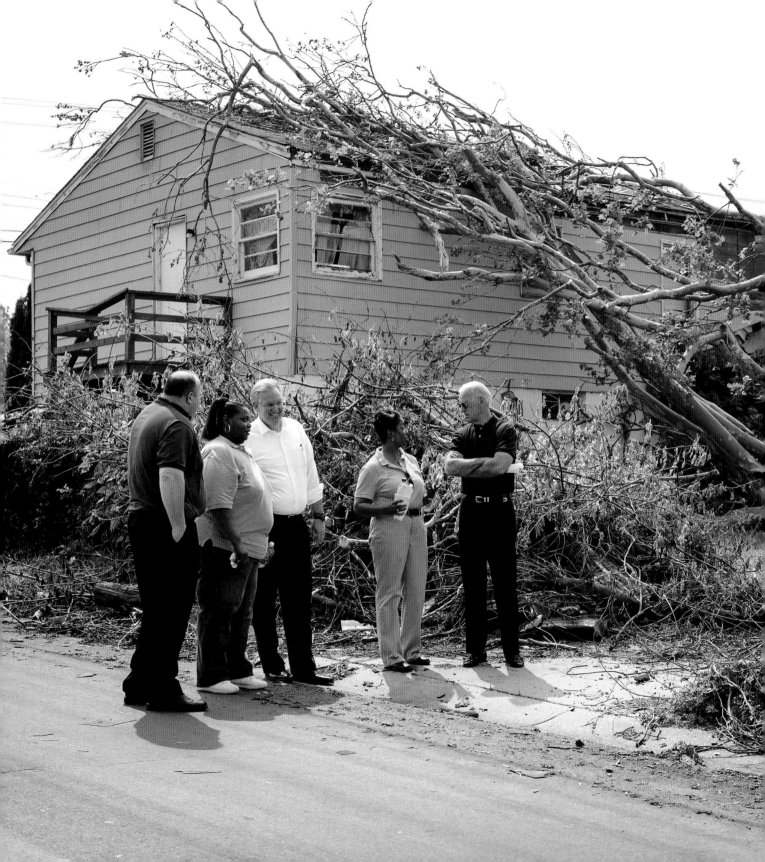

Viewing tornado damage with
Missouri governor Jay Nixon, in
Berkeley, Missouri, May 11, 2011.

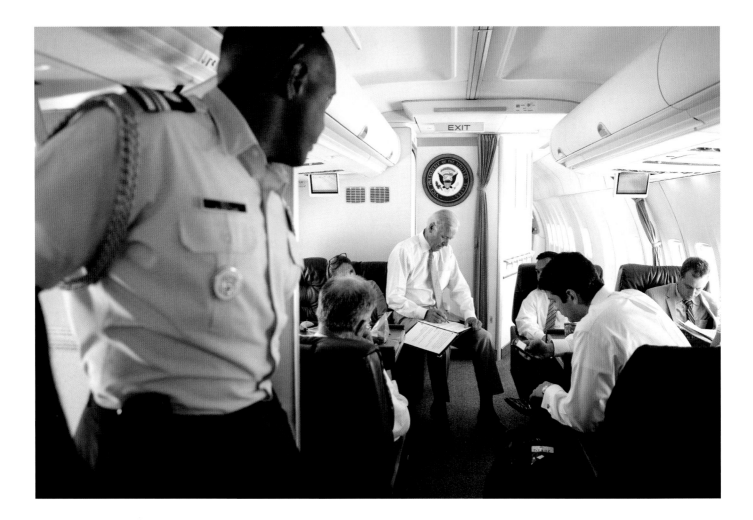

Reviewing a speech for the International
Brotherhood of Teamsters National Convention,
with Nate Tamarin, Shailagh Murray, Fran Person,
Mike Donilon, and Matt Teper, aboard *Air Force
Two,* en route to Las Vegas, Nevada, July 1, 2011.

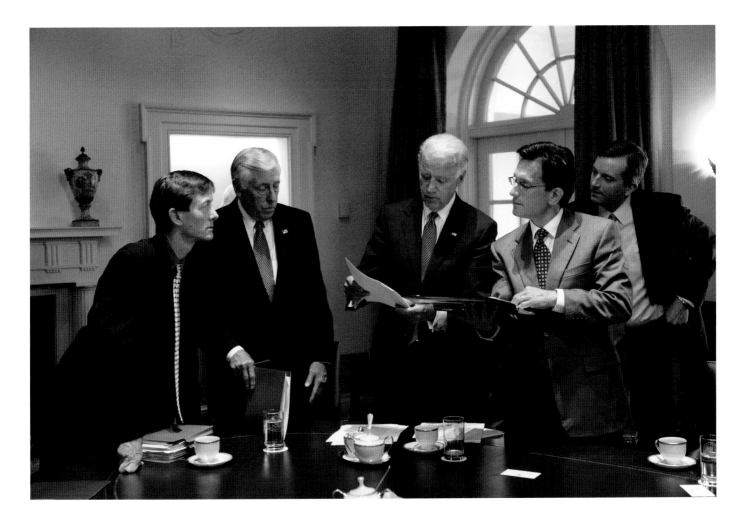

Going over terms of an agreement on the deficit
with Representatives Steny Hoyer and Eric Cantor
in the Cabinet Room, July 12, 2011.

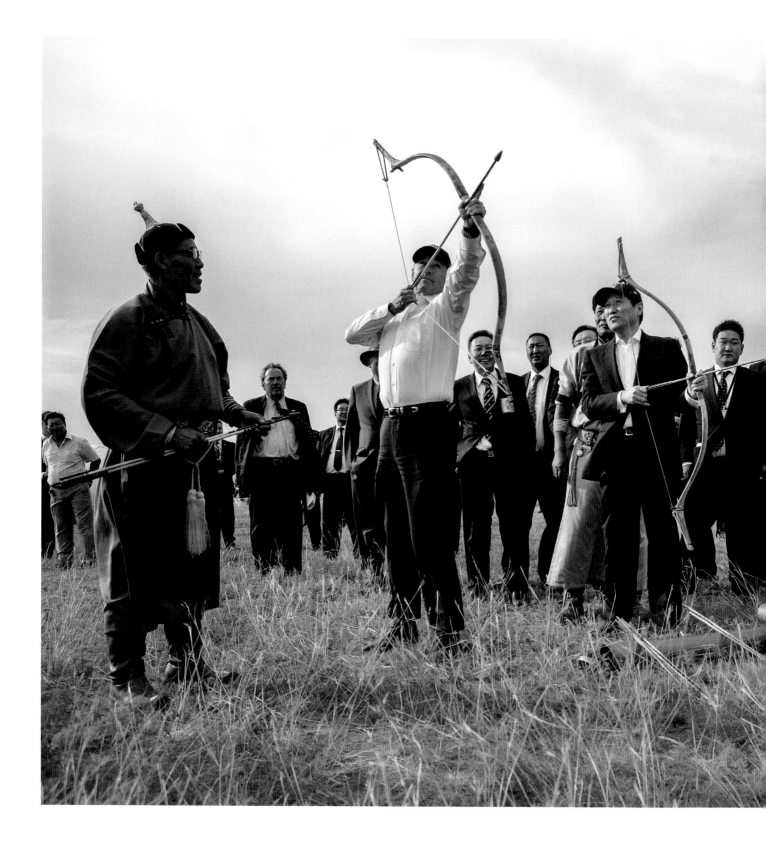

Archery with Mongolian prime minister
Sükhbaataryn Batbold during a cultural
demonstration, outside Ulaanbaatar,
Mongolia, August 22, 2011.

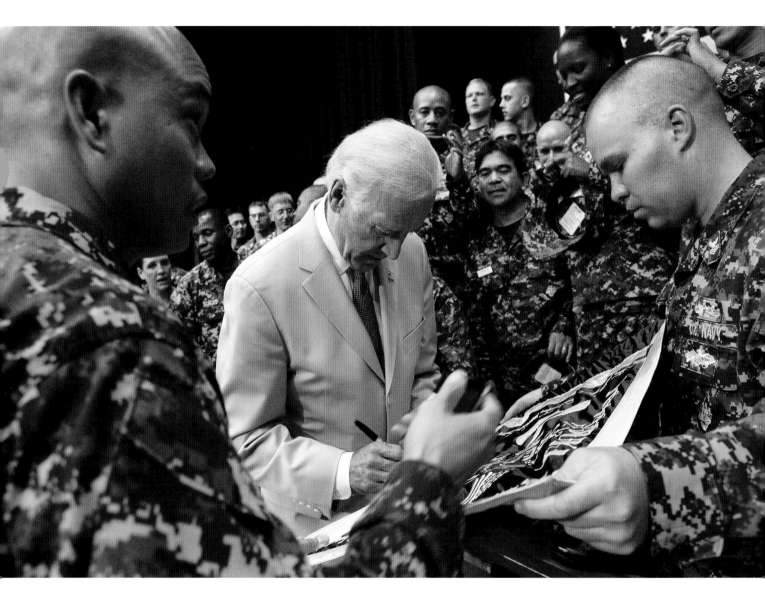

Signing a unit flag while visiting U.S. personnel
at Yokota Air Base, Japan, August 24, 2011.

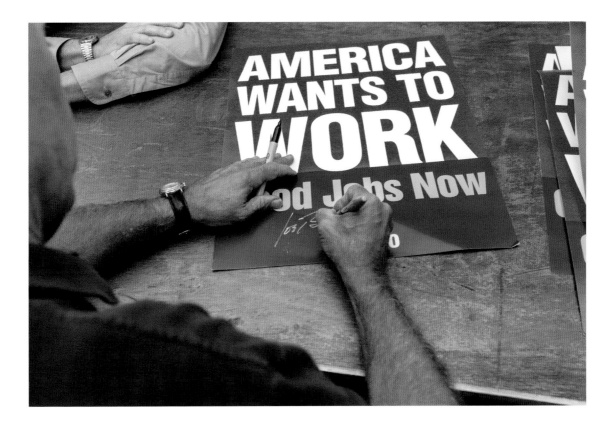

Signing autographs backstage after an
AFL-CIO Labor Day picnic, in Cincinnati, Ohio,
September 5, 2011.

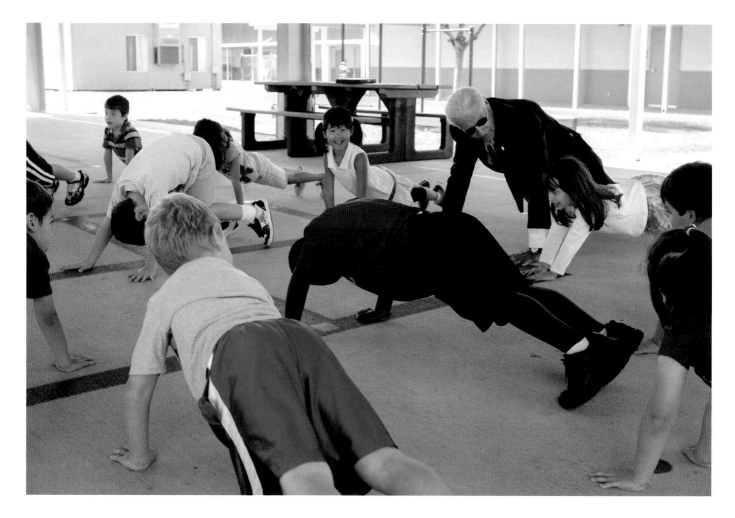

Doing pushups with a gym class on the way to a
classroom visit at Oakstead Elementary School, in
Land O'Lakes, Florida, October 4, 2011.

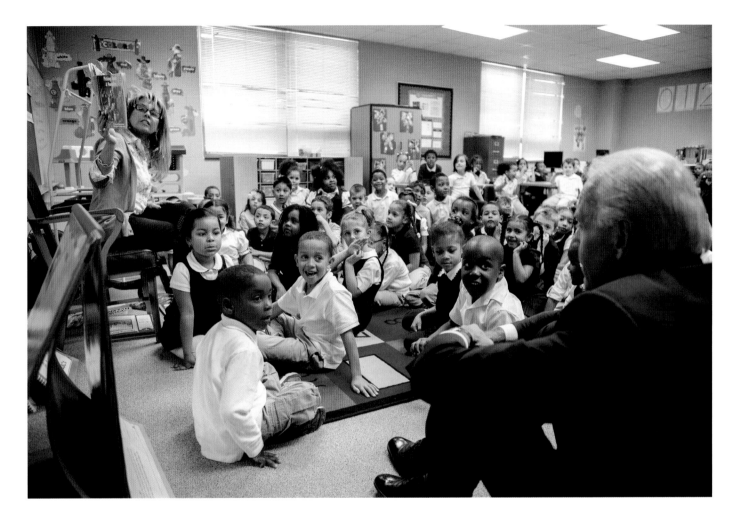

Squeezing in story time at Goode Elementary
School, in York, Pennsylvania, after a speech on the
American Jobs Act, October 18, 2011.

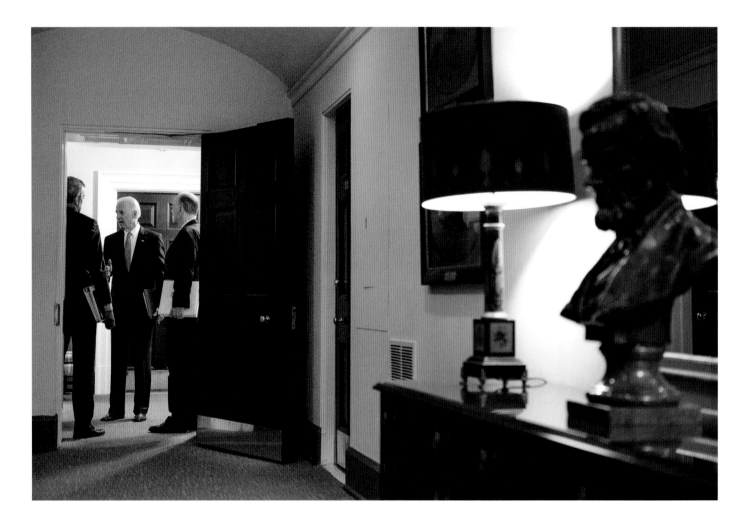

(**ABOVE**) With Deputy National Security Advisor Dennis McDonough (left) and National Security Advisor Tom Donilon, after the President's daily intelligence briefing, February 27, 2012.

(**OPPOSITE**) Thanking wounded warriors and their families at the Wounded Warrior Hope and Care Center at Camp Pendleton, California, January 20, 2012.

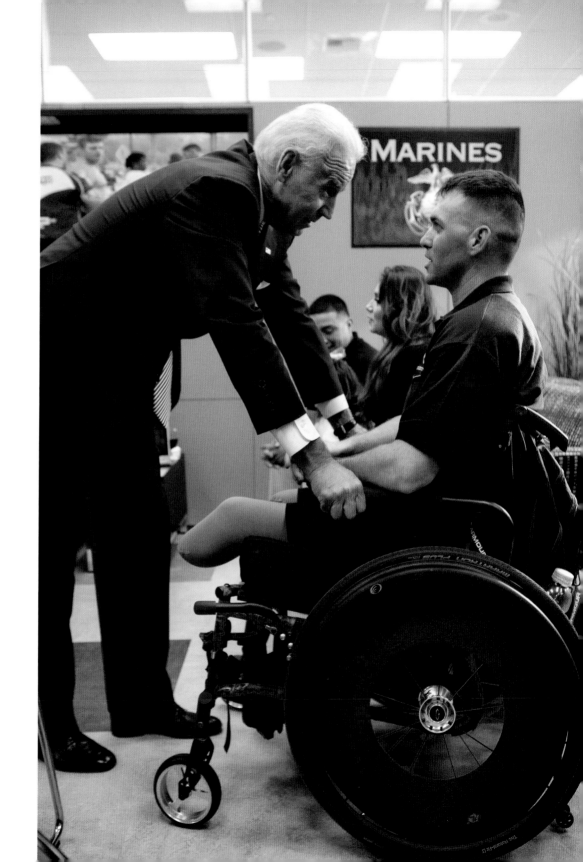

Listening to the President's Own Marine Band before President Barack Obama and First Lady Michelle Obama's A Nation's Gratitude Dinner, in the Cross Hall on the State Floor of the White House, February 29, 2012.

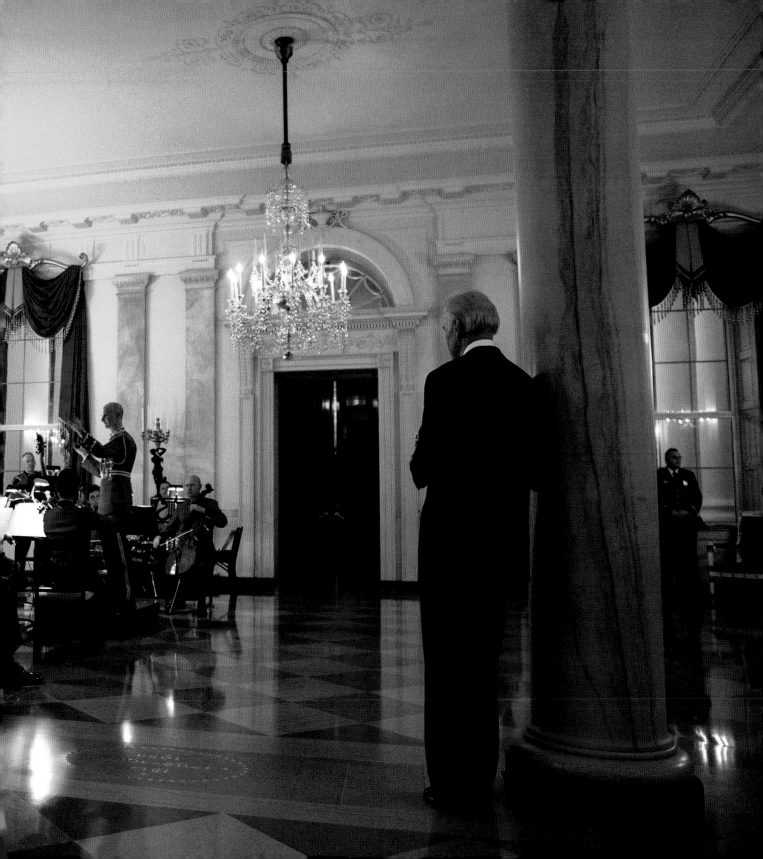

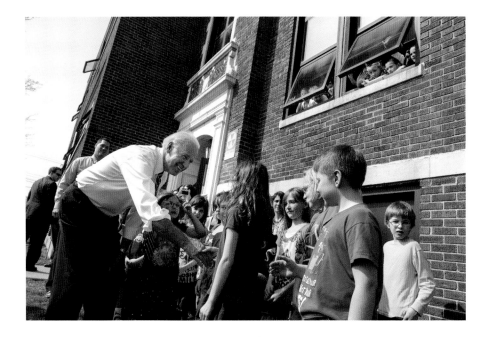

(RIGHT) Talking with workers at the Toledo Machining Plant, in Perrysburg Township, Ohio, March 15, 2012.

(ABOVE) Stop the motorcade: The Vice President takes a detour to greet students who had lined up to see him pass in front of Rossford Elementary School, in Rossford, Ohio, March 15, 2012.

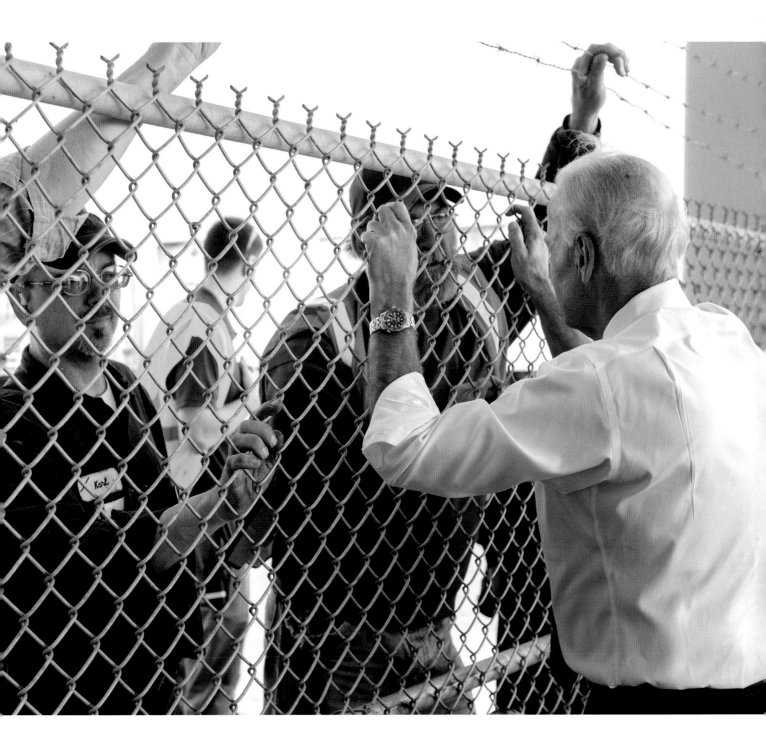

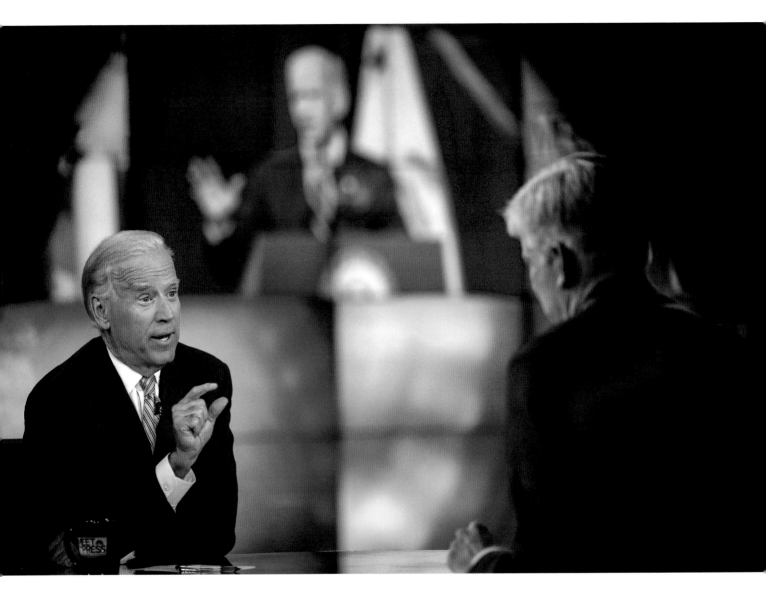

Declaring that he supports same-sex marriage to
David Gregory during a *Meet the Press* interview, in
Washington, D.C., May 4, 2012.

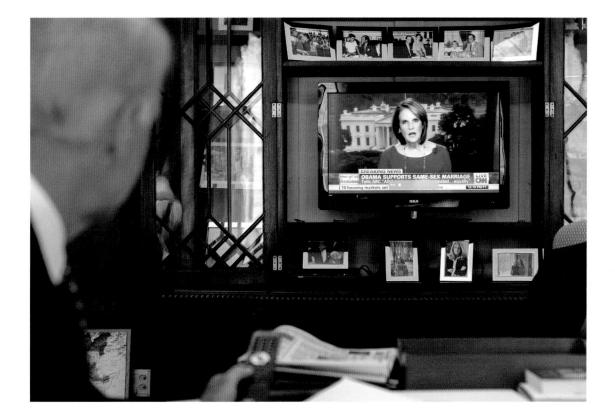

Watching five days later as President Obama's
support for marriage equality is announced, in his
West Wing office, May 9, 2012.

A round of golf with President
Obama at Joint Base Andrews,
Prince George's County, Maryland,
May 12, 2012.

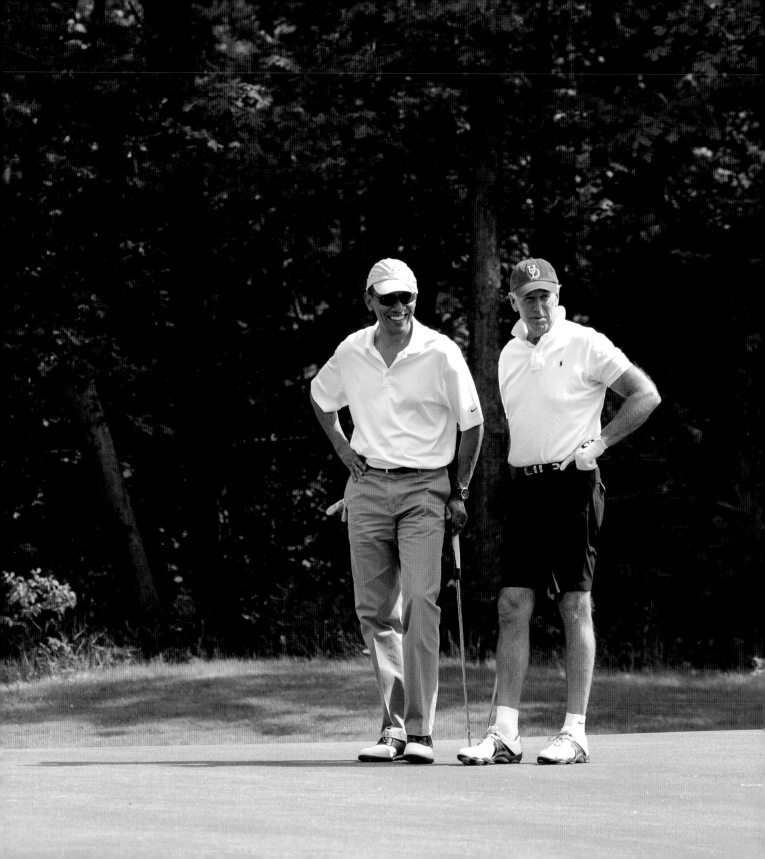

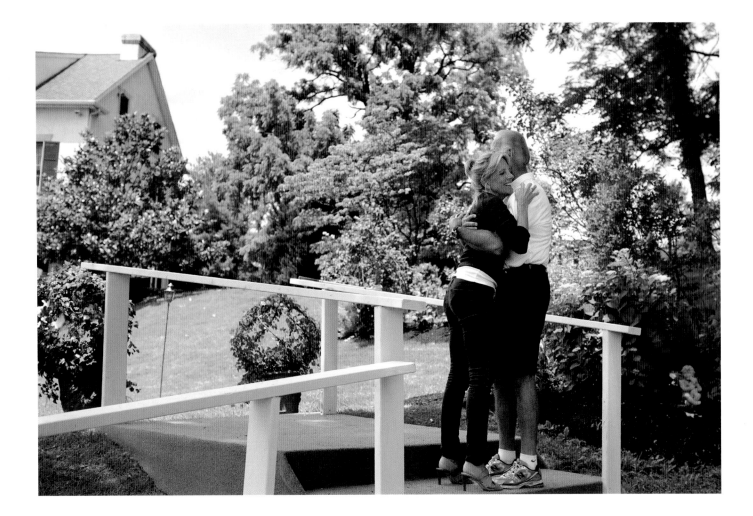

Hugging Dr. Jill Biden as the two make backyard
preparations for their daughter Ashley's wedding,
in Wilmington, Delaware, June 2, 2012.

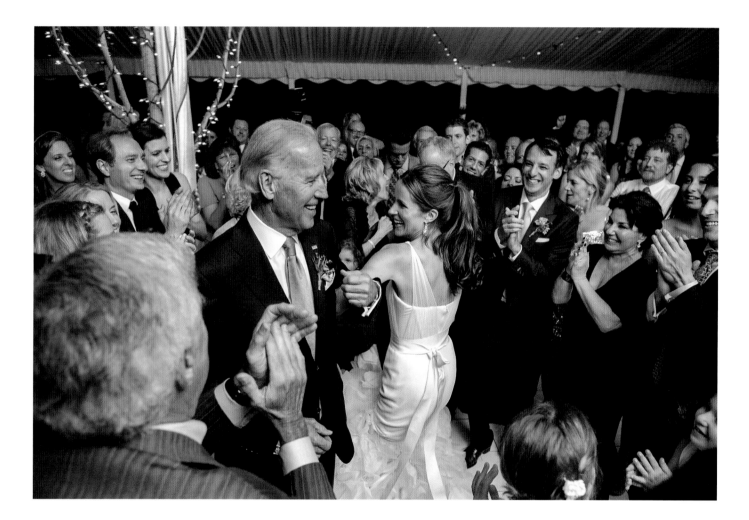

Dancing the hora with his daughter Ashley at her wedding reception in Wilmington, Delaware, June 2, 2012.

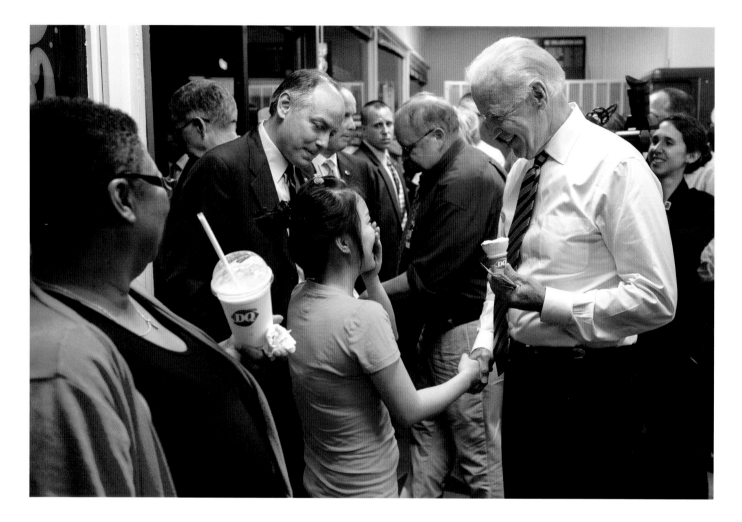

Greeting patrons at Dairy Queen, one of many ice
cream stops in my eight years at the White House,
in Steubenville, Ohio, May 16, 2012.

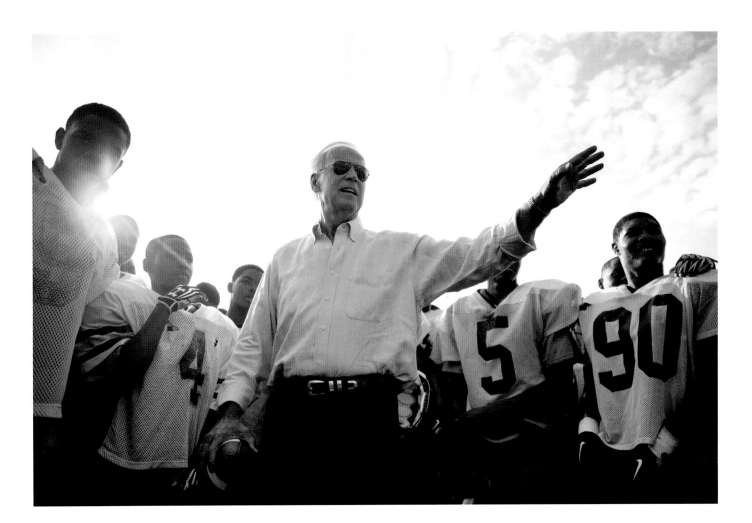

Talking with players at football practice at George
Washington High School, in Danville, Virginia,
August 13, 2012.

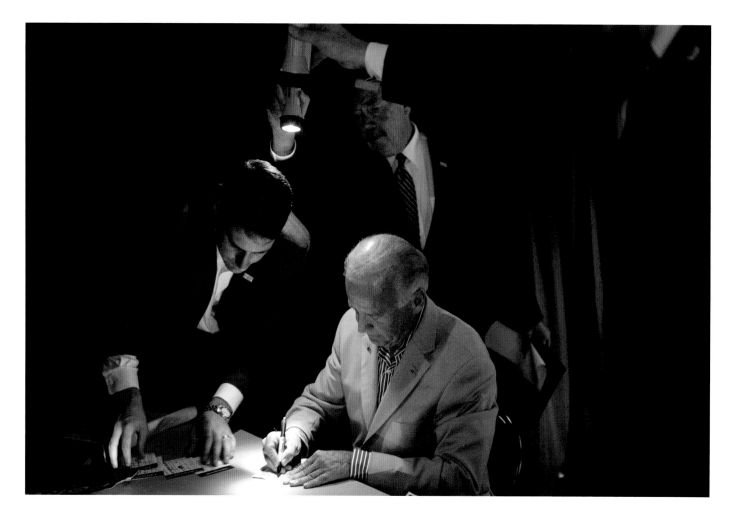

Signing autographs backstage by flashlight after
an Obama for America rally in York, Pennsylvania,
September 2, 2012.

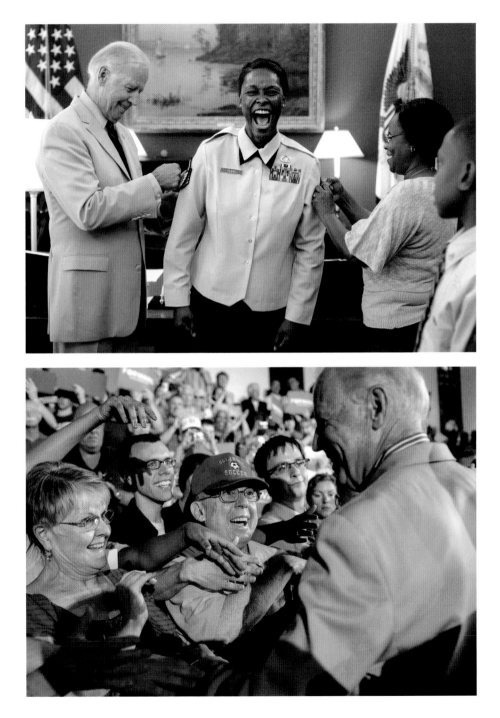

Promoting Katisha Clark from Technical to Master Sergeant, in his West Wing office, August 23, 2012.

Greeting supporters on the rope line at an Obama for America rally in York, Pennsylvania, September 2, 2012.

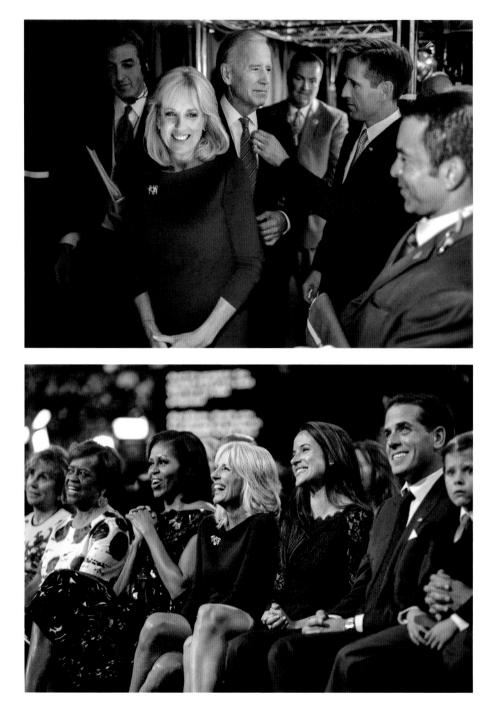

Delaware attorney general Beau Biden adjusts his father's tie backstage as Dr. Jill Biden is introduced at the Democratic National Convention, in Charlotte, North Carolina, September 6, 2012.

(LEFT) First Lady Michelle Obama and Second Lady Dr. Jill Biden and family listen as the Vice President speaks at the Democratic National Convention, in Charlotte, North Carolina, September 6, 2012.

(OPPOSITE) Walking on at the Democratic National Convention, in Charlotte, North Carolina, September 6, 2012.

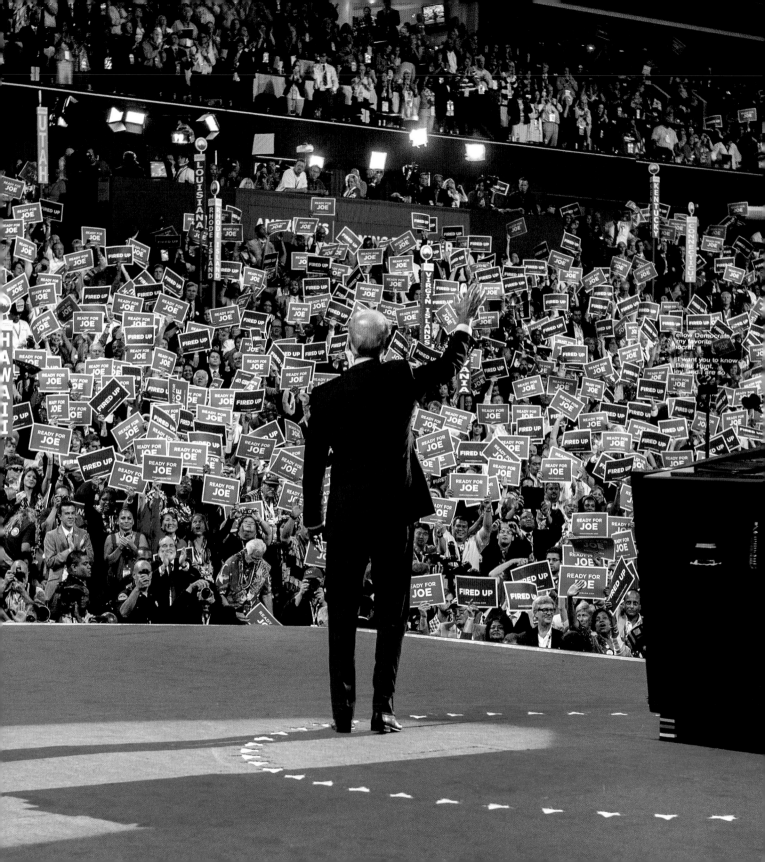

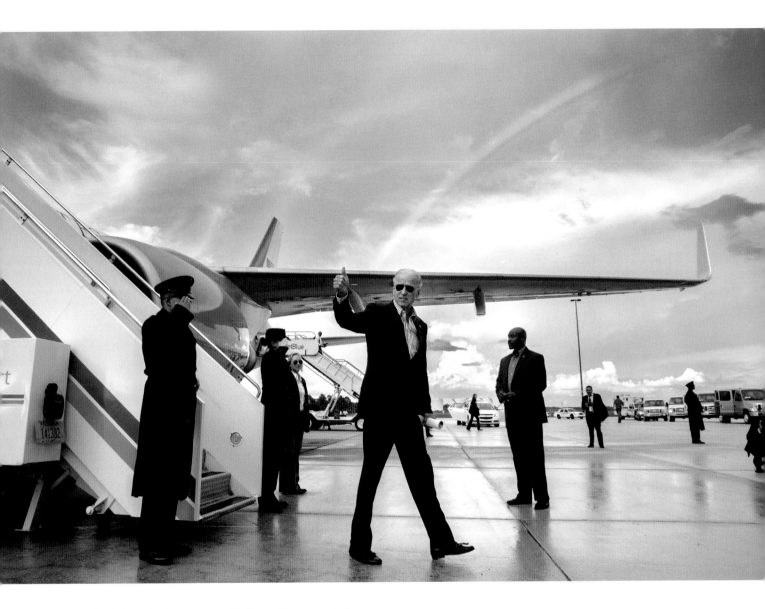

A rainbow broke out over *Air Force Two* on arrival
at Southwest Florida International Airport, Fort
Myers, Florida, September 28, 2012.

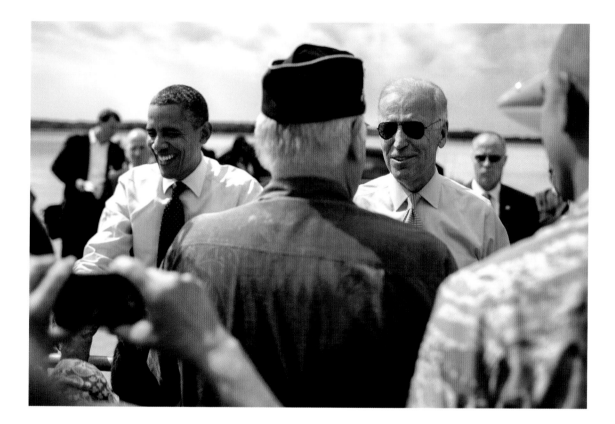

(ABOVE) Greeting guests at Portsmouth International Airport with President Obama in Portsmouth, New Hampshire, September 7, 2012.

(FOLLOWING SPREAD) Speaking at a campaign rally in Portsmouth, New Hampshire, September 7, 2012.

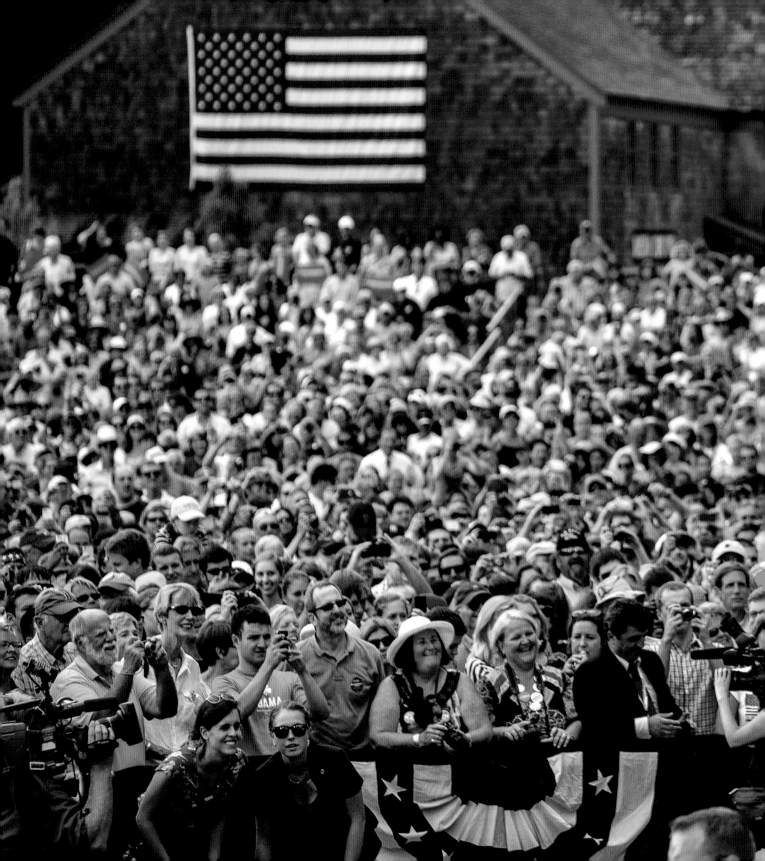

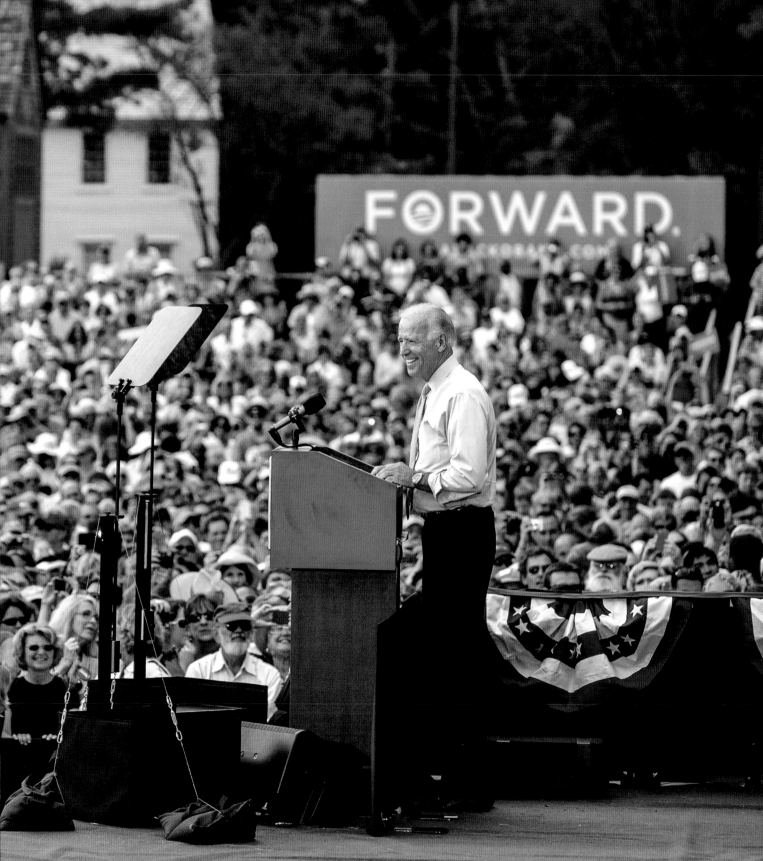

EVERY STORY MATTERS

DURING A REELECTION CAMPAIGN stop in Fort Myers, Florida, in 2012, the Vice President met 15-year-old Kobe Groce. I captured this photograph of raw emotion on Kobe's face as the Vice President embraced him like one of his own sons. Groce explained to Biden that the administration's policies had improved his family's life. When interviewed later by the reelection campaign Groce said:

Life would not be the way it is today if they hadn't taken office four years ago...I had this impulse to hug him, so I did. And I cried. I think I even got tears on the Vice President's suit jacket! ...I am hugging the man who will help me and help our President move forward.

This is one of my favorite photographs, but it is not unique. Over eight years, I photographed the Vice President shaking hands, hugging, and connecting with thousands of people. They all radiate the same energy you feel in this scene. Whether greeting heads of state, business leaders, young people on the campaign trail, all garnered the same respect and engagement from the Vice President. Everyone had a story and every story mattered.

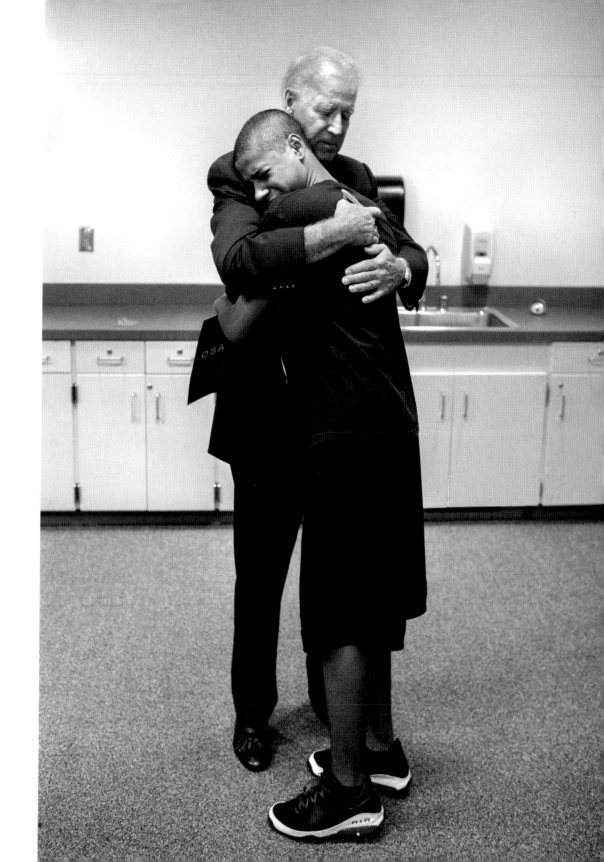

Preparing for the Vice Presidential Debate, in
Wilmington, Delaware, October 7, 2012.

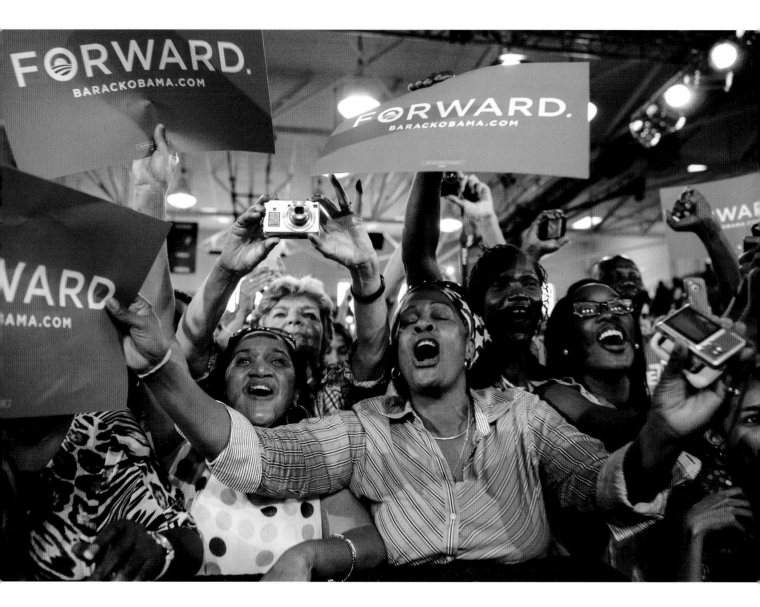

Campaign rally in Fort Pierce, Florida, October 19, 2012.

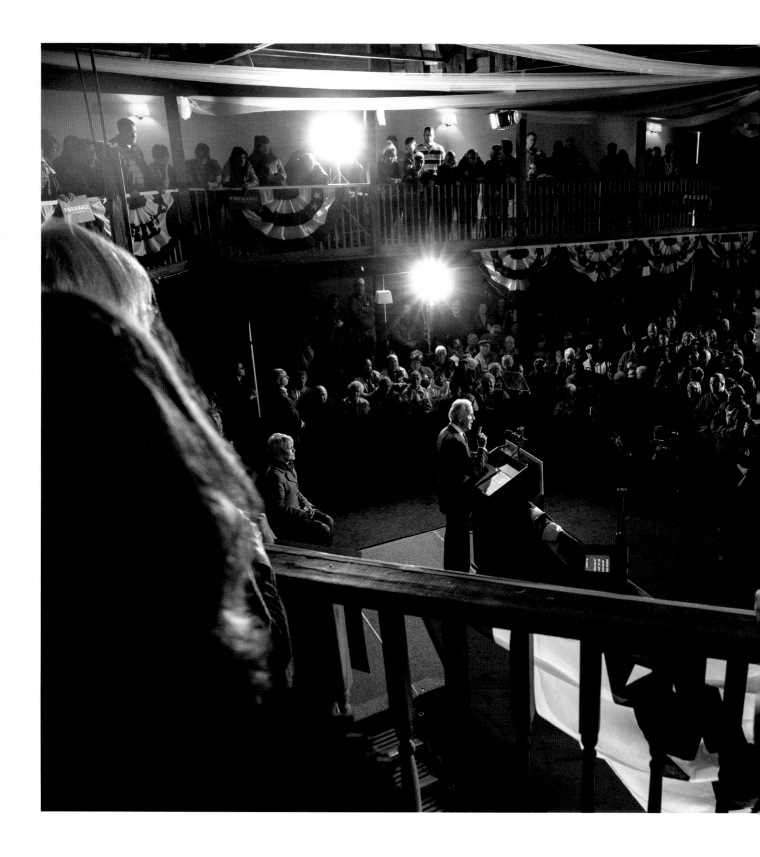

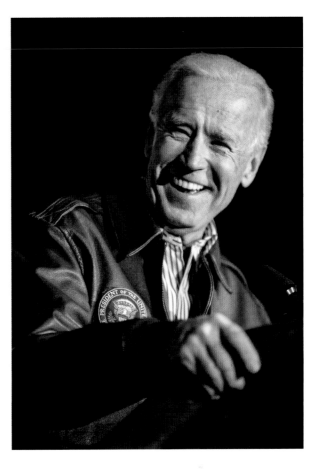

(LEFT) Supporters line the balcony railings at an Obama for America rally at the Opera House in Fort Dodge, Iowa, November 1, 2012.

(ABOVE) At an Obama for America rally the night before the election, in Richmond, Virginia, November 5, 2012.

(FOLLOWING SPREAD) Celebrating reelection with President Barack Obama, First Lady Michelle Obama, and Dr. Jill Biden, in Chicago, Illinois, November 6, 2012.

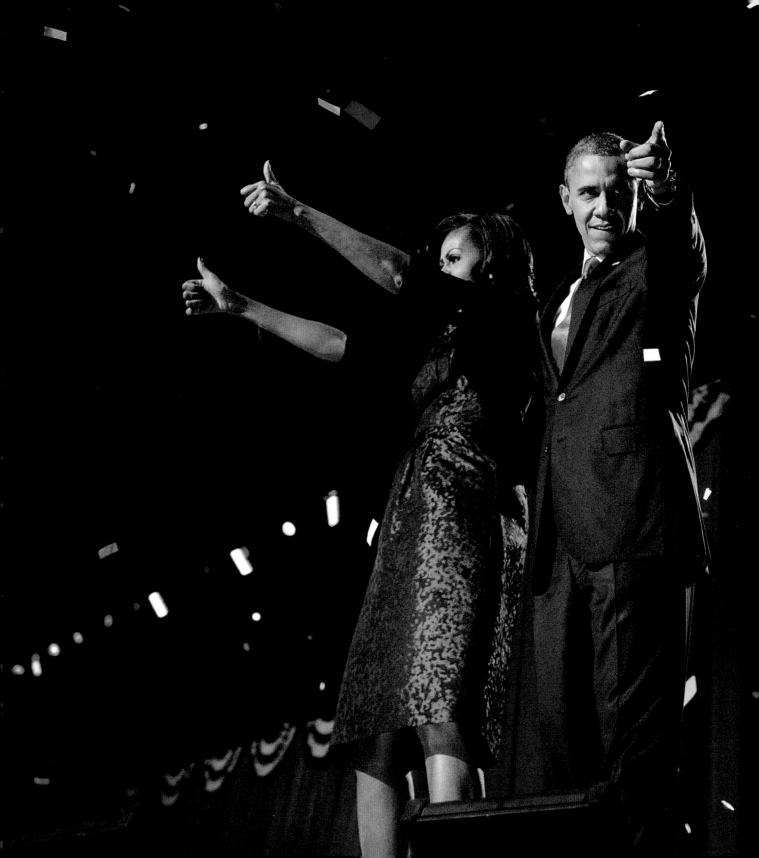

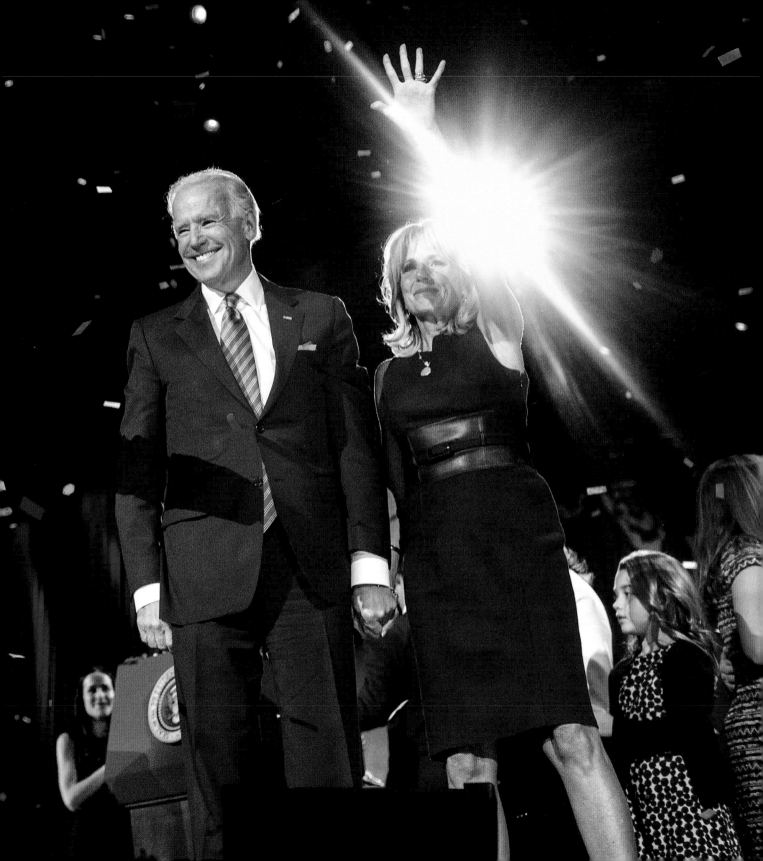

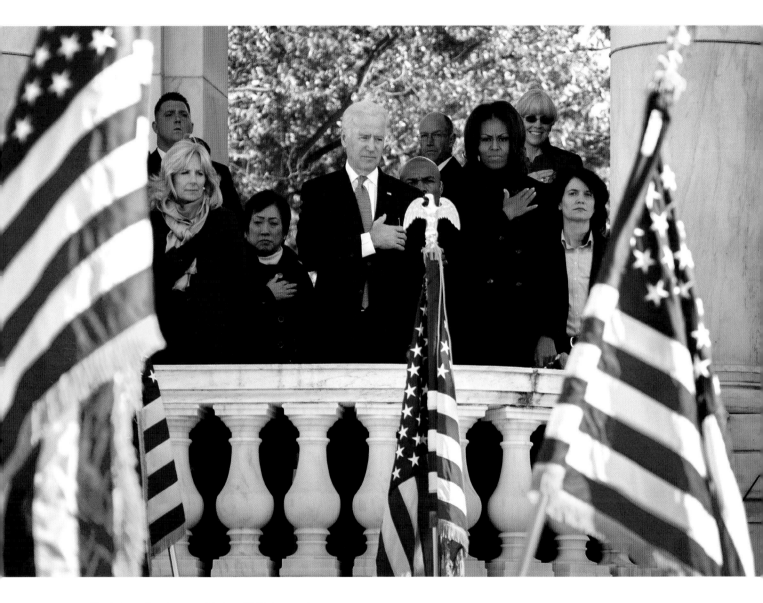

Pledging allegiance with Dr. Jill Biden and
First Lady Michelle Obama at a Veterans
Day event at Arlington National Cemetery,
November 11, 2013.

WINDS OF CHANGE
Second Term

The second term called on the Vice President to deepen his role as a public servant — representing the Obama administration both domestically and abroad, championing veterans' rights, education, and social equity. Personal tragedy befell the Bidens as their older son, Beau, succumbed to a battle with brain cancer. Shortly thereafter, the Vice President's capacity for empathy helped soothe the nation's heartache from horrific mass shootings, including at the Mother Emanuel AME Church in South Carolina.

A NEW TERM

I JOINED THE OBAMA-BIDEN administration in March of 2009, so my first inauguration was their second, after being reelected in November 2012. The following January, Washington D.C. , prepared for the massive influx of citizens eager to celebrate the new term. In the days leading up to the ceremony, streets were closed, manhole covers were welded shut, and newspaper boxes were removed to ensure the safety of the hundreds of thousands of people who would descend on the city. I went to a dress rehearsal of the inauguration at the Capitol, to ensure that I understood the movements of the Vice President and the President, and also where I would be positioned. Our office wasn't sure which of the inaugural balls the Bidens would attend, so they credentialed me for all of them. I wore a lanyard with dozens of credentials on it around my neck for several days and had to flip through them depending on the event. Inauguration normally falls on the 20th of January after the presidential election, but this year that date was a Sunday. The President and Vice President were officially sworn in in small private ceremonies at the White House and Naval Observatory respectively, and then re-sworn in on the steps of the Capitol the next day. Here, Supreme Court Associate Justice Sonia Sotomayor swears in Vice President Biden for his second term as he stands with. Jill, Beau, Ashley, and Hunter Biden.

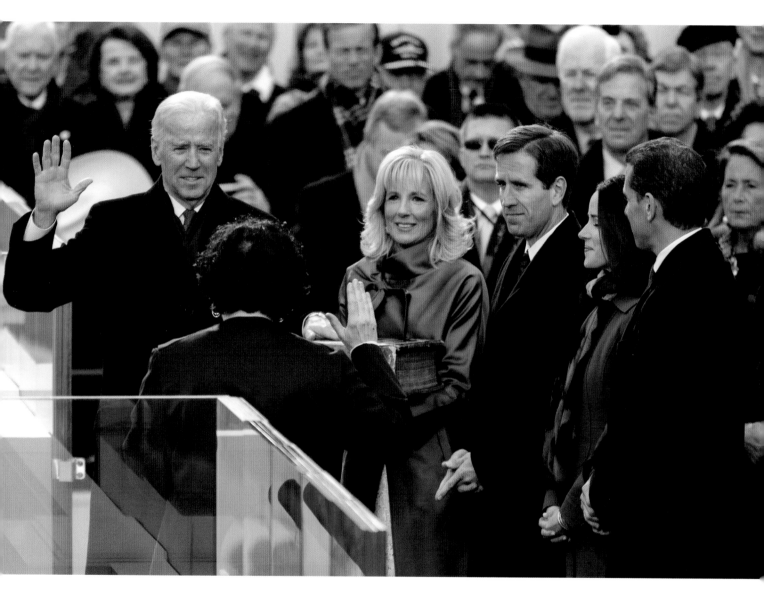

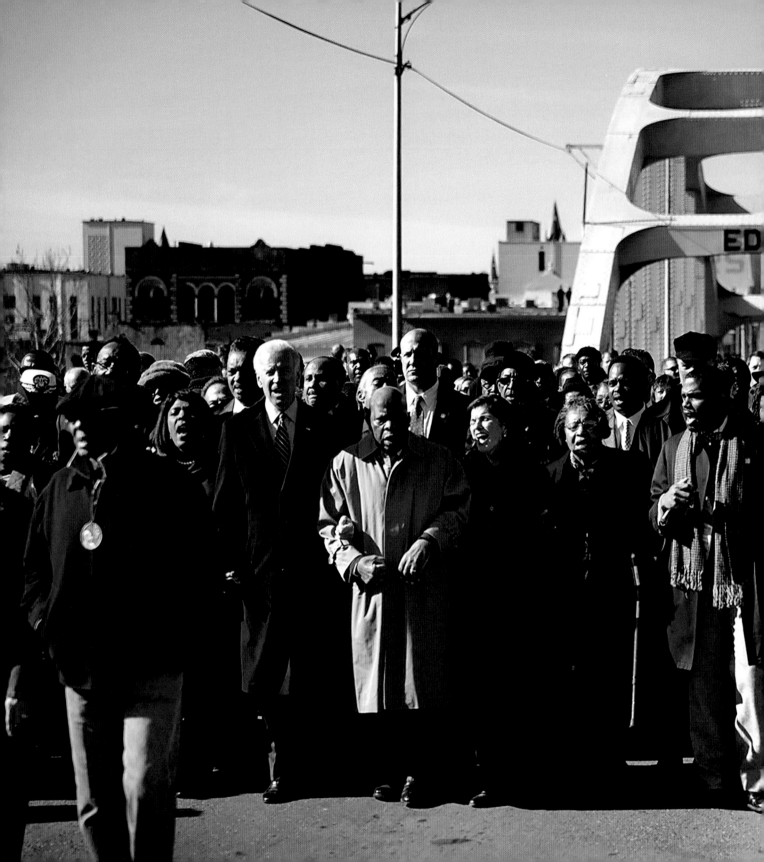

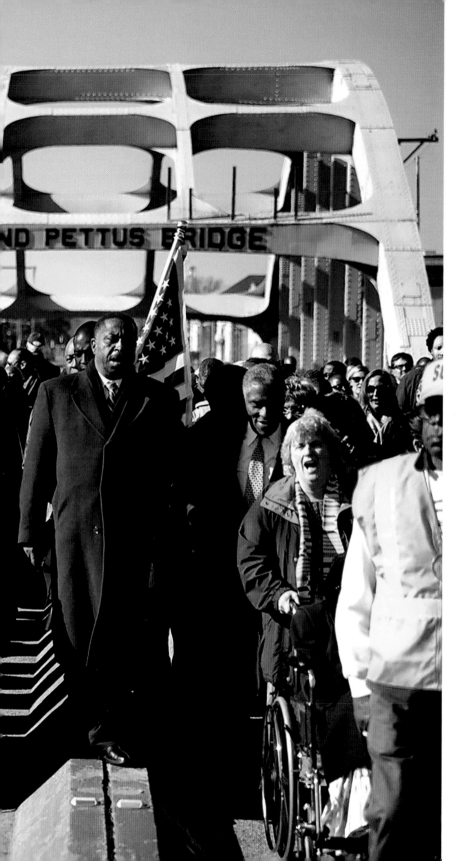

Commemorating the Civil Rights movement at the 48th annual Bridge Crossing Jubilee, on the Edmund Pettus Bridge with Congresswoman Terri Sewell and Congressman John Lewis, in Selma, Alabama, March 3, 2013.

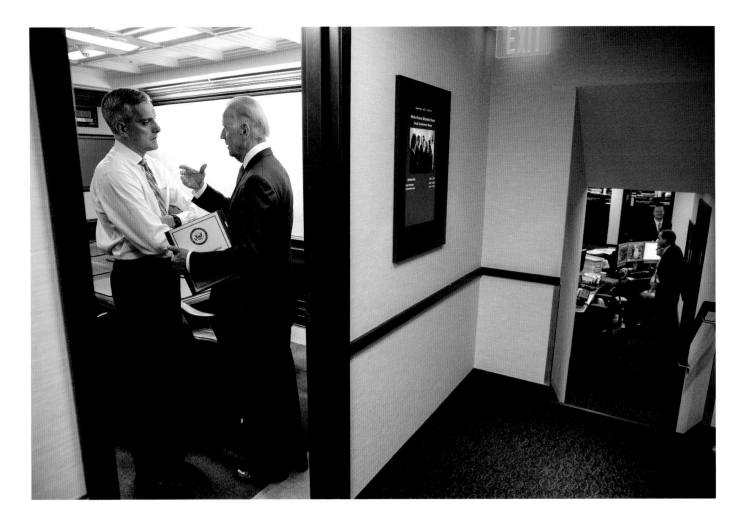

Talking with the President's chief of staff, Denis McDonough, before a National Security staff meeting in the Situation Room, July 17, 2013.

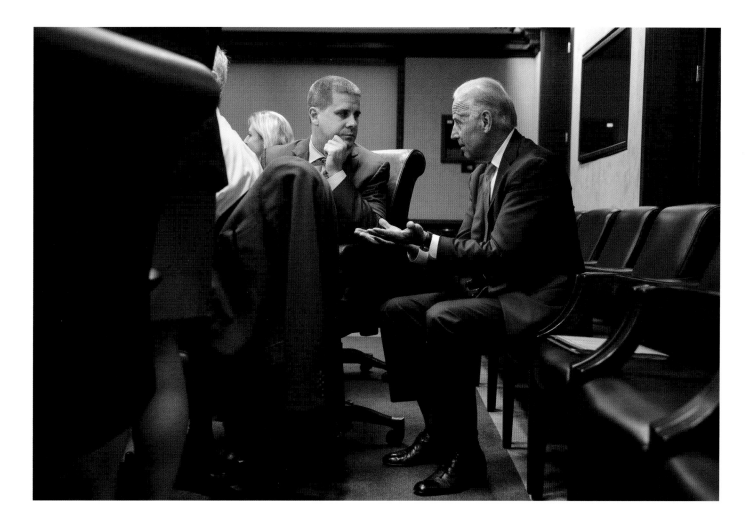

Talking with senior advisor for strategy and
communications Dan Pfeiffer before a National
Security staff meeting in the Situation Room,
July 17, 2013.

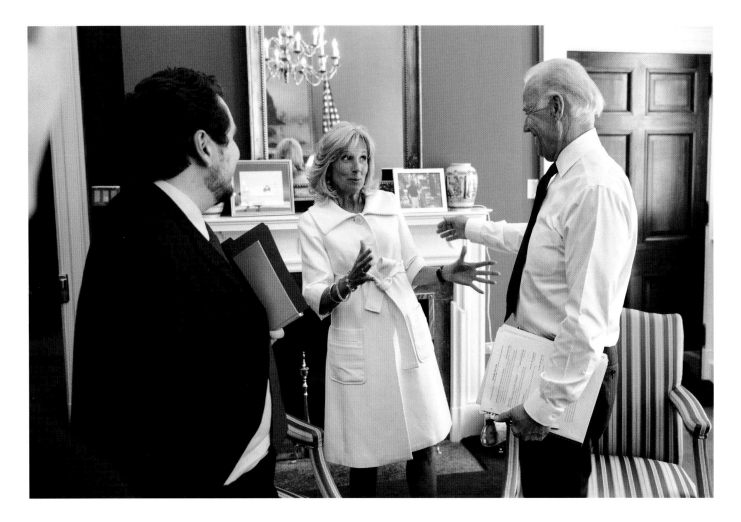

Dr. Jill Biden drops by during a meeting with
foreign policy speechwriter Dan Benaim, in the
West Wing, April 3, 2013.

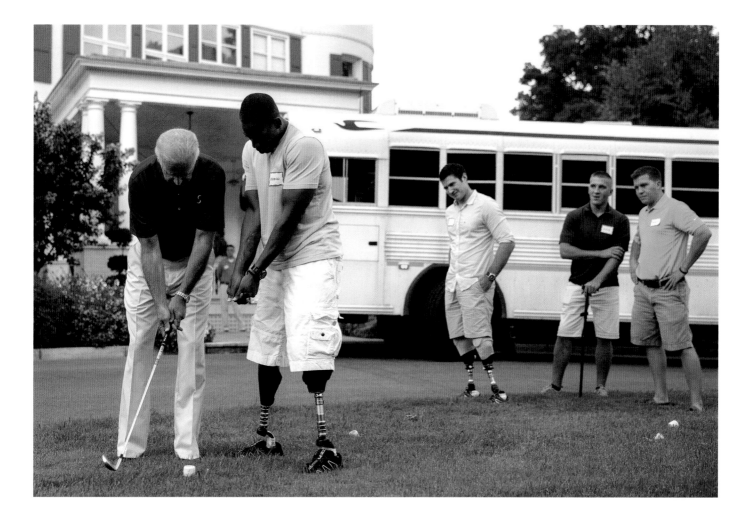

Helping Army Ranger Master Sergeant Cedric King
with his golf swing during a barbecue for Wounded
Warriors at the Naval Observatory Residence,
September 11, 2013.

(RIGHT) Watching a tactical team demonstration with Commander Timothy Wilke from the cargo bay of his command, the littoral combat ship USS *Freedom*, at Changi Navy Base, in Singapore, July 27, 2013.

(FOLLOWING SPREAD) Observing a moment of silence to honor the 12th anniversary of the 9/11 attacks on the South Lawn of the White House with the President, First Lady, and Dr. Jill Biden, September 11, 2013.

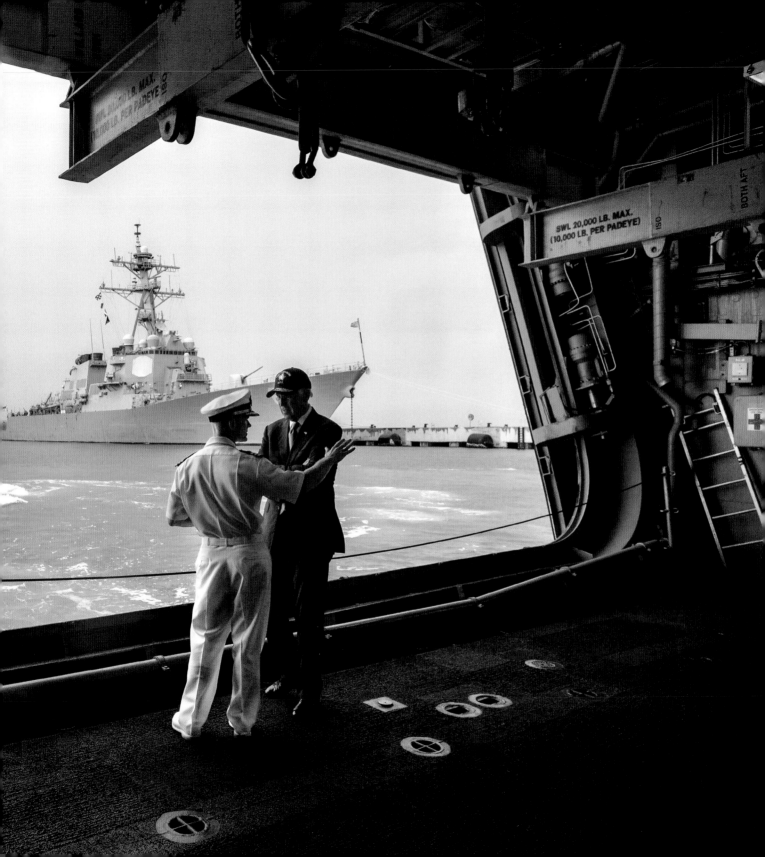

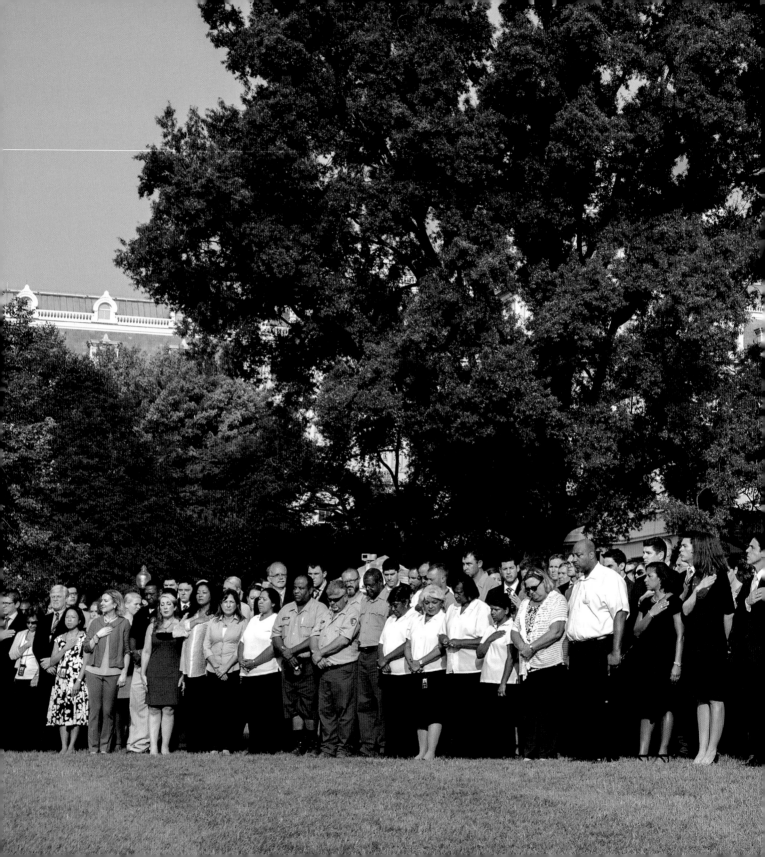

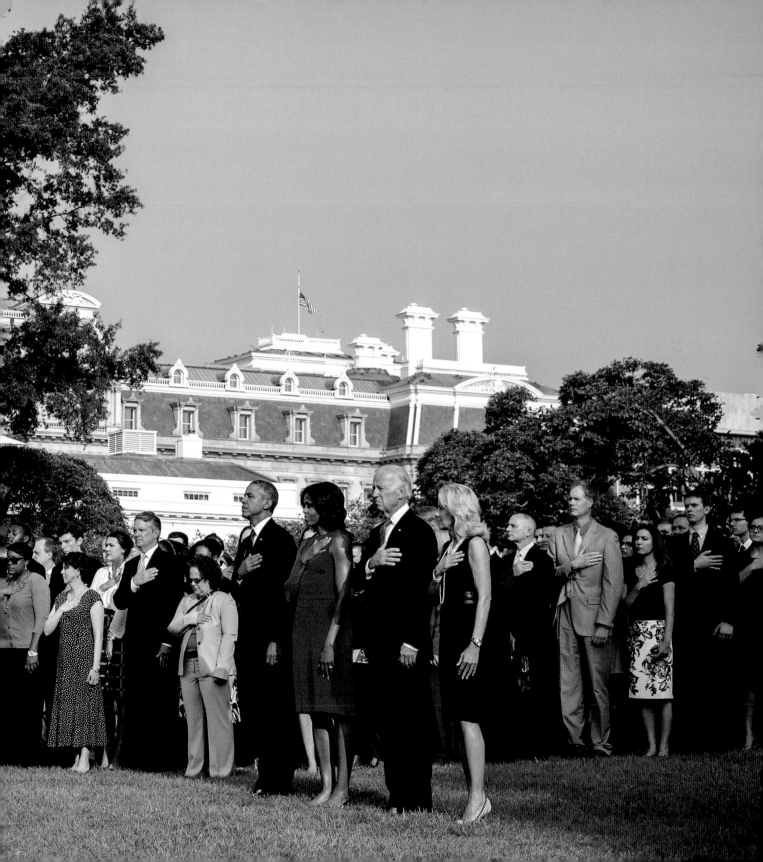

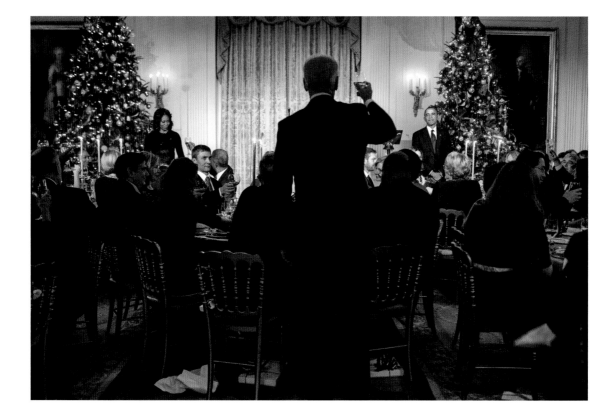

(ABOVE) Toasting President Barack Obama and First Lady Michelle Obama during a White House Senior Staff Holiday Dinner on the State Floor and in the East Room of the White House, December 16, 2013.

(OPPOSITE) Hosting the Congressional holiday party on behalf of the President and First Lady, who were in South Africa for Nelson Mandela's funeral, December 10, 2013.

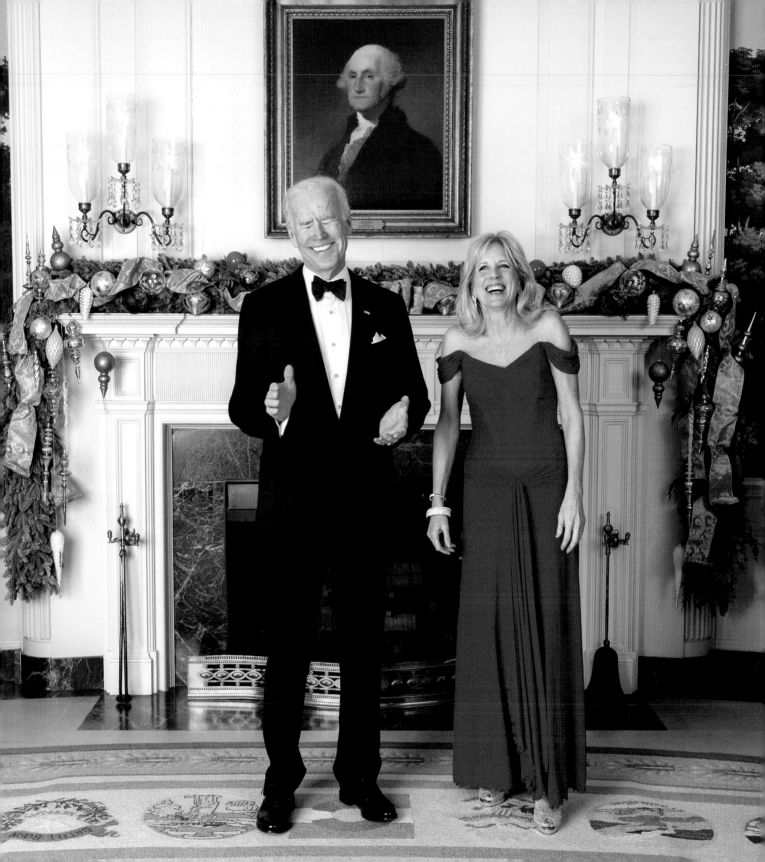

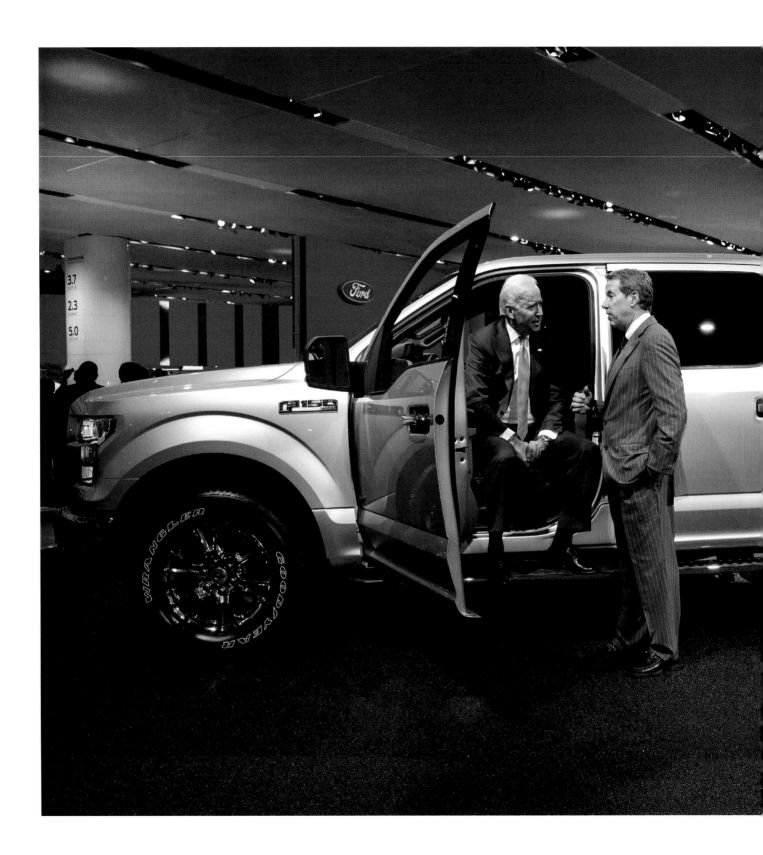

William Clay Ford Jr., chairman of Ford Motor Company, shares his thoughts on the 2015 F-150 with the Vice President at the North American Auto Show, in Detroit, Michigan, January 16, 2014.

Open concept: The Vice
President helps rearrange
his West Wing office before
hosting SEIU President
Mary Kay Henry for lunch,
January 17, 2014.

Waiting outside the Oval
Office with National Security
Advisor to the Vice President
Jake Sullivan, Secretary
of Defense Chuck Hagel,
Vice Chairman of the Joint
Chiefs of Staff Admiral
James A. Winnefeld, Deputy
National Security Advisor
Tony Blinken, and National
Security Advisor Susan Rice,
January 21, 2014.

Meeting Jason Collins, the first openly gay NBA
player, and his twin brother, Jarron Collins, in his
West Wing office, January 28, 2014.

Rosie the Riveters raise a good point, in the Roosevelt Room of the White House, March 31, 2014. Pictured are: Phyllis Gould, Priscilla "Pat" Elder, Catherine Morrison, Marian Sousa, Marian Wynn, and Agnes Moore.

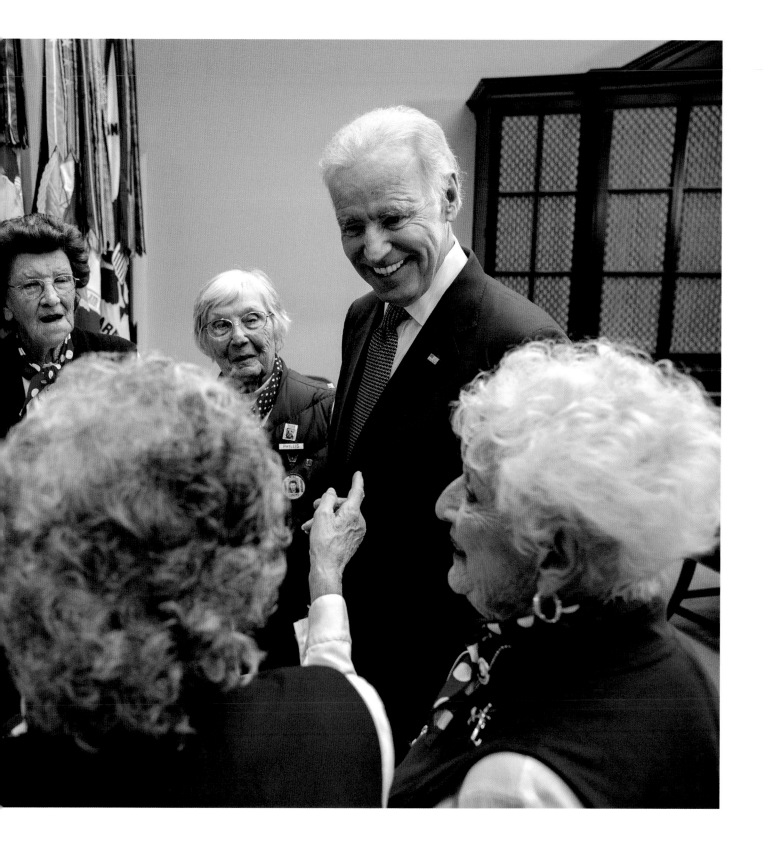

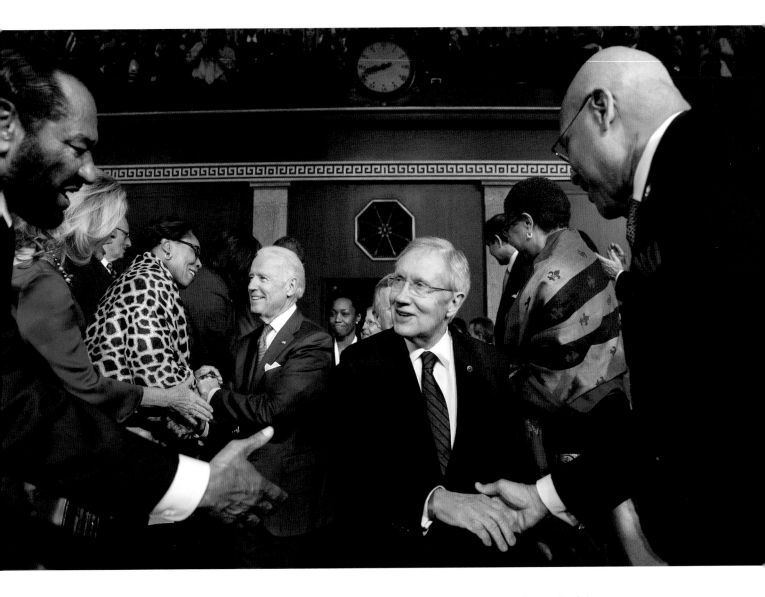

(ABOVE) Greeting members of the House of
Representatives with Senate Majority Leader Harry
Reid as they lead the Senate onto the floor of the
House, before the State of the Union address,
January 28, 2014.

(OPPOSITE) The plaque on the back of the
Vice President's chair in the Cabinet Room,
February 26, 2014.

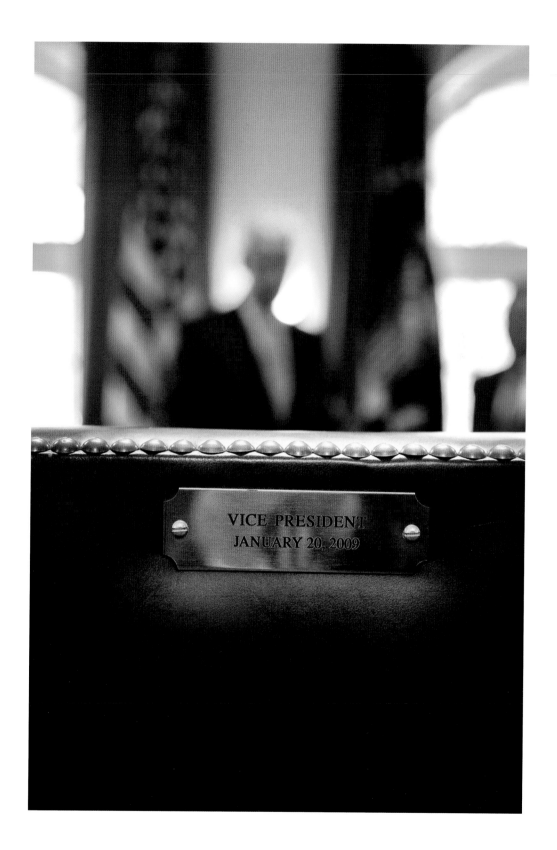

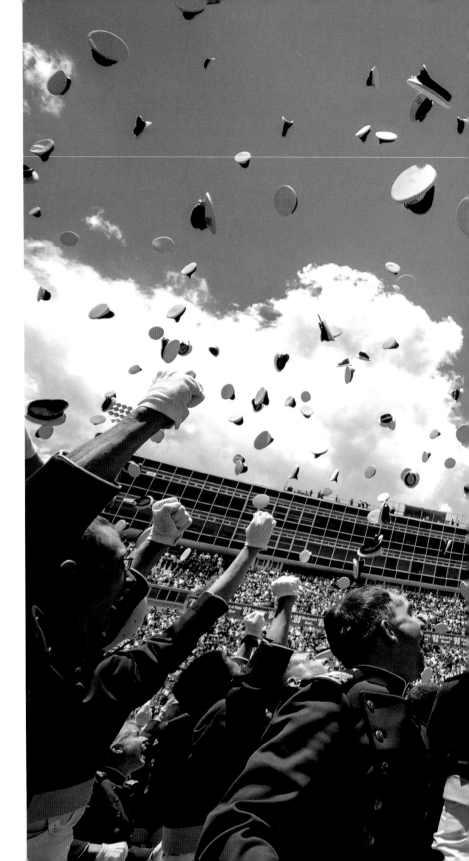

Caps fly as Thunderbirds fly over the 2014 Air Force Academy commencement, where the Vice President addressed cadets, Falcon Stadium, the Air Force Academy in Colorado Springs, Colorado, May 28, 2014.

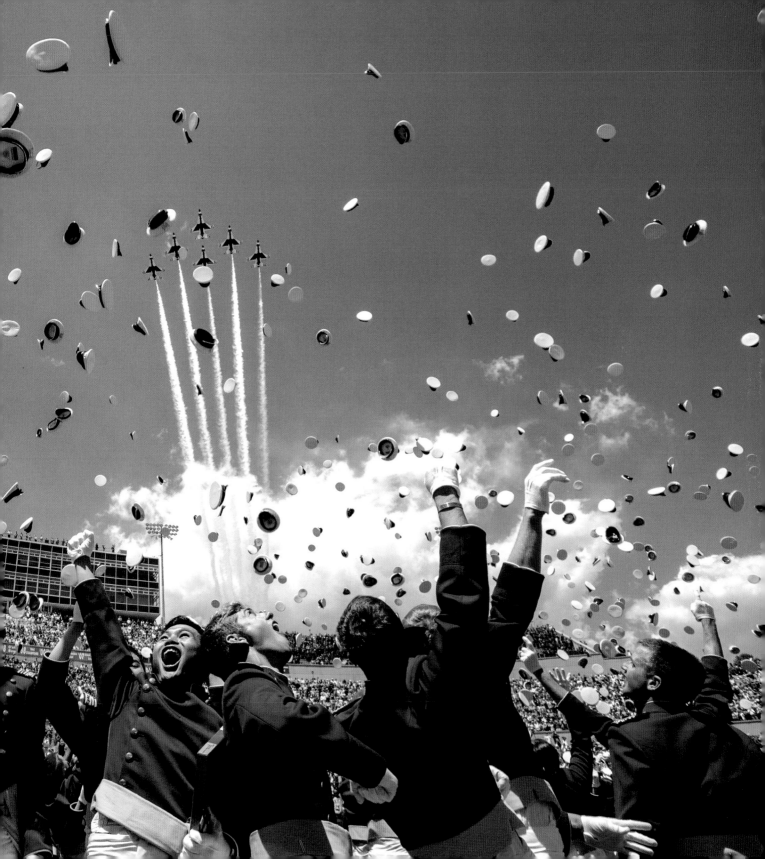

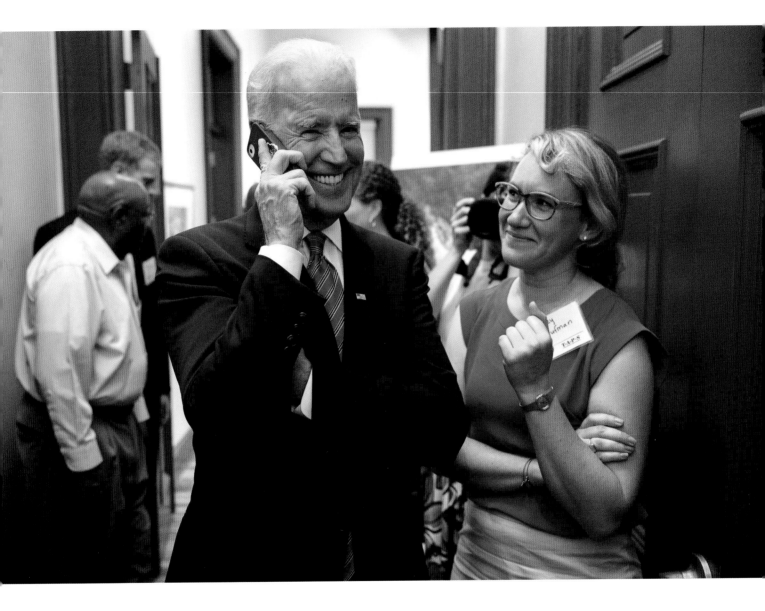

MEETING SYDNEY

DAYS AT THE WHITE HOUSE could be long and unpredictable. For example, on June 11, 2014, I'd traveled to and from New York City, where the Vice President delivered remarks at the North American Energy Summit. But the day was not done—our return to D.C. was followed by a few unscheduled stops, first a fundraiser, then a book party for Congressman Jim Clyburn of South Carolina, and finally, a surprise stop at a reception cohosted by Dr. Biden and Deb Bonito, wife of then-Senator Mark Begich of Alaska, for an organization that supports children who have lost a parent in war.

After speaking at the reception, the Vice President shook hands with attendees. When one of them, a staffer for Senator Begich, mentioned that her stepmother was Joe Biden's biggest fan, the Vice President offered to call her up—not an unusual occurrence. When the staffer's father picked up, he assumed it was a robocall and hung up. The VP dialed back and ended up on the phone speaking with him for several minutes while the dad explained that his daughter was the smartest and most wonderful person on earth.

Meanwhile, she turned bright red with embarrassment as everyone waited for her dad to finish reciting her resume. It was late in the evening and I frankly just wanted to go home, but something about the interaction seemed special. I took a couple of photos and handed off my business card so I could send them to her later. As it turns out, her father was absolutely right. The congressional staffer I met that day, Dr. Sydney Kaufman, is now my wife.

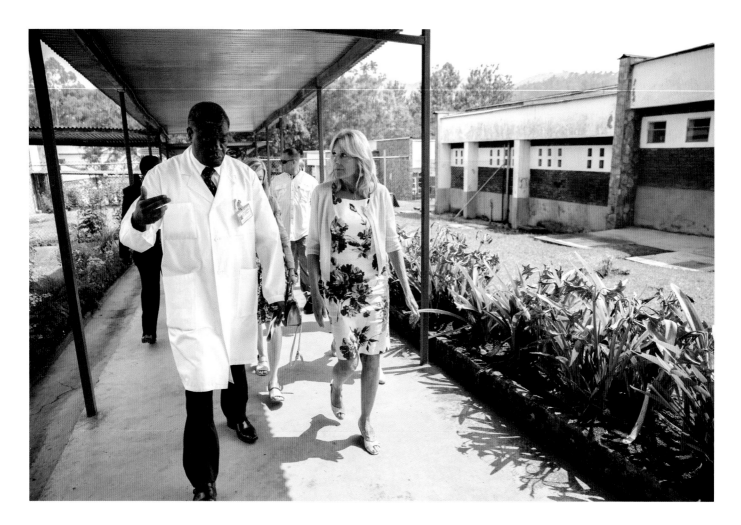

Dr. Jill Biden touring the Panzi Hospital with
Medical Director Dr. Denis Mukwege, in Bukavu,
Democratic Republic of Congo, July 5, 2014.

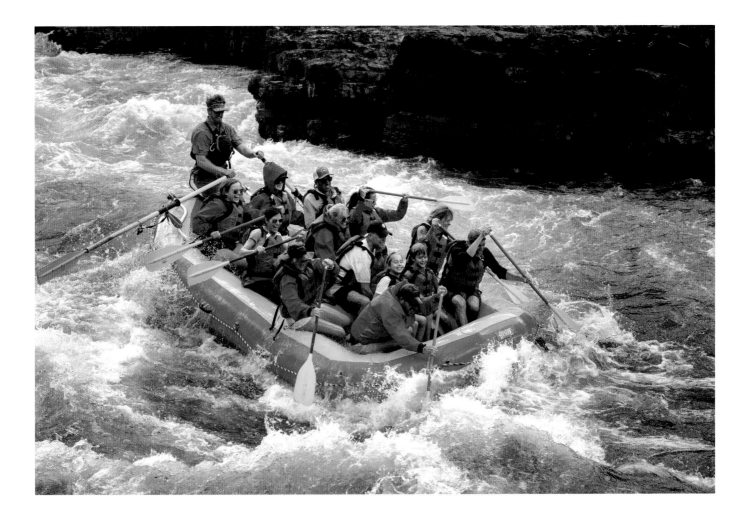

Family bonding: The Biden family rafting the
Snake River, south of Jackson Hole, Wyoming,
August 8, 2014.

Introducing the It's On Us campaign, a public awareness and action drive to prevent sexual assault at colleges and universities, in the East Room of the White House, September 19, 2014.

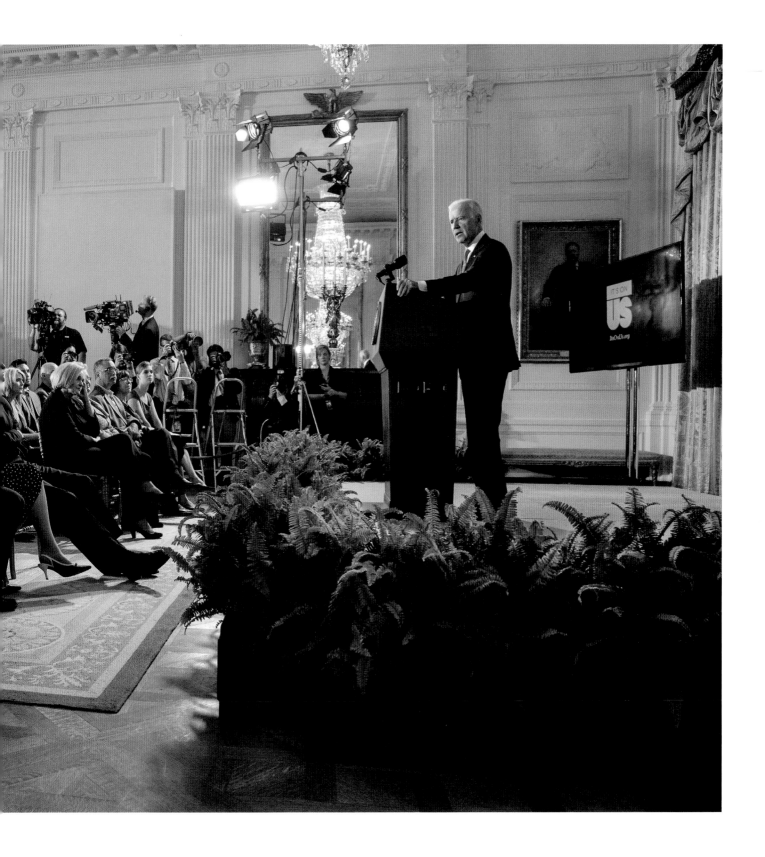

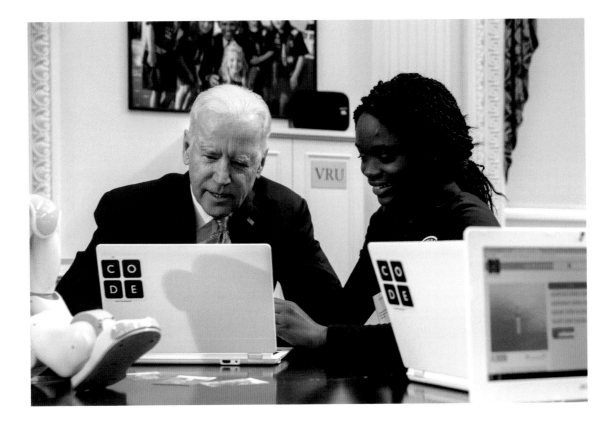

With middle school students participating in
an "hour of code" event for computer science
education week, in the Eisenhower Executive
Office Building, December 8, 2014.

Dancing with seven-year-old Nevaeh Costello before
she introduced the Vice President at the White House
Early Education Summit, in the Eisenhower Executive
Office Building, December 10, 2014.

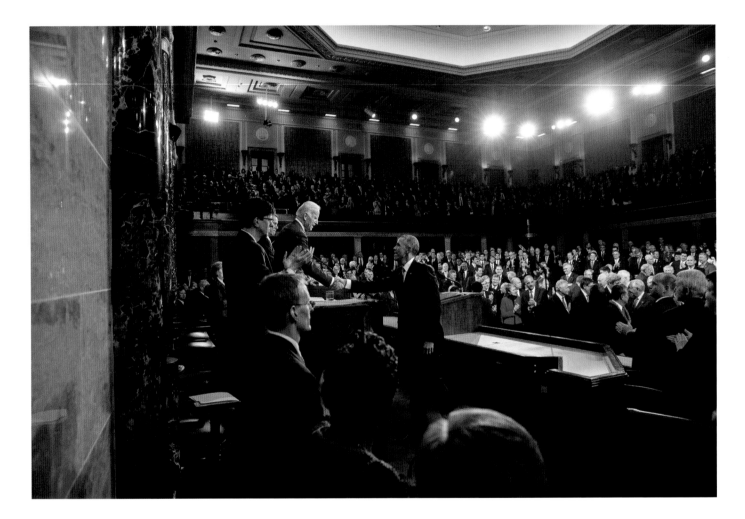

Greeting President Obama with Speaker of the
House John Boehner before the State of the Union
address, in Washington, D.C., January 20, 2015.

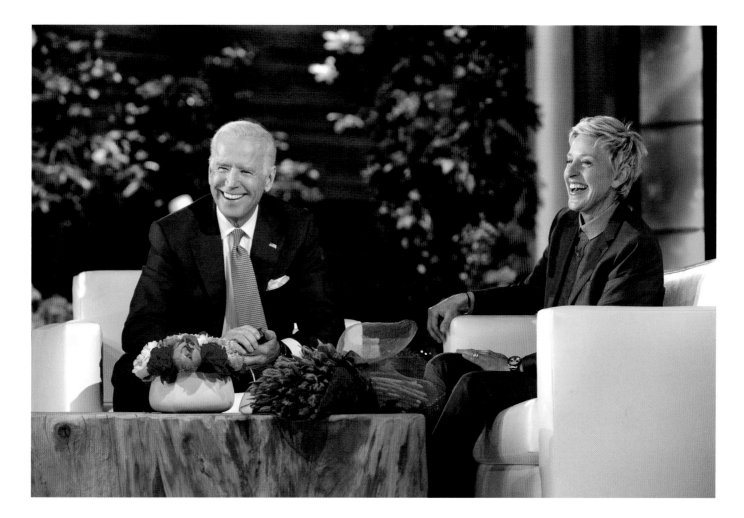

Laughing during a taping with Ellen DeGeneres,
in Burbank, California, January 22, 2015.

Walking through the crematorium gate with Max Mannheimer, a 95-year-old former prisoner and Holocaust survivor, and granddaughter Finnegan Biden, at Dachau concentration camp, in Dachau, Germany, February 8, 2015.

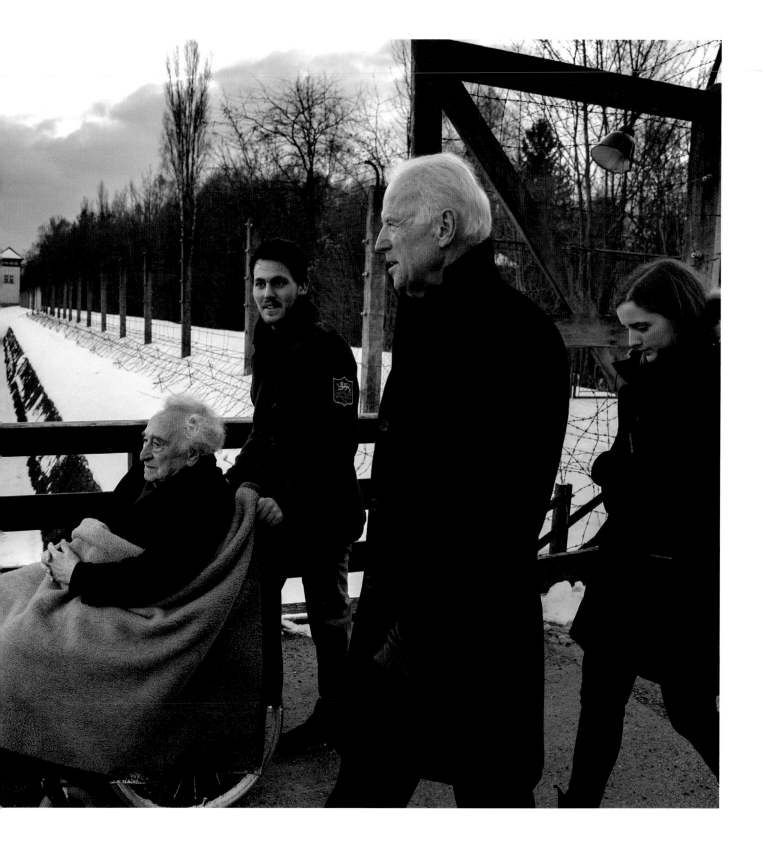

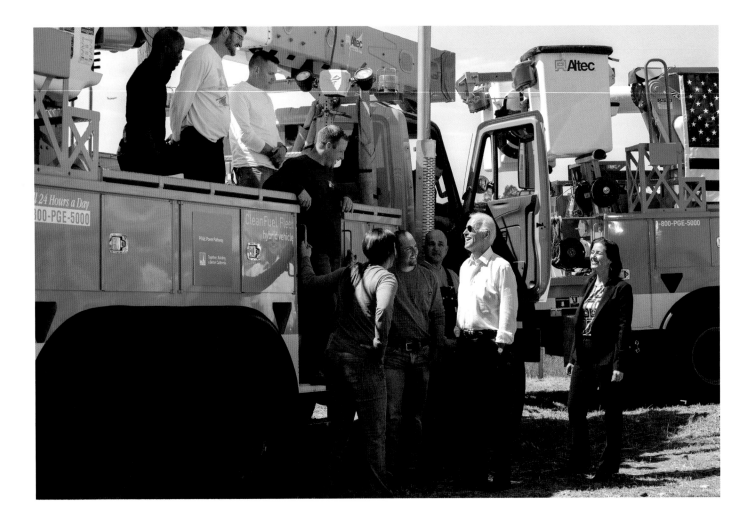

(**ABOVE**) Talking shop with trainees at Pacific Gas and Electric, in Oakland, California, April 10, 2015.

(**OPPOSITE**) Viewing a tunnel-boring machine at the Anacostia Tunnel Project, in Washington, D.C., January 16, 2015.

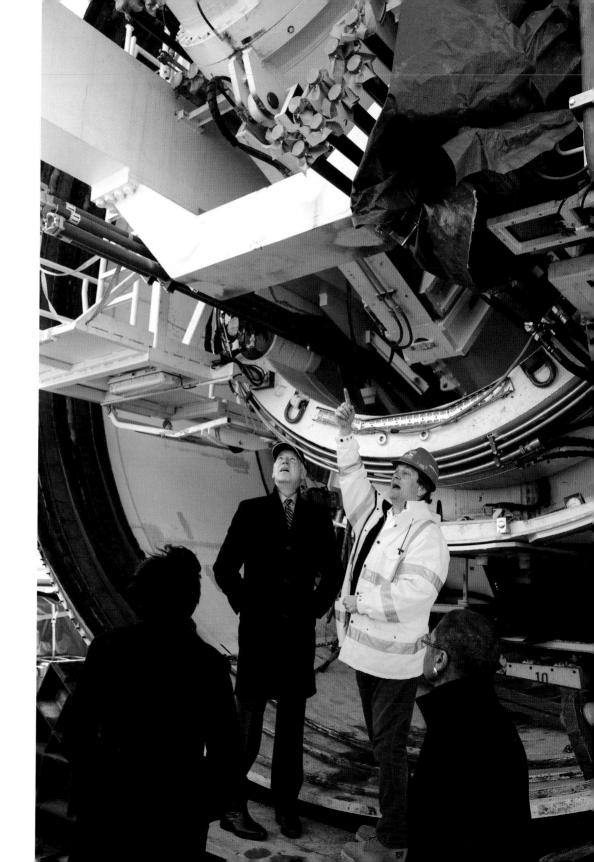

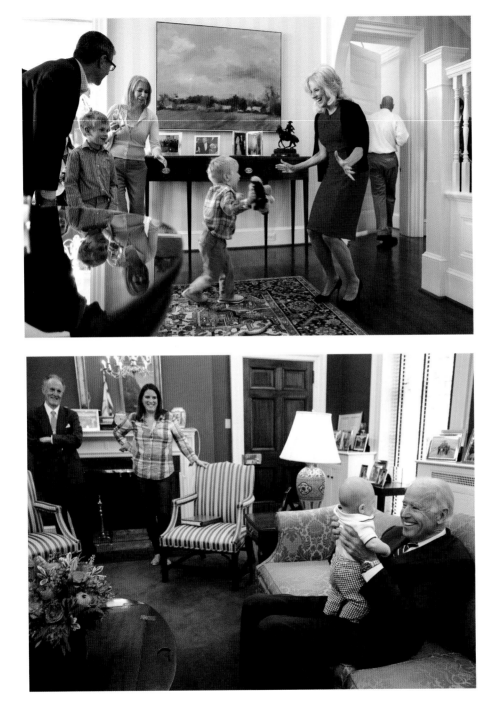

Dr. Jill Biden welcomes military families before a dinner she cohosted with Reading Rainbow, at the Naval Observatory Residence, April 15, 2015.

Holding press secretary Kendra Barkoff Lamy's son, Griffin, in his West Wing office, May 21, 2015.

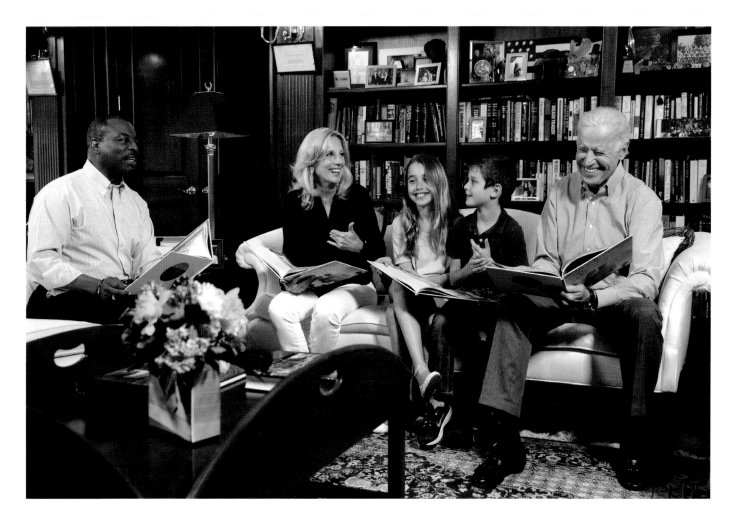

(**ABOVE**) Laughing with actor LeVar Burton, Dr. Jill Biden, and grandchildren Natalie and Hunter Biden during a Reading Rainbow taping in the library of the Vice President's private residence in Wilmington, Delaware, April 12, 2015.

(**FOLLOWING SPREAD**) Visiting with the families of fallen New York City police officers Rafael Ramos and Wenjian Liu, in the Vice President's West Wing office, May 19, 2015. The Ramoses and Lius had come to the White House for the signing of Senate Bill 665, the Rafael Ramos and Wenjian Liu National Blue Alert Act of 2015.

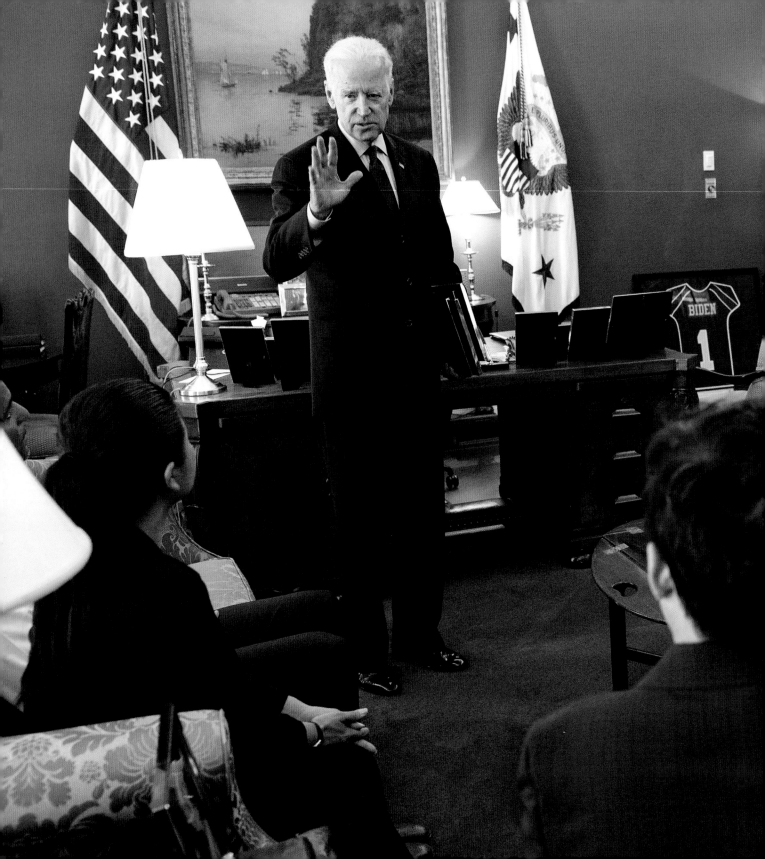

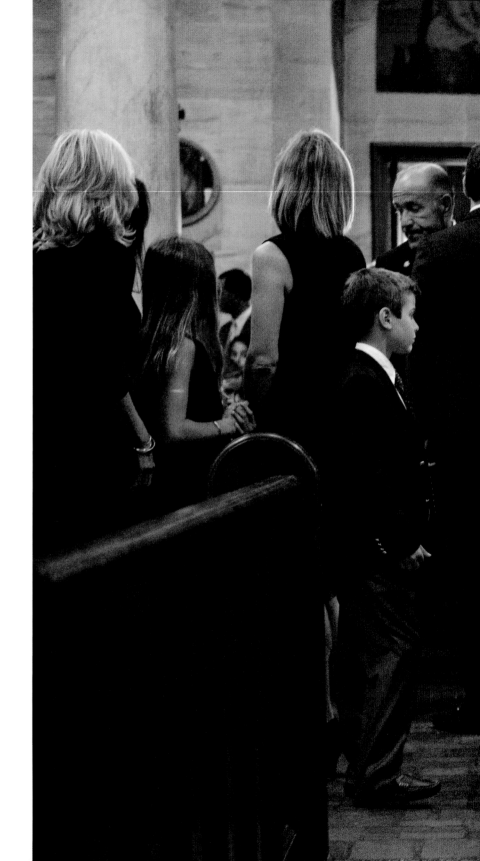

Reaching out to touch the flag-draped casket of his older son and former Delaware attorney general Beau Biden, before the public wake, in Wilmington, Delaware, June 5, 2015.

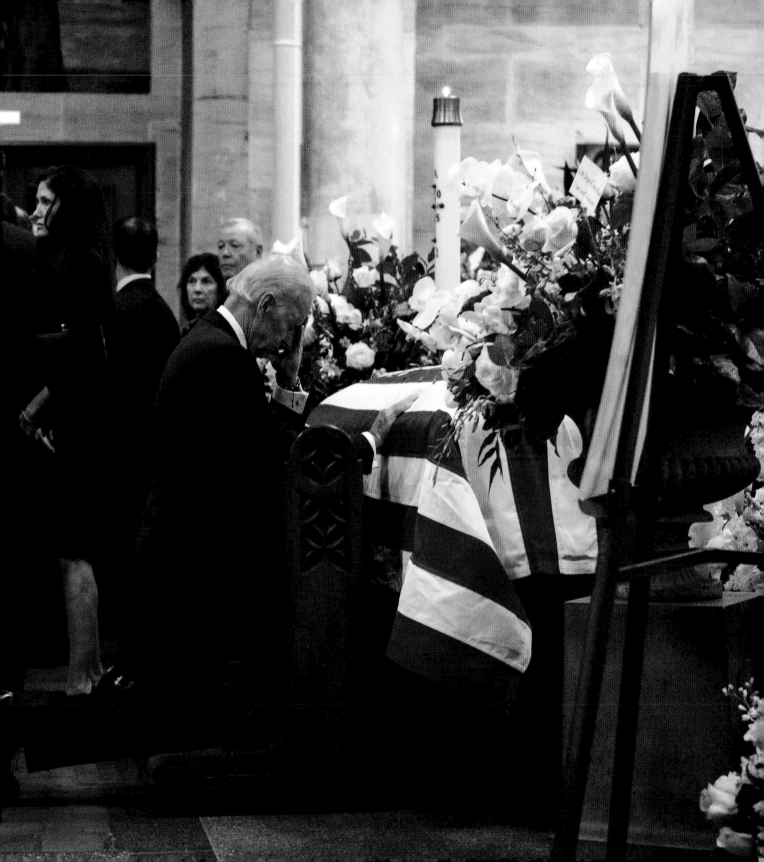

"JOE, YOU ARE MY BROTHER"

AFTER A TWO-YEAR BATTLE with brain cancer, Beau Biden passed away on May 30, 2015. I had first met Beau in Iraq in 2009. Unassuming, clean cut, slender, he looked like his dad and was thoughtful, careful with his words, and immediately friendly. At the time, Beau was serving as part of the Delaware Army National Guard while simultaneously working remotely as the Attorney General of Delaware. After he had returned to the United States, he would stop by the office every so often. On family trips, he and his younger brother, Hunter, would try to get staff to join the family for meals. We always demurred—it felt like vacation should be enjoyed as a family, but Beau always treated us like part of the family.

Beau's illness and death devastated the Bidens. To this day the Vice President still often refers to Beau as "his soul" when he speaks about him, a sentiment that I didn't truly understand until I had a child of my own. The loss, even after enduring so much tragedy in his life, was profound.

The following days were a wrenching balance for the Vice President and Dr. Biden—mourning publicly as Beau lay in state at the State Capitol in Dover, Delaware; rushing back to Washington for their granddaughter (Beau's niece) Maisy's eighth-grade graduation; back to Delaware for another school ceremony for Beau's daughter, Natalie, the next morning—followed by receiving thousands of Delawareans, friends, and family members during a nearly ten-hour wake.

"ISN'T THAT FINALLY THE MEASURE OF A MAN—THE WAY HE LIVES, HOW HE TREATS OTHERS, NO MATTER WHAT LIFE MAY THROW AT HIM?"

The next morning, at St. Anthony of Padua Church, in Wilmington, Delaware, President Obama eulogized Beau: "He did in 46 years what most of us couldn't do in 146. He left nothing in the tank. He was a man who led a life where the means were as important as the ends. And the example he set made you want to be a better dad, or a better son, or a better brother or sister, better at your job, the better soldier. He made you want to be a better person. Isn't that finally the measure of a man—the way he lives, how he treats others, no matter what life may throw at him?"

The President then addressed the Bidens: "To Joe and Jill—just like everybody else here, Michelle and I thank God you are in our lives. Taking this ride with you is one of the great pleasures of our lives. Joe, you are my brother. And I'm grateful every day that you've got such a big heart, and a big soul, and those broad shoulders."

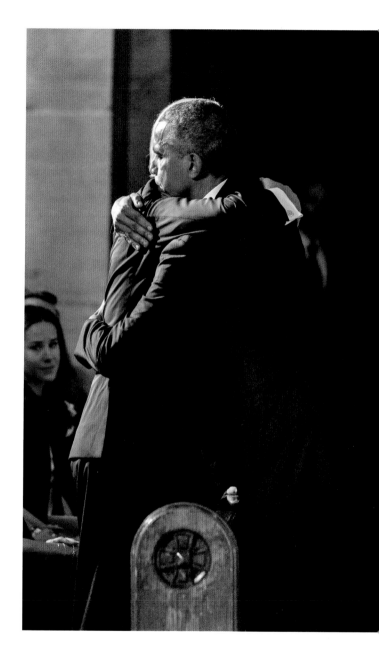

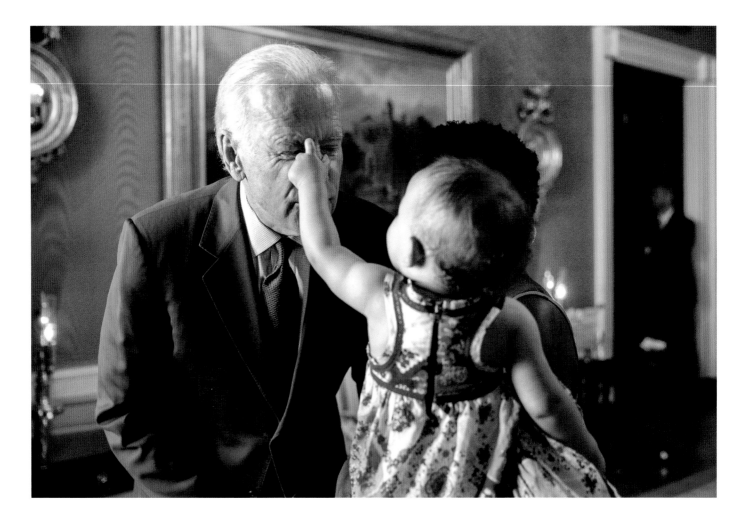

I've got your nose: A quick pinch from a child in the Green Room of the White House before a reception for LGBT Pride Month, June 24, 2015.

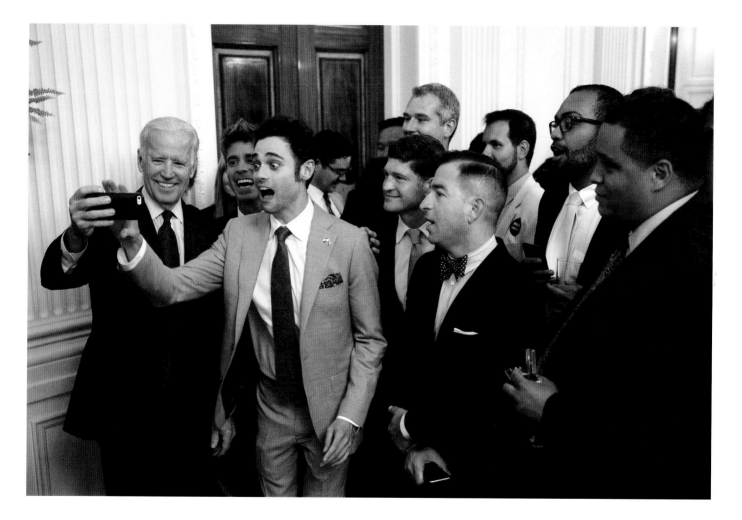

Taking a selfie with excited guests during a
reception for LGBT Pride Month in the East Room
of the White House, June 24, 2015.

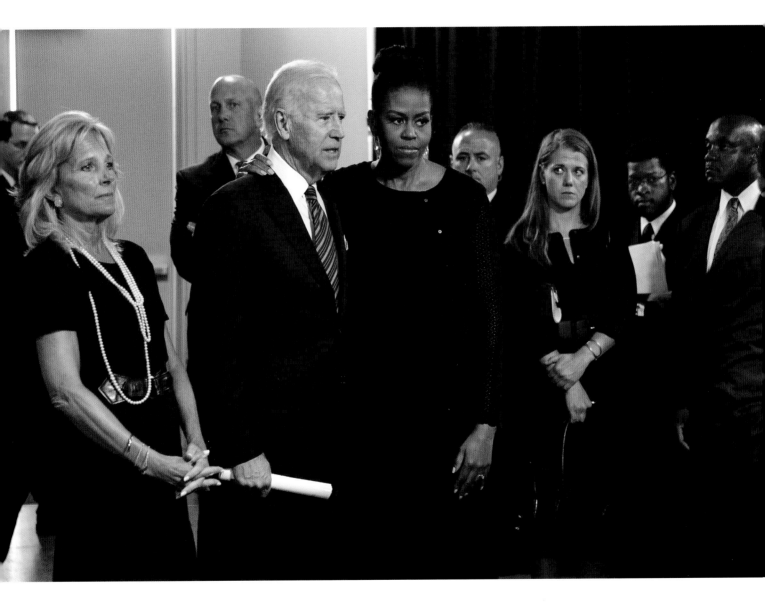

LIKE FAMILY

JUST ELEVEN DAYS AFTER the Bidens buried their older son, Beau, there was another tragedy—the latest in a horrifying series of mass shootings. At Mother Emanuel AME Church in Charleston, South Carolina, a gunman sat through a Bible study class before opening fire, killing eight parishioners and the Reverend Clementa C. Pinckney. Without hesitation, the Vice President and Dr. Jill Biden along with the President and First Lady traveled to South Carolina to support the families of the survivors and victims. While waiting backstage before the memorial service for Reverend Pinckney, First Lady Michelle Obama reached over and quietly squeezed the Vice President's shoulder—a small gesture that told a much bigger story about their two families.

For me, much as I'd seen at Beau's funeral only a few weeks before, this gentle touch marked the deepening of the connection between the Bidens and the Obamas. Saturday mornings were often spent together watching the Obamas' daughter Sasha and the Vice President's granddaughter Maisy play basketball (they were on the same team), and the Vice President's grandchildren often slept over with the Obama children or went on vacation with them. For many, this was the first time they saw the incredible bond that had been forged between the Obamas and the Bidens. Through great triumphs and hardship, President Obama and Vice President Biden had become more than partners—they had become family. They celebrated together, grieved together, and at the devastating memorial service for nine people murdered while they prayed together, Michelle Obama embraced Joe Biden, whose heartbreak was visible.

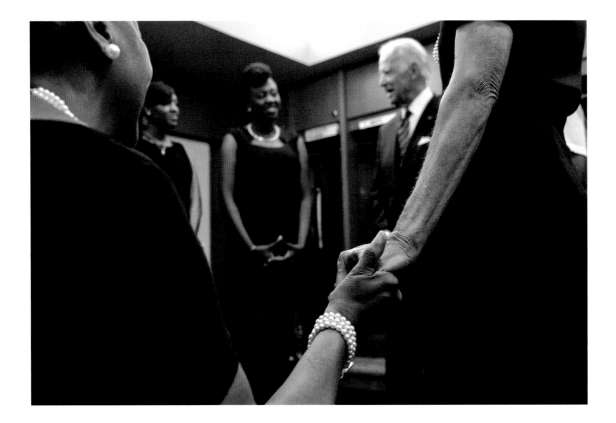

Meeting with family members of survivors and victims
of the mass shooting at Mother Emanuel AME Church,
after the funeral for Reverend Clementa C. Pinckney,
in Charleston, South Carolina, June 26, 2015.

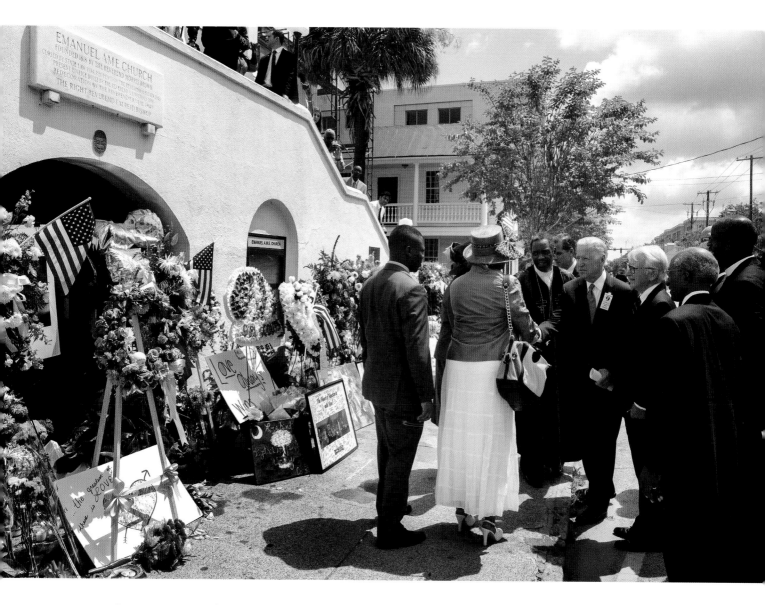

Paying respects with community leaders, as flowers from all over the world rest in front of Mother Emanuel AME Church, in Charleston, South Carolina, June 28, 2015.

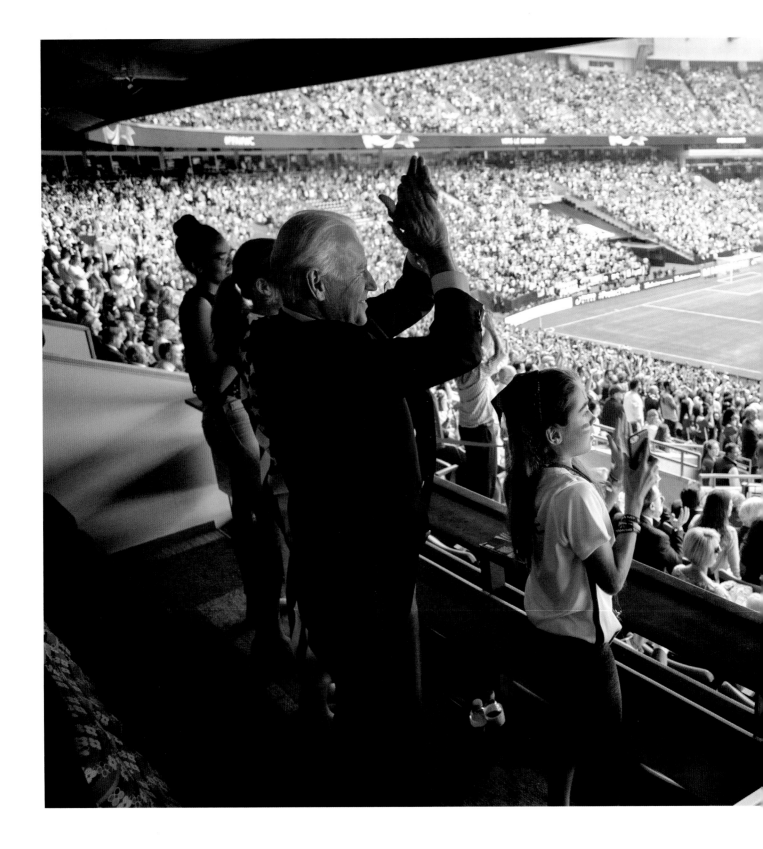

Cheering for the champion U.S. Women's National Soccer team during the World Cup finals against Japan, in Vancouver, Canada, July 5, 2015.

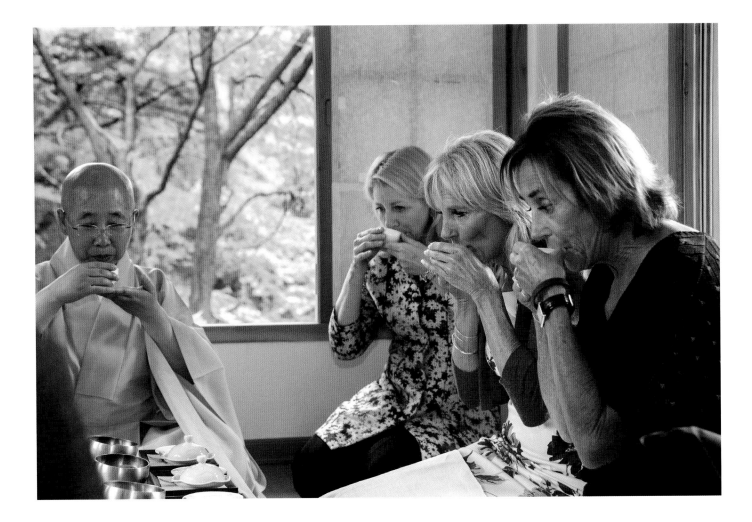

Dr. Jill Biden participates in a tea ceremony at
the Jingwansa Temple, in Seoul, South Korea,
July 18, 2015.

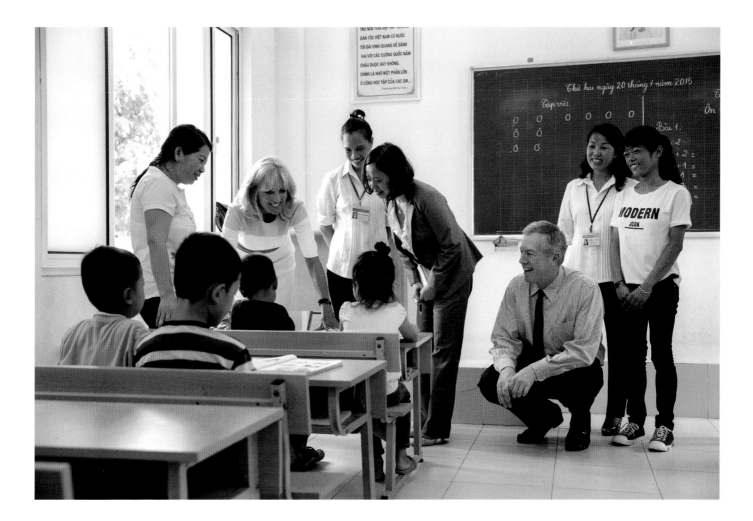

Dr. Jill Biden and U.S. Ambassador to Vietnam
Ted Osius meet students at the Ba Vi Orphanage,
outside Hanoi, Vietnam, July 20, 2015.

Praying with Catholic leaders over
breakfast in the dining room of
the Naval Observatory Residence,
September 9, 2015.

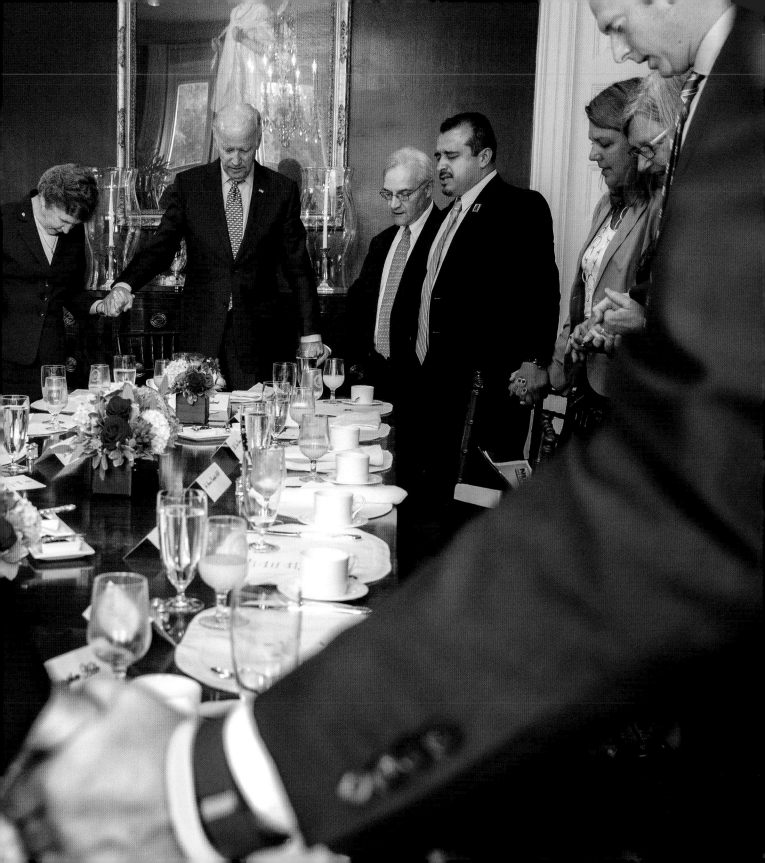

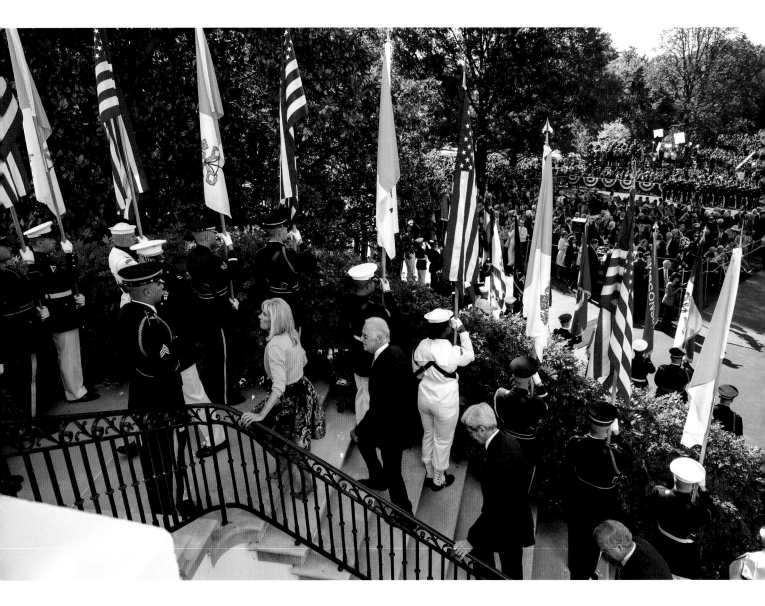

Ascending the stairs to the Truman Balcony after
the State Arrival Ceremony for Pope Francis,
September 23, 2015.

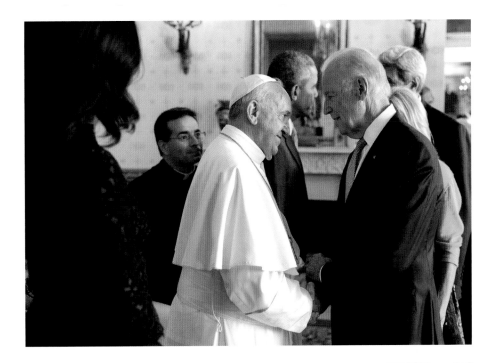

Greeting Pope Francis in the Blue Room at the White House, following the State Arrival Ceremony on the South Lawn, September 23, 2015.

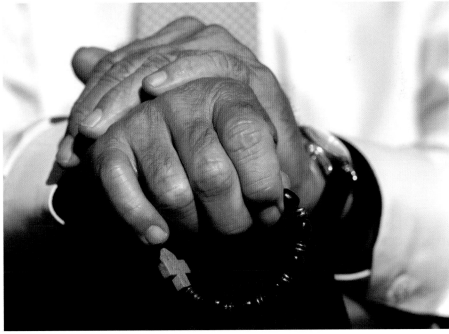

Holding a rosary during a Mass at the Basilica of the National Shrine of the Immaculate Conception, in Washington, D.C., September 23, 2015.

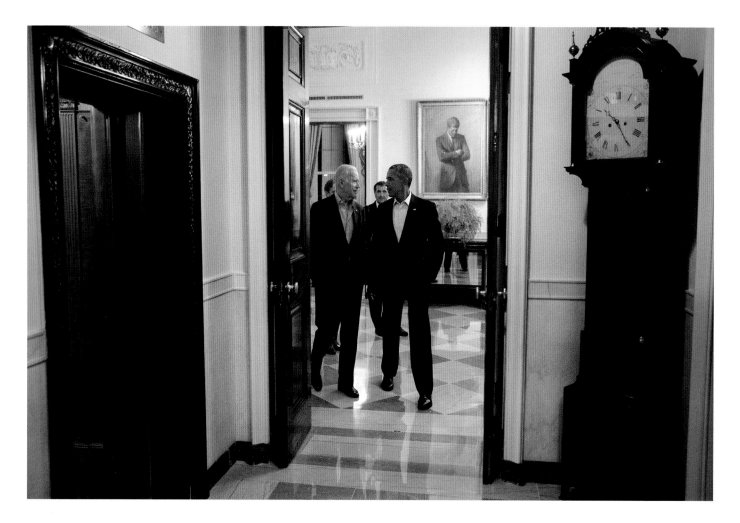

Touching base with President Obama after a
private dinner with Chinese President Xi Jinping,
in the Cross Hall of the White House,
September 24, 2015.

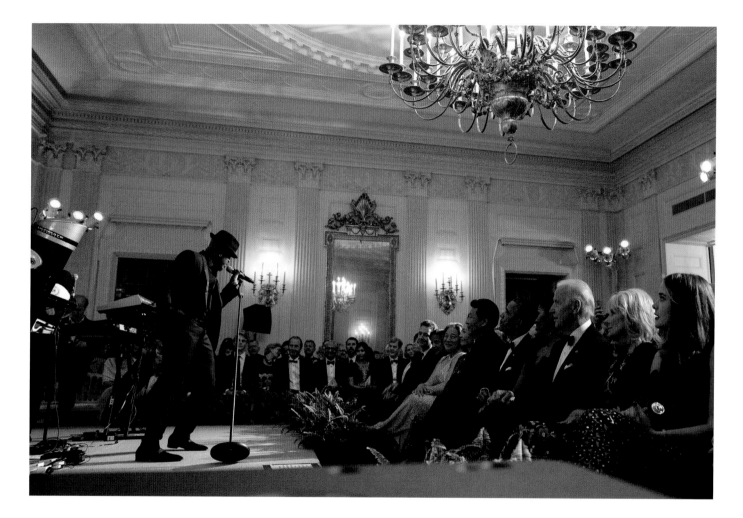

Ne-Yo performs during a state dinner for
President Xi Jinping of China, in the State Dining
Room, April 28, 2015.

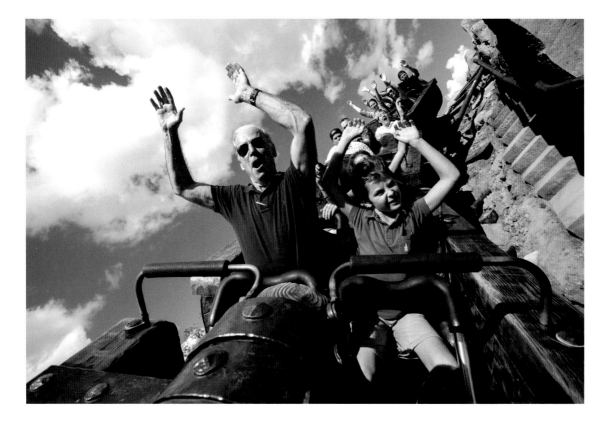

On the Seven Dwarfs Mine Train with grandson Hunter
in the Magic Kingdom Park at Walt Disney World, in
Orlando, Florida, November 7, 2015.

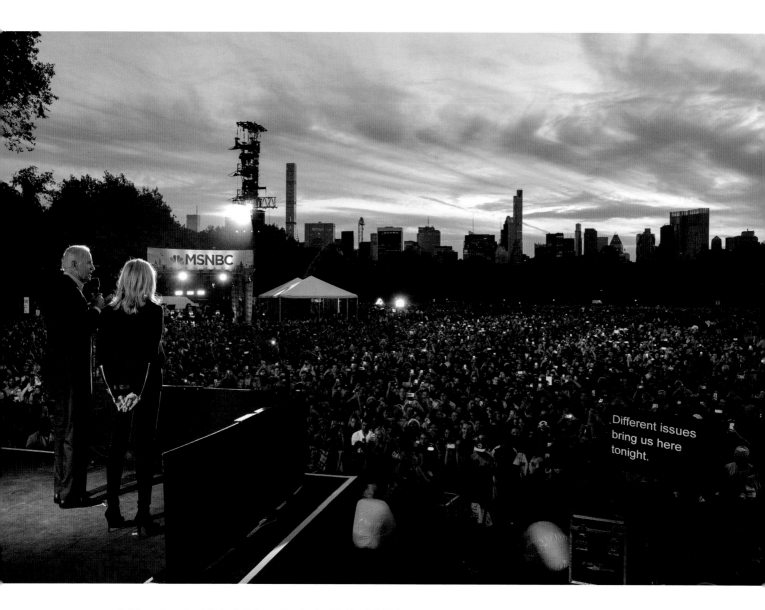

Addressing the Global Citizen Festival with Dr. Jill Biden,
in Central Park, New York, September 26, 2015.

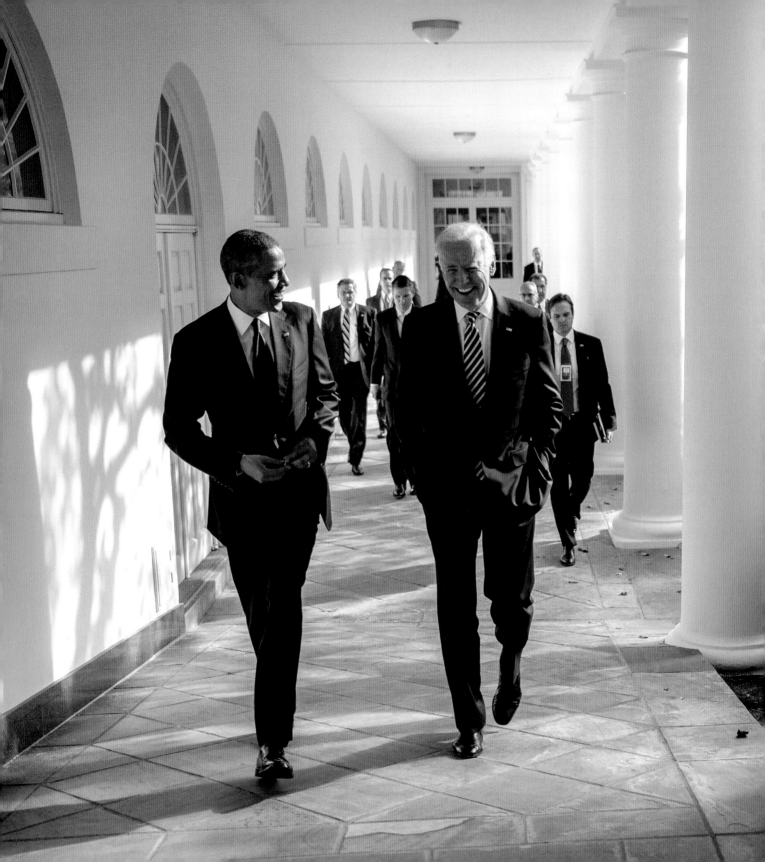

Walking down the Colonnade
with President Obama,
November 11, 2015.

Flying in a darkened CH-47 Chinook helicopter with
National Security Advisor Colin Kahl en route to Erbil
International Airport in Erbil, Iraq, April 28, 2016.

CLOUDS ON THE HORIZON

The Changing of the Guard

Mourning drove the Obama administration to further action, launching a slate of progressive legislation as their final year in office began. Vice President Biden stepped up as an advocate for marriage equality and health care, spearheading the Cancer Moonshot culminating in the passage of the 21st Century Cures Act, which appropriated $6.3 billion for cancer research. Before leaving office, the President awarded the Vice President the Medal of Freedom with Distinction, a recognition that, over the past eight years, Biden had become a statesman of the first order. As the new administration prepared to take office, the Bidens said farewell to staff as they left Washington to return to Delaware.

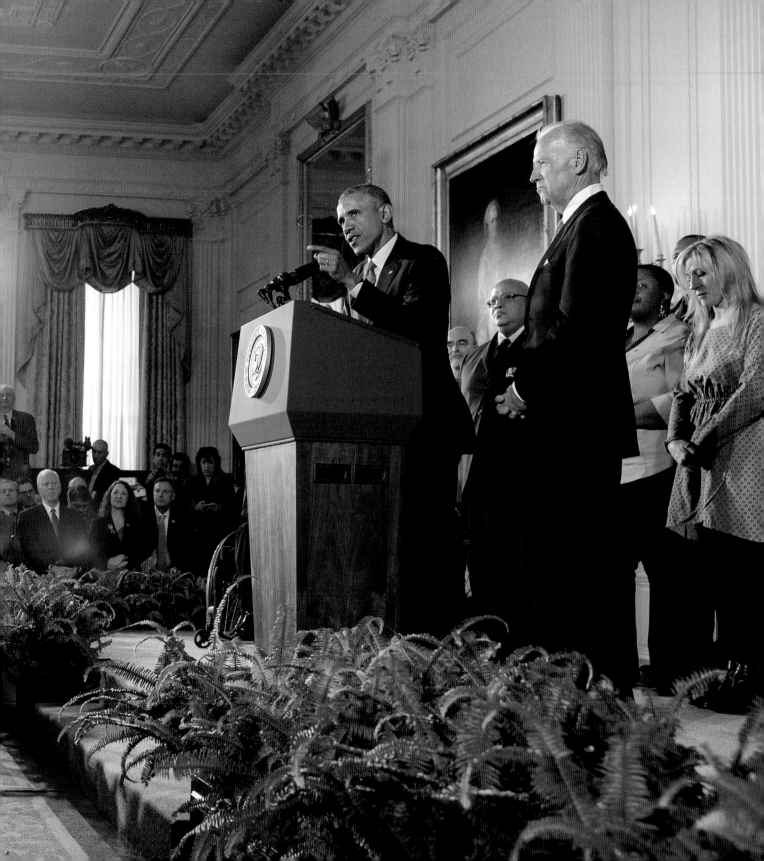

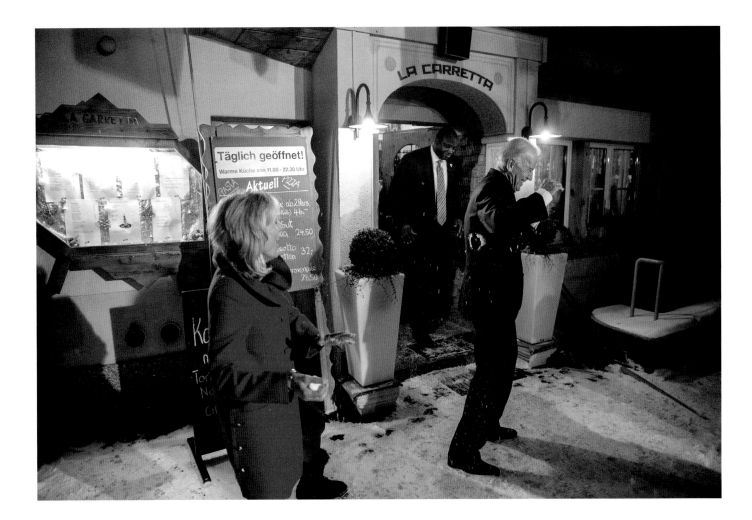

(PREVIOUS) With President Obama as he announces steps the administration is taking to reduce gun violence to a room full of those who have been personally affected, in the East Room of the White House, January 5, 2015.

(ABOVE) Taking a hit from a snowball-wielding Dr. Jill Biden outside the restaurant La Carretta, in Davos, Switzerland, January 19, 2016.

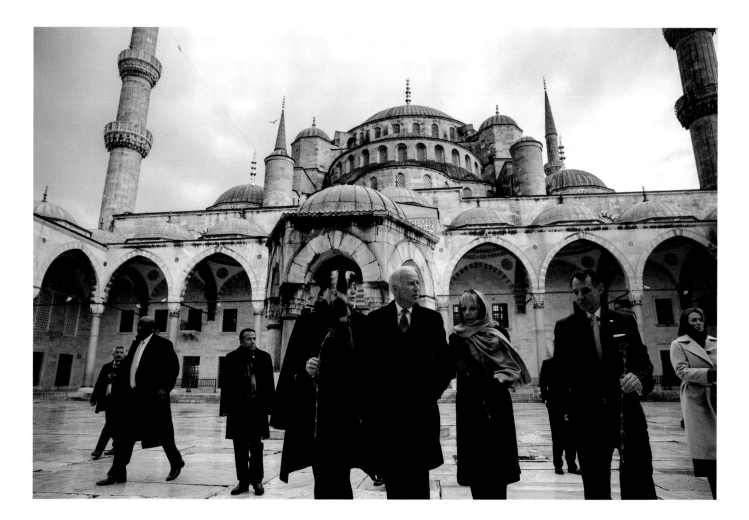

Touring the Blue Mosque with Dr. Jill Biden,
granddaughter Naomi Biden (left), and
son-in-law Howard Krein, in Istanbul, Turkey,
January 22, 2016.

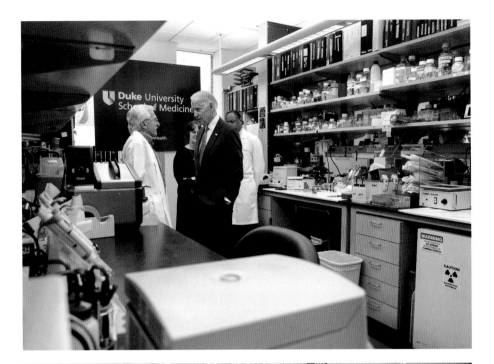

Learning about the cancer research conducted by the Modrich laboratory as part of the Cancer Moonshot initiative, at Duke University, in Durham, North Carolina, February 10, 2016.

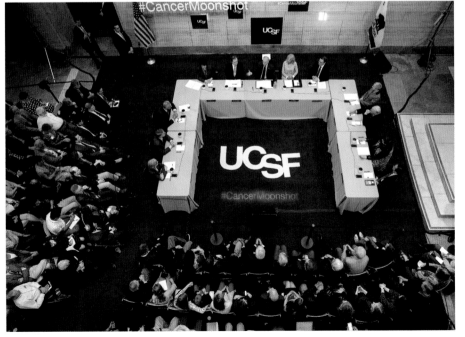

Participating in a roundtable discussion on cancer research with Dr. Jill Biden as part of the Cancer Moonshot initiative, at the University of California San Francisco, February 27, 2016.

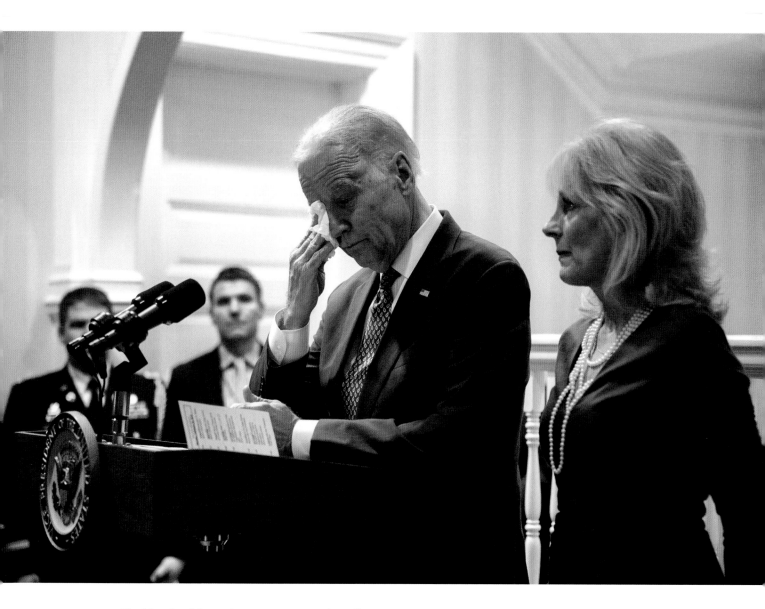

The Vice President wipes away tears as he talks about his son Beau, who served in the Delaware National Guard, during a reception in honor of the National Guard Adjutants General and their spouses, at the Naval Observatory Residence, February 22, 2016.

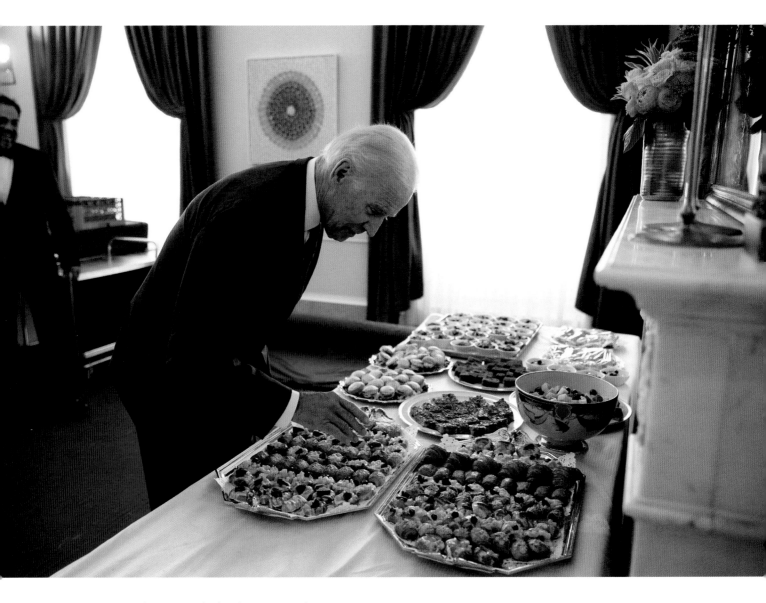

Dropping by to sample the dessert tray after an
event, in the Old Family Dining Room of the White
House, March 30, 2016.

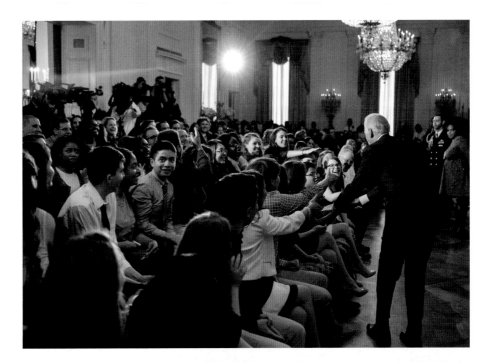

Greeting guests before a performance of musical selections from *Hamilton* in the East Room of the White House, March 14, 2016.

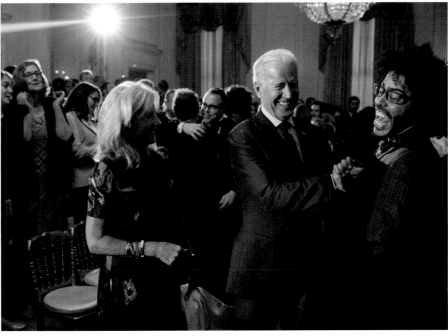

With Dr. Jill Biden, meeting cast member Daveed Diggs, after a performance of selections from *Hamilton* in the East Room of the White House, March 14, 2016.

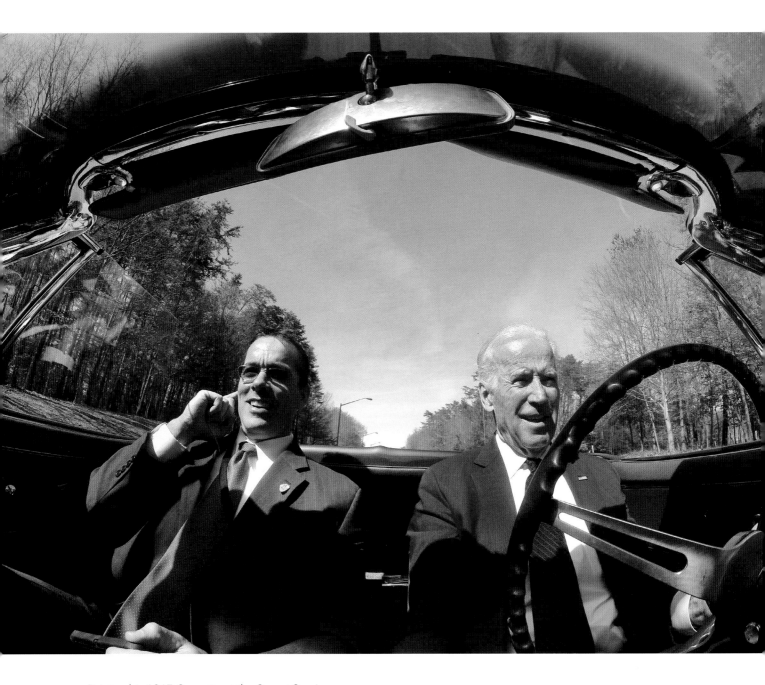

Driving his 1967 Corvette at the Secret Service
training facility in Laurel, Maryland, March 30, 2016.

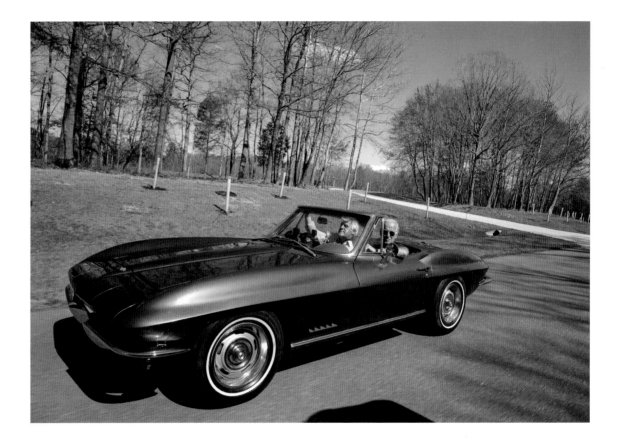

With Jay Leno, taping an episode of *Jay Leno's Garage* in the Vice President's 1967 Corvette, at the Secret Service training facility in Laurel, Maryland, April 1, 2016.

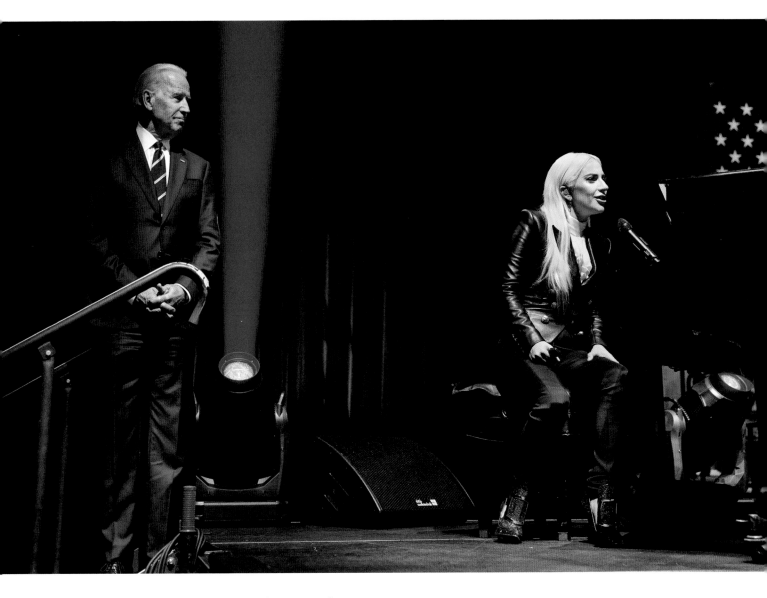

The Vice President looks on as Lady Gaga performs
at an It's On Us rally at the University of Las Vegas,
in Las Vegas, Nevada, April 7, 2016.

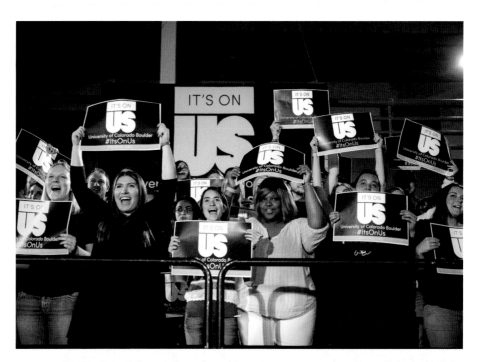

Students cheer during an It's On Us event at the University of Colorado, Boulder, April 8, 2016.

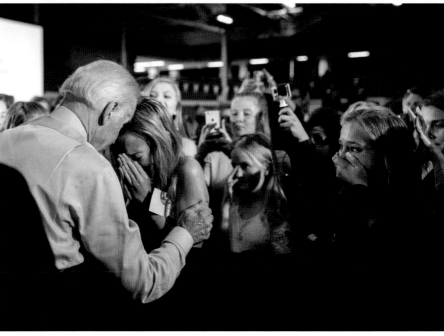

Comforting an attendee on the rope line after delivering remarks at an It's On Us event at the University of Colorado, Boulder, April 8, 2016.

(RIGHT) Boarding a C-17 serving as *Air Force Two*, at Baghdad International Airport, Iraq, April 28, 2016.

(FOLLOWING SPREAD) Filming a scene for the White House Correspondents' Dinner with President Obama, April 27, 2016.

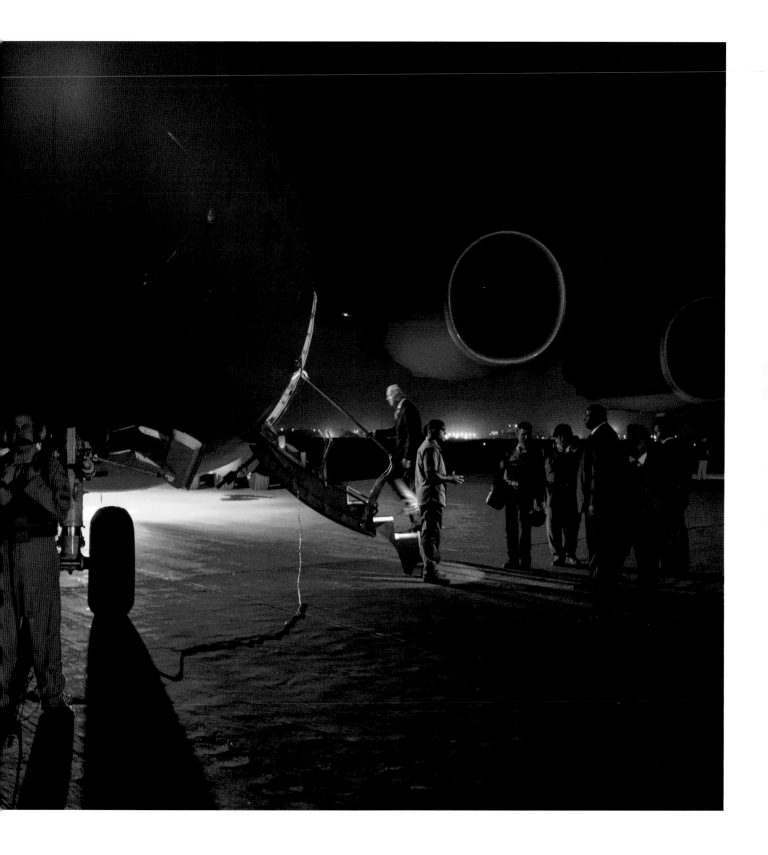

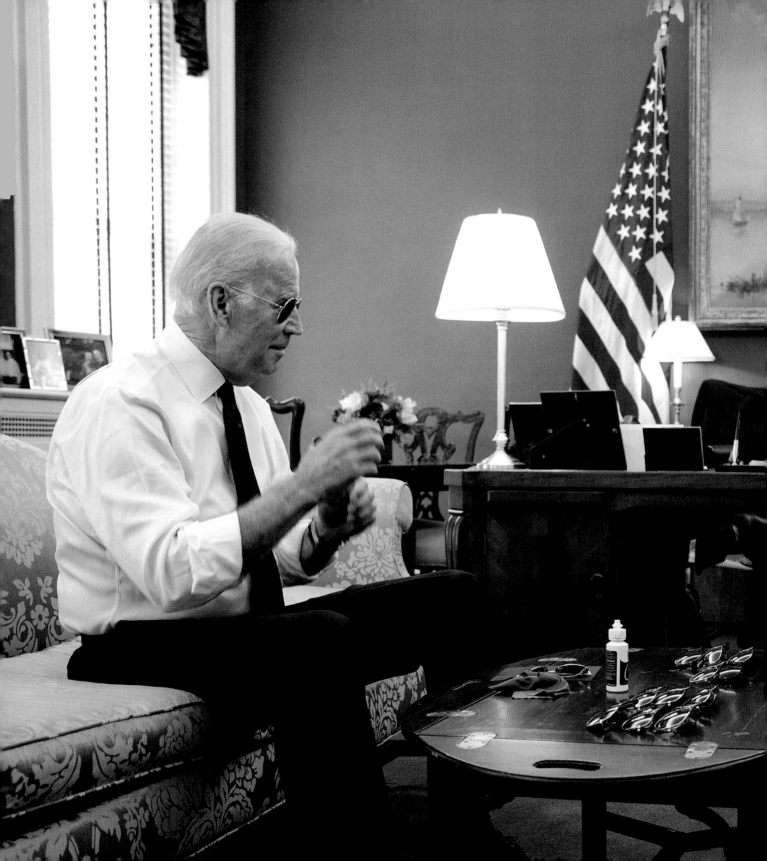

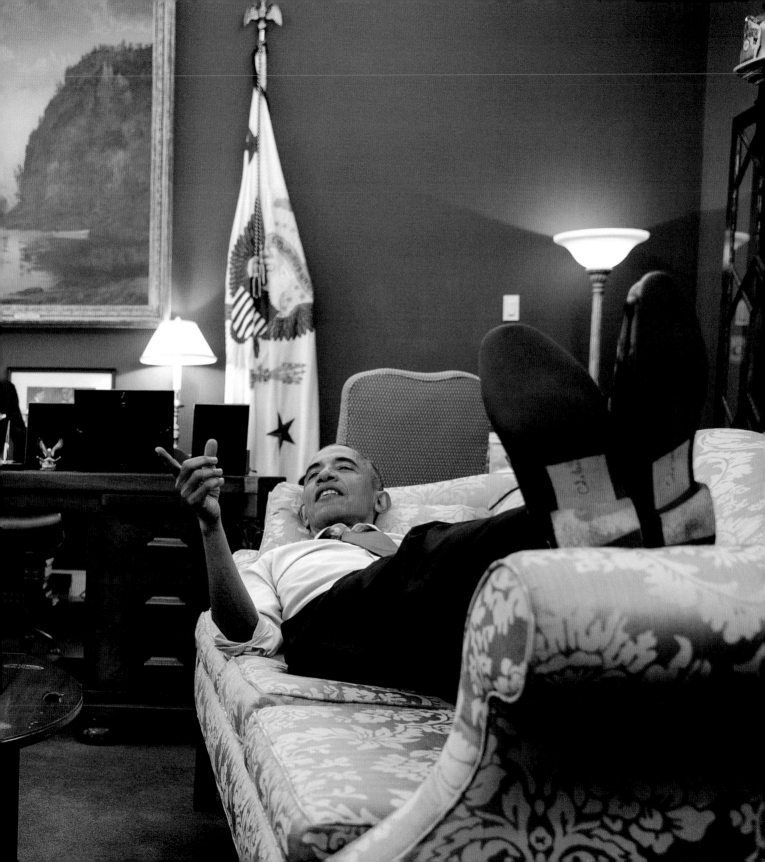

Taping a segment for *Funny or Die* with Adam Devine,
in Washington, D.C., May 17, 2016.

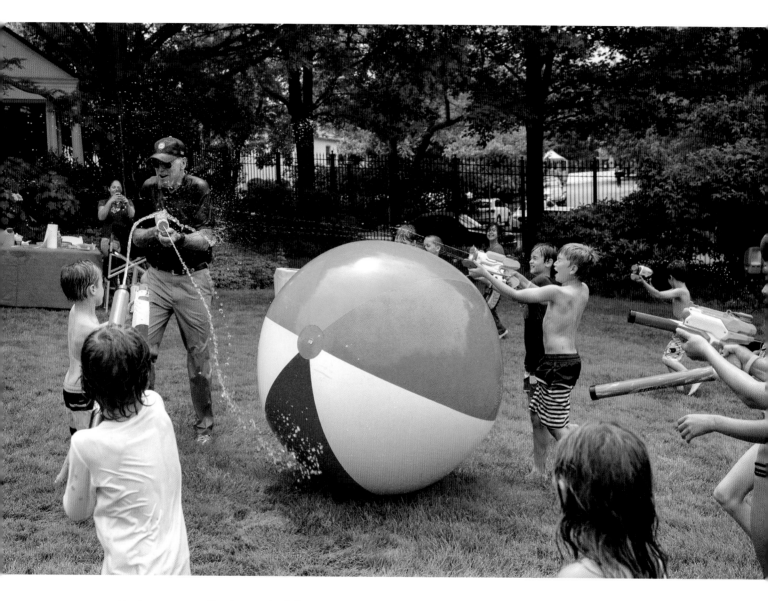

Under pressure: Getting soaked during a water gun fight at the 2016 Biden Beach Boardwalk Bash, held at the Naval Observatory Residence, June 4, 2016.

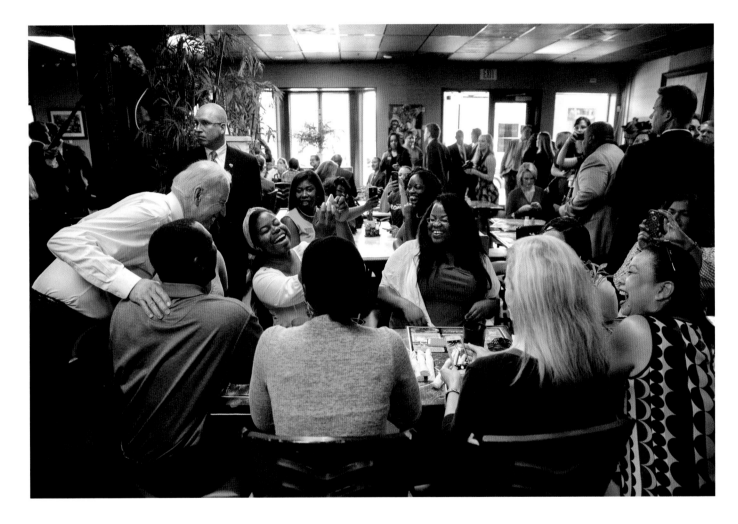

Greeting patrons at Chef Eddie's Soul Food
restaurant, in Orlando, Florida, May 12, 2016.

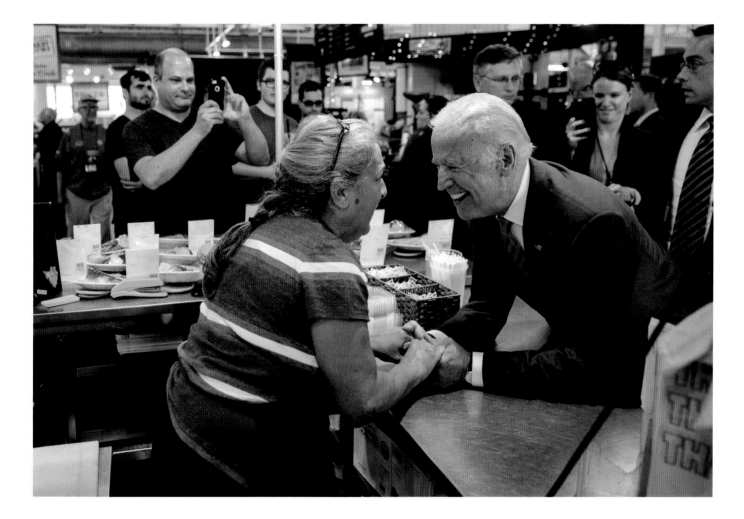

Talking with a worker at Pastaria in the North
Market, in Columbus, Ohio, May 18, 2016.

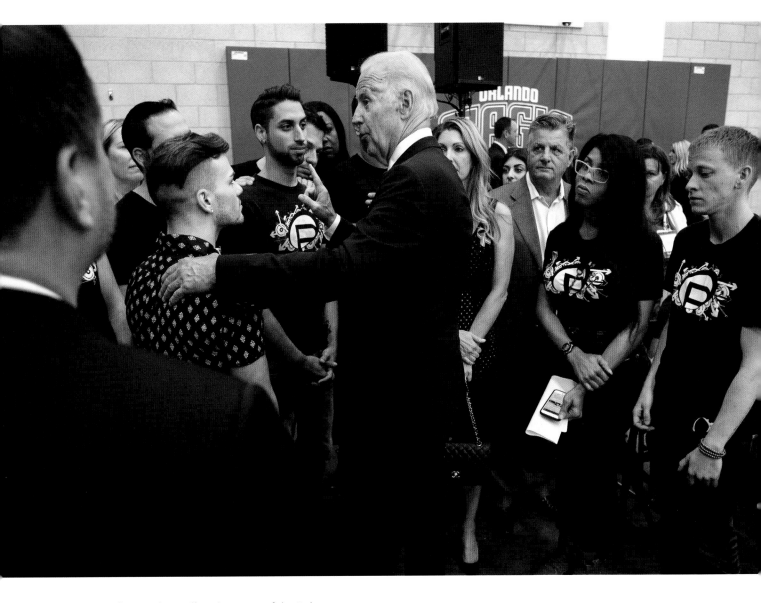

Comforting the staff and owners of the Pulse
nightclub, after the mass shooting in Orlando,
Florida, June 16, 2016.

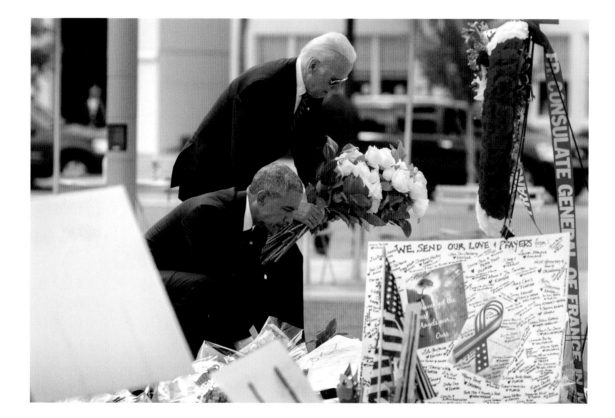

With the President laying flowers at a memorial for victims of the mass shooting at the Pulse nightclub, in Orlando, Florida, June 16, 2016.

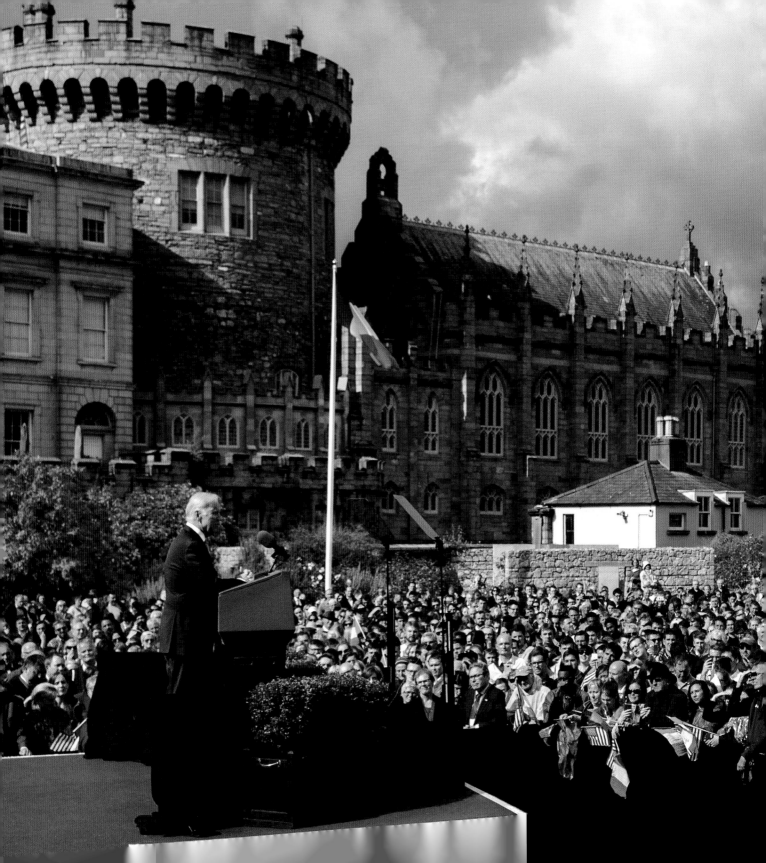

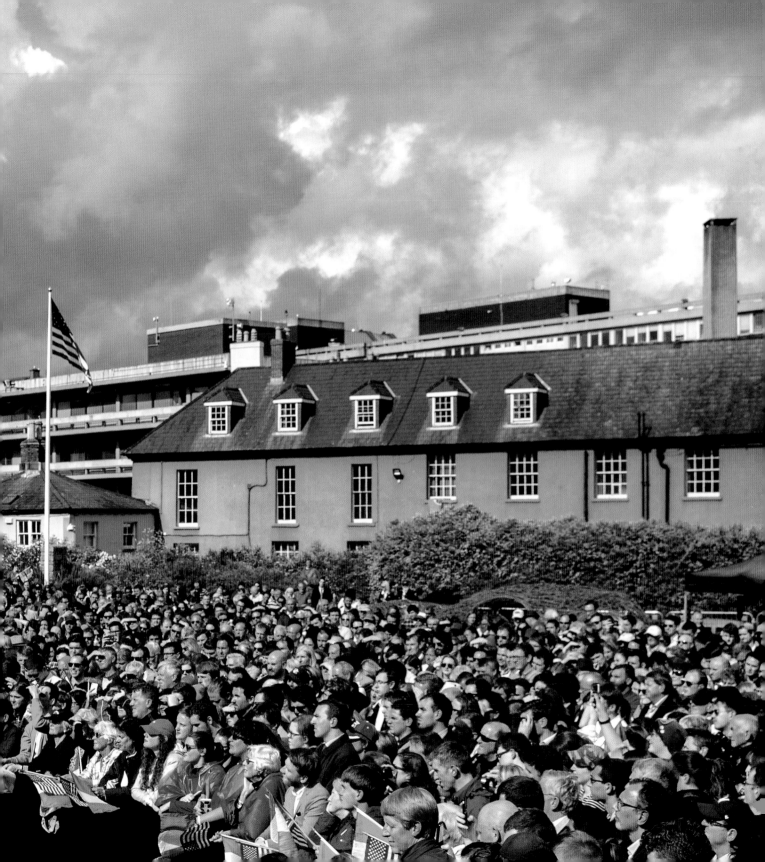

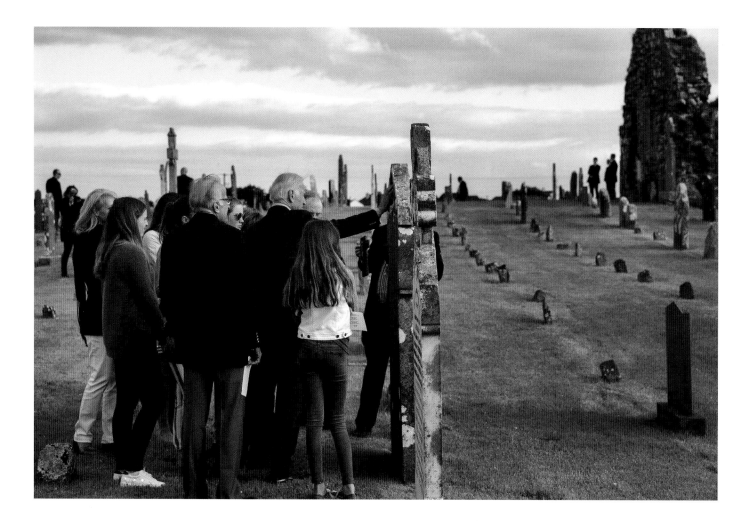

(**PREVIOUS**) Speaking to a crowd about the shared heritage of the Irish and American people and the values of tolerance, diversity, and inclusiveness, on the lawn of Dublin Castle, in Dublin, Ireland, June 24, 2016.

(**ABOVE**) Visiting an ancestral grave with his family, at Kilwirra Church and Cemetery in County Louth, Ireland, June 25, 2016.

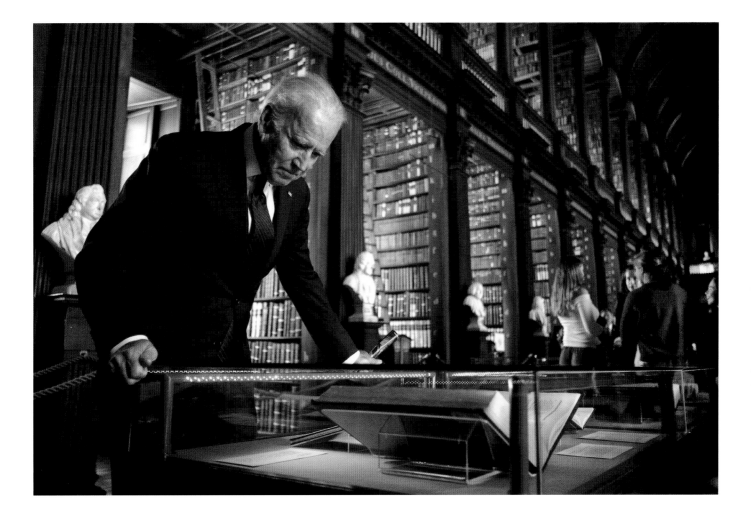

Looking at James Joyce works in the Trinity
College Library, in Dublin, Ireland, June 24, 2016.

DELAWARE PARADE

IN HIS FINAL YEAR in office, Vice President Biden made an unusual request: On the 4th of July, he wanted to walk in the parade in Hockessin, Delaware. In previous years, he had visited troops in Iraq for the holiday or been on the campaign trail, so his staff wondered why he would choose instead to walk in a parade in a small town in Delaware.

His son Beau had always walked in the parade, the Vice President explained, and since this was the first year after his passing, he felt it was important to take Beau's place. The message was not lost on us: personal commitments and upholding family traditions are immensely important to the Vice President.

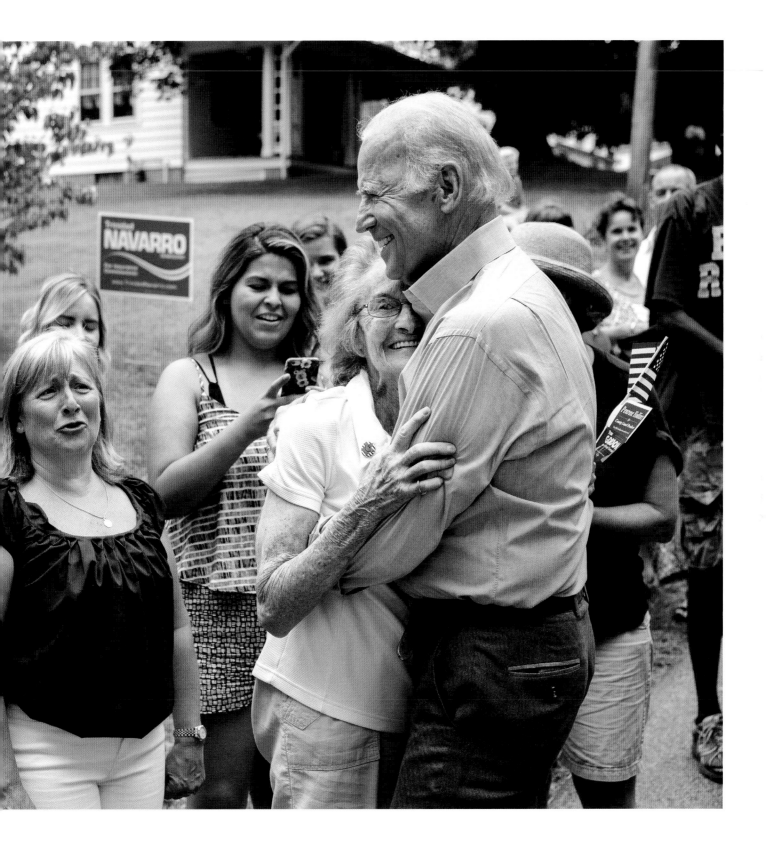

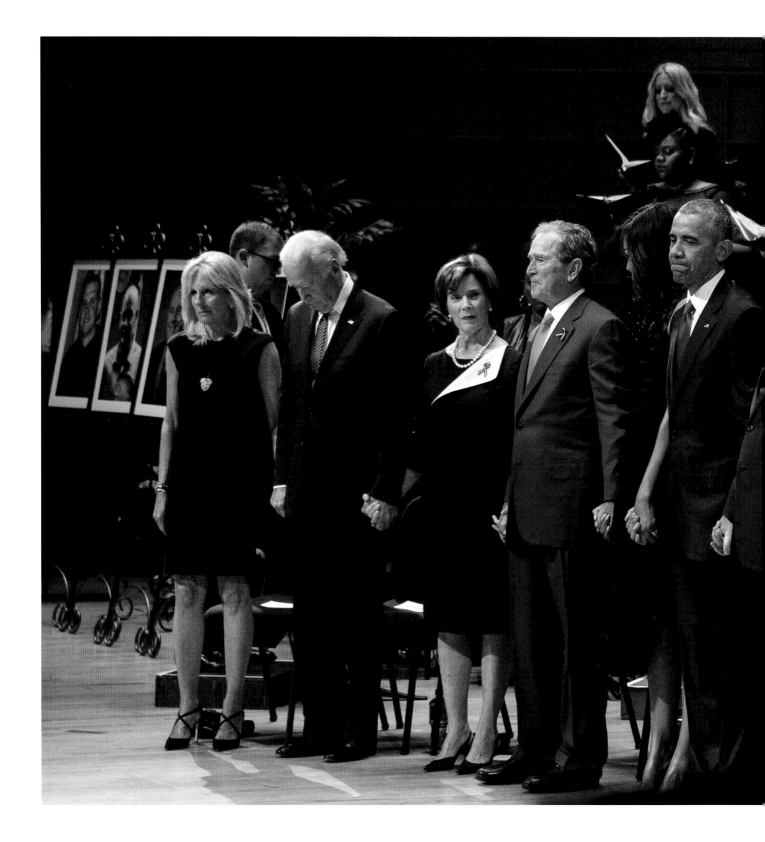

Attending an interfaith memorial service for
families of fallen police officers, with Dr. Jill Biden,
former President Bush and Laura Bush, and
President Barack Obama and Michelle Obama,
at the Morton H. Meyerson Symphony Center, in
Dallas, Texas, July 12, 2016.

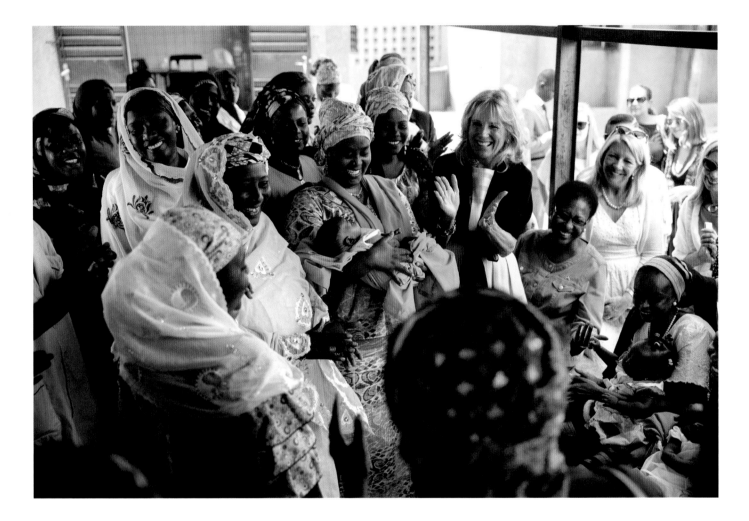

Dr. Jill Biden visits the Marie Stopes clinic, a women's health clinic funded by USAID, and hears from doctors and patients, in Niamey, Niger, July 21, 2016.

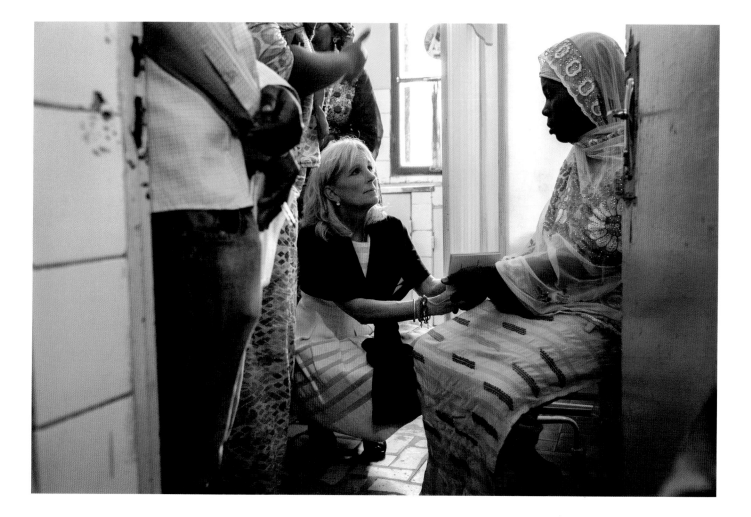

Dr. Jill Biden meets the mother of triplets while touring the maternity ward at the Marie Stopes clinic, in Niamey, Niger, July 21, 2016.

REMEMBER HOME BASE

AT THE DEMOCRATIC NATIONAL Convention in 2012, I had made a photograph similar to this one, as the Vice President's older son, Beau, adjusted his father's tie (page 108) before he took the stage in Charlotte, North Carolina. Four years later, at the 2016 convention in Philadelphia, the Vice President and Dr. Jill Biden waited backstage. I couldn't help but think of that memory and the absence of Beau, which I imagined the Vice President and his wife were also feeling.

In the photo from the last convention, the VP recounted the story of Beau telling him, "Dad, remember: home base. Remember, Dad, none of this is worth it unless you can be yourself, home base, stick to it." Through the loss of Beau, the Bidens remained true to themselves and turned their grief into action, creating the Cancer Moonshot, leading a White House task force to achieve a decade's worth of progress in five years, making clinical trials more accessible, and forcing researchers to share more data so that labs working in the same areas aren't spending precious time and research dollars doing the same work. All this work in the hopes that other families won't have to endure the loss they felt.

As the Vice President often mentioned in speeches, his mother always told him, "Joey, when you get knocked down, get up!" And while I'm certain the Bidens feel the loss of Beau to this day, they also got back up.

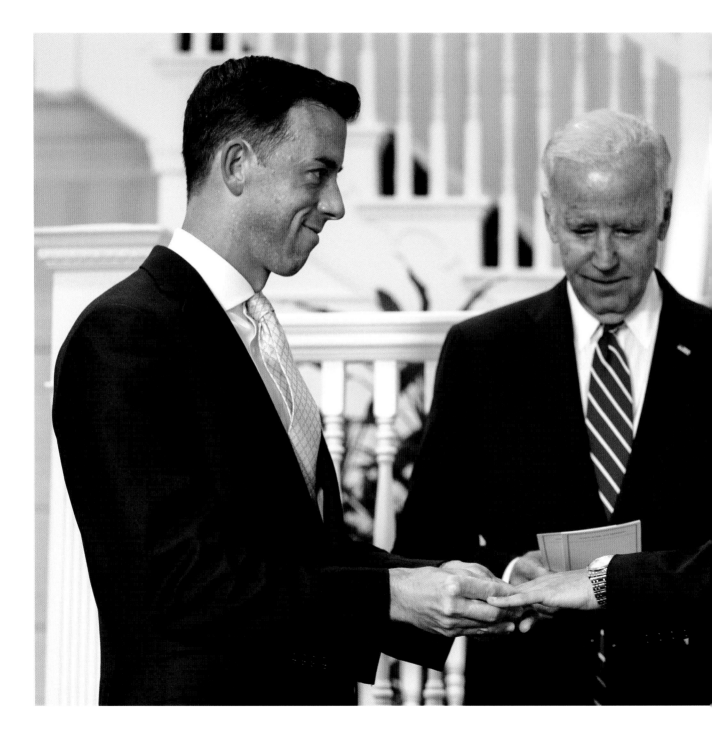

WHO DO YOU LOVE

JOE BIDEN OFFICIATED at only one marriage ceremony in his time as Vice President. It was in 2016, between two longtime White House staffers, director of Oval Office operations Brian Mosteller and Joe Mashie, trip coordinator for First Lady Michelle Obama.

Like that of many Americans in that era, Vice President Biden's position on marriage equality had evolved over the years. In 2012, he attended a fundraiser at the home of a gay couple and met their children. Despite his staunchly Catholic upbringing, he saw that love is love and family is family. When he was asked his opinion on marriage equality a few weeks later on *Meet the Press*, he didn't think of politics or talking points, but simply spoke from his heart, saying "The good news is that as more and more Americans come to understand that what this is all about is, this is a simple proposition, who do you love, who do you love? And will you be loyal to the person you love?"

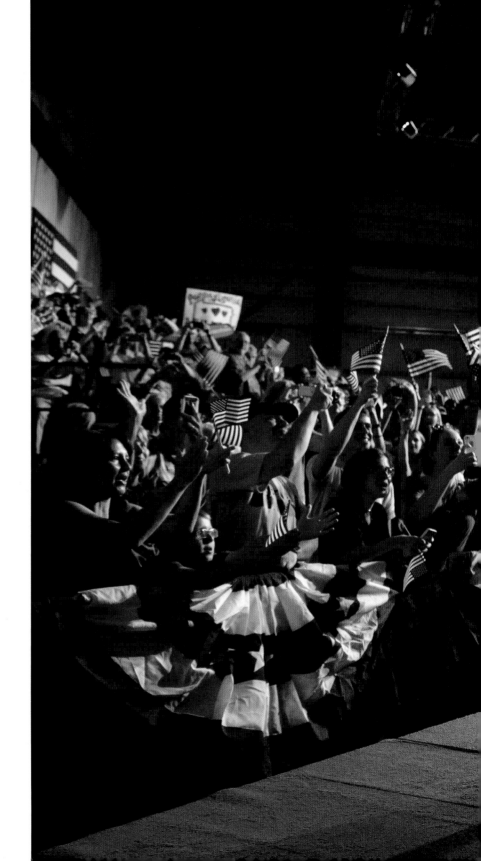

At a campaign event for former
Secretary of State Hillary Clinton,
in Scranton, Pennsylvania,
August 15, 2016.

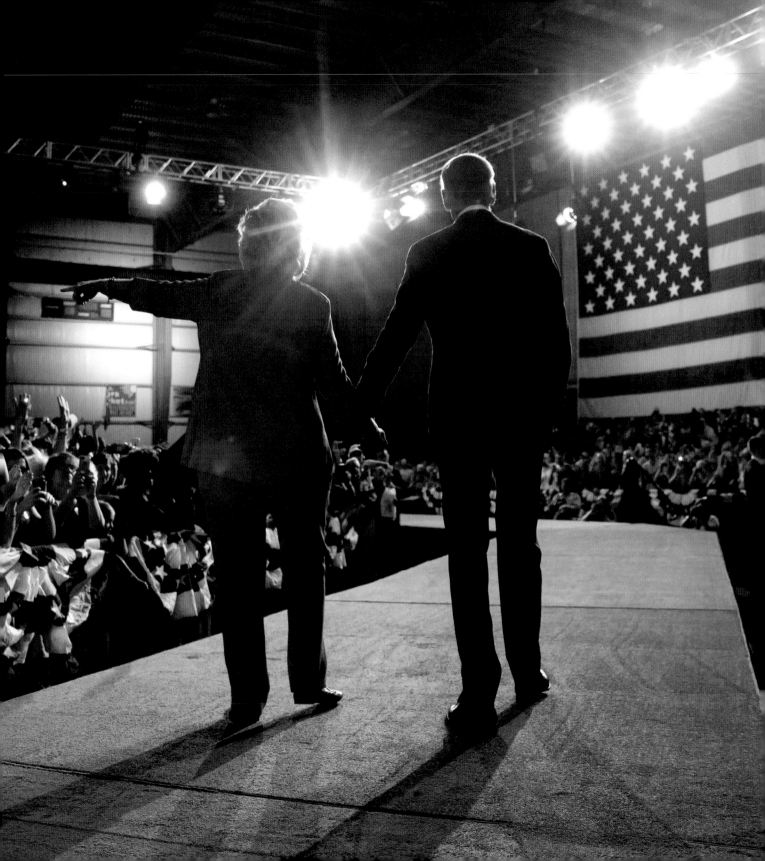

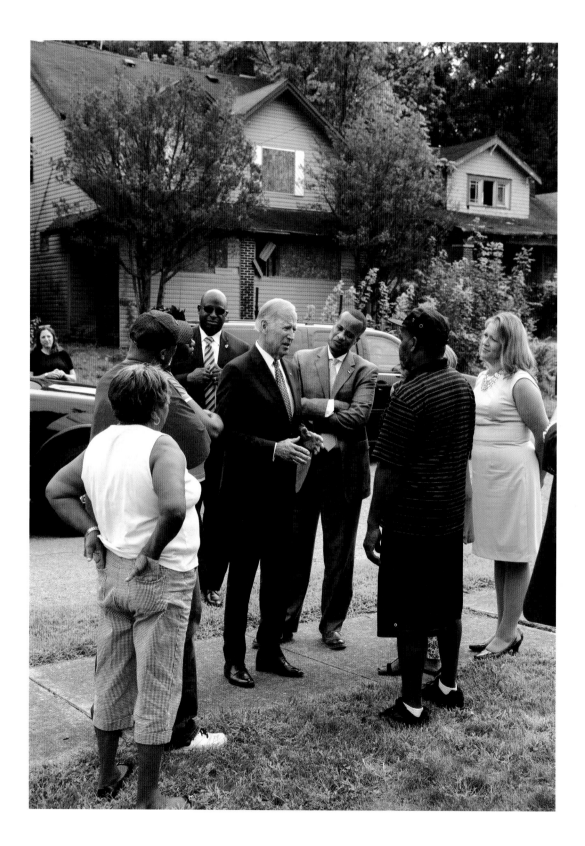

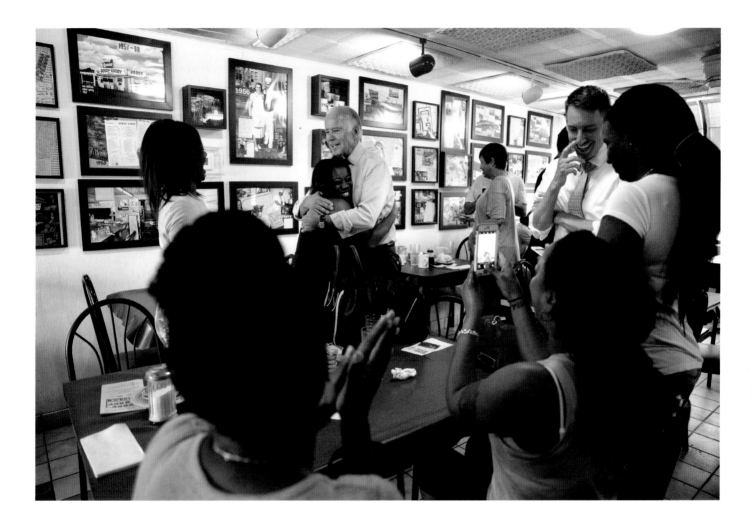

(**OPPOSITE**) Touring the Southside neighborhood and meeting residents whose homes were slated for redevelopment, in Youngstown, Ohio, September 1, 2016.

(**ABOVE**) Stopping by the Goody Goody Diner at lunchtime with U.S. Senate candidate Jason Kander, in St. Louis, Missouri, September 9, 2016.

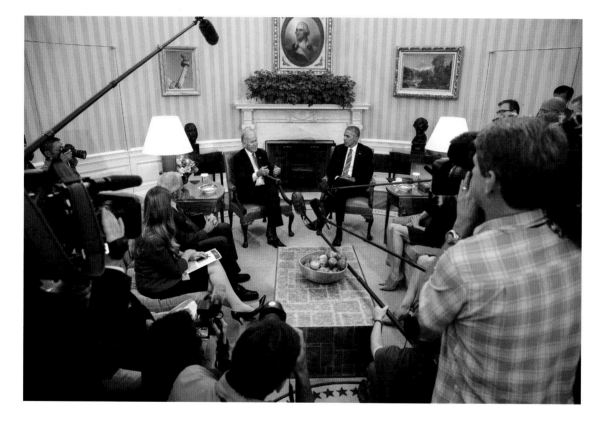

Presenting President Obama with the
Cancer Moonshot report, in the Oval Office,
October 17, 2016.

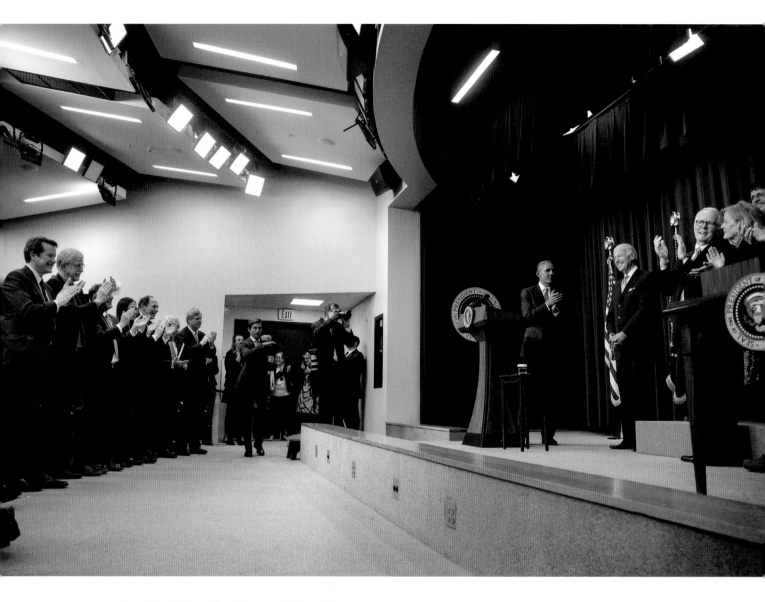

President Obama leads a round of applause for the Vice President at the signing of the 21st Century Cures Act, part of which was inspired by the Vice President's son Beau, who lost his battle with cancer the year before, in Washington, D.C., December 13, 2016.

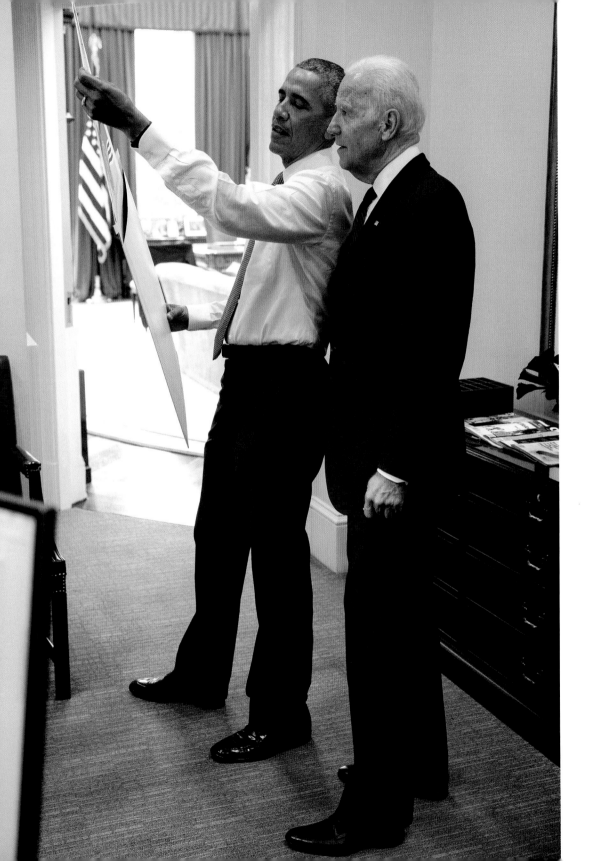

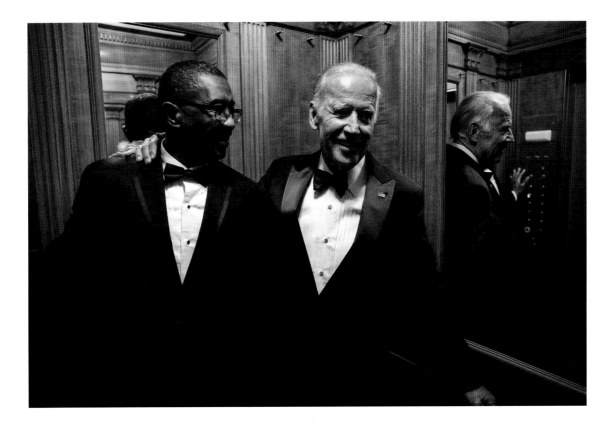

(OPPOSITE) Receiving a print signed by the artist Shepard Fairey from the President, in the outer Oval Office, January 19, 2017.

(ABOVE) Elevator ride with assistant usher Reggie Dickson to the private residence of the White House prior to the state dinner for Prime Minister Matteo Renzi of Italy and his wife, Agnese Landini, at the White House, October 18, 2016.

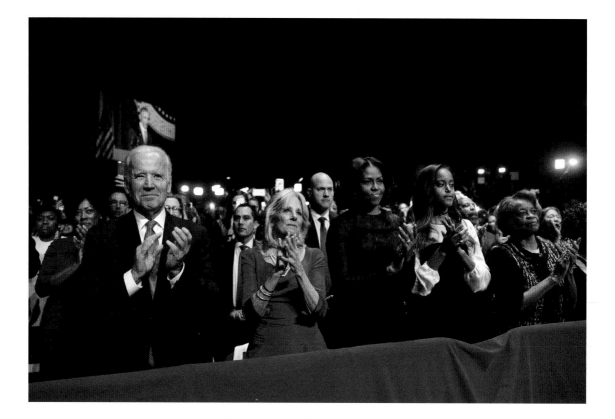

Applauding President Obama with Dr. Jill Biden,
First Lady Michelle Obama, and Malia Obama,
at the President's farewell address to the nation,
at McCormick Place in Chicago, Illinois,
January 10, 2017.

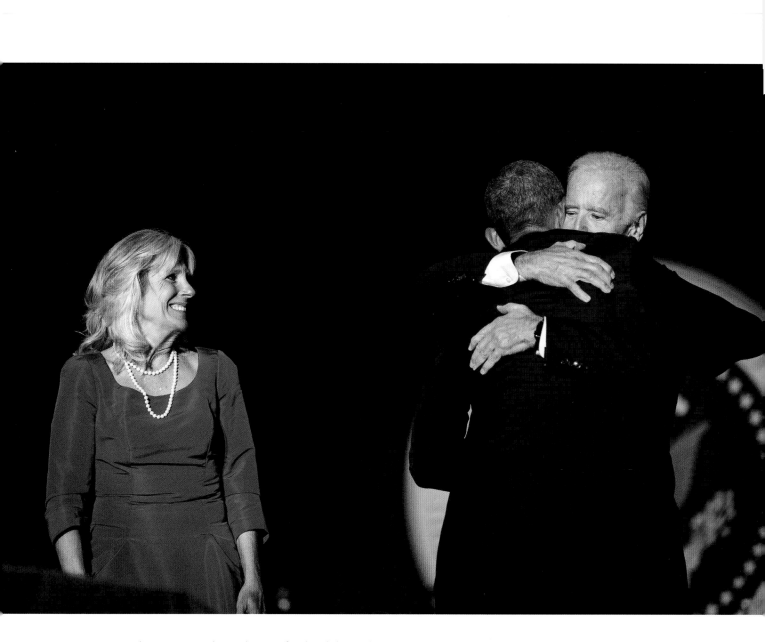

Embracing President Obama after he delivered his farewell address to the nation, at McCormick Place in Chicago, Illinois, January 10, 2017.

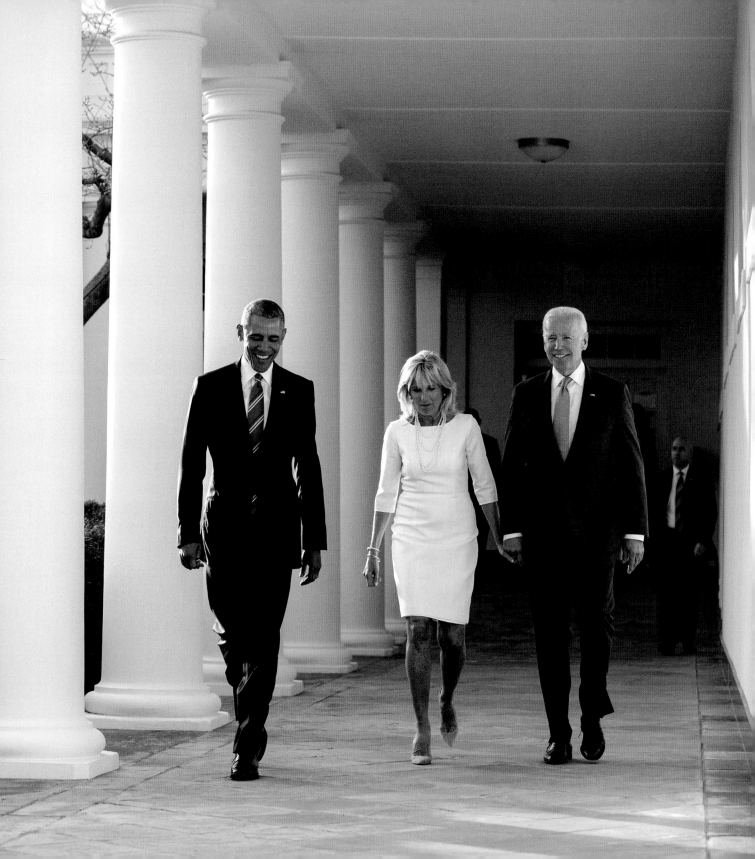

MEDAL OF FREEDOM

AS THE PRESIDENT, VICE PRESIDENT, and Dr. Jill Biden walked across the Colonnade from the West Wing to the White House, a flicker of a smile crossed President Obama's face. They were on the way to a friends-and-family reception in the State Dining Room—or that's what the Bidens had been told. It was to be a tribute of sorts to Joe Biden's eight years of service in the administration, and his 36 years in the Senate before that. But the President's smile wasn't just about going to a reception with his Vice President. He had planned a special tribute that only a few of us had been given a heads up about in the days before.

During his introduction, in front of the Vice President's family, friends, and a few former Senate colleagues, the President said, "It was eight and a half years ago that I chose Joe to be my vice president. There has not been a single moment since that time that I have doubted the wisdom of that decision. It was the best possible choice, not just for me but for the American people. This is an extraordinary man, with an extraordinary career in public service."

He went on to say, "The best part is he's nowhere close to finished. In the years ahead as a citizen, he will continue to build on that legacy internationally and domestically. He's got a voice of vision and reason and optimism and love for people and we're gonna need that."

President Obama then presented Joe Biden with the nation's highest honor, the Presidential Medal of Freedom with Distinction—the only time he had so designated the award during his administration.

Receiving the Presidential Medal of
Freedom with Distinction during a
tribute in the State Dining Room of
the White House, January 12, 2017.

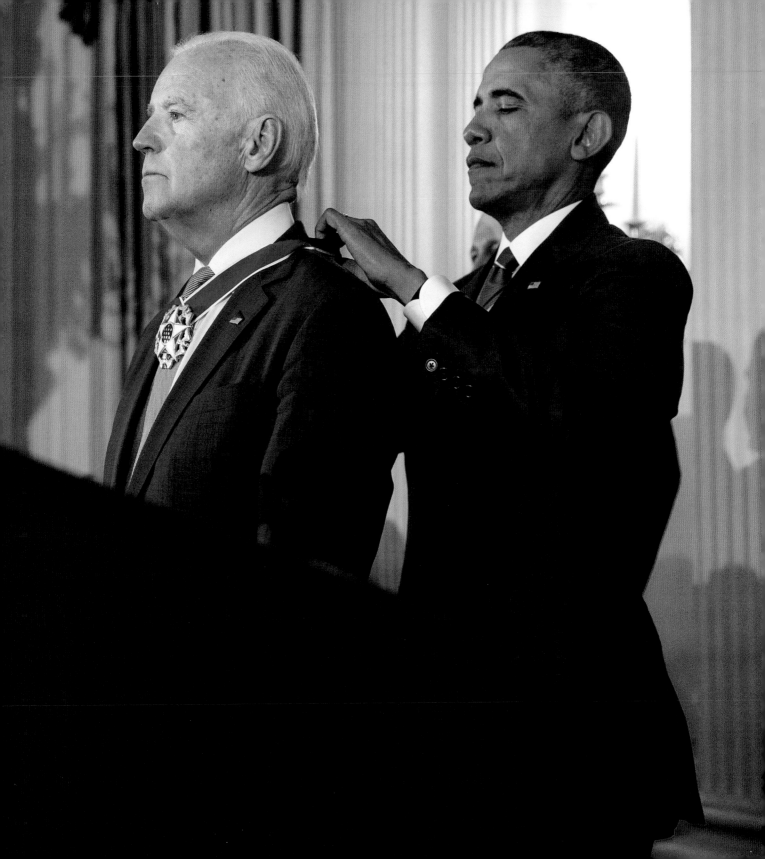

FINAL DAYS

THE RESULTS OF THE 2016 ELECTION were a shock to the administration. The Vice President had campaigned hard for Secretary of State Hillary Clinton, who he saw as the natural successor to the Obama-Biden administration. Yet, after the disappointment of her Electoral College loss in November, he and the President worked hard to ensure a smooth transition to the Trump administration.

On November 10, two days after the election, the Vice President met with Vice President–elect Mike Pence to discuss his views on the Vice Presidency and how to be successful in the role. On November 16, he and Dr. Biden hosted the Pences at the Naval Observatory Residence for lunch, gave them a tour of the home and the grounds, and introduced them to key staff who would help them coordinate their move into the residence.

On January 20, 2017, his final day in office, the Vice President sat down at his desk and hand-wrote a note to his successor. Then, he and Dr. Biden walked across the Colonnade to the White House to welcome the incoming administration—continuing a commitment to the peaceful transition of power that has been honored since George Washington left office in March of 1797.

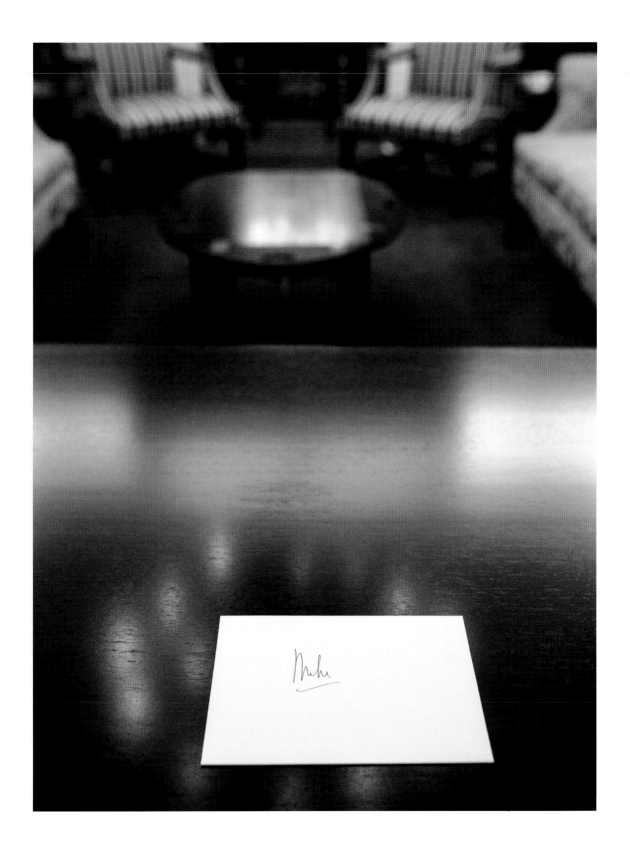

Talking to the White House butlers before the inaugural tea reception for President-elect Donald Trump, Melania Trump, Vice President–elect Mike Pence, and Karen Pence, in the Blue Room of the White House, Inauguration Day, January 20, 2017.

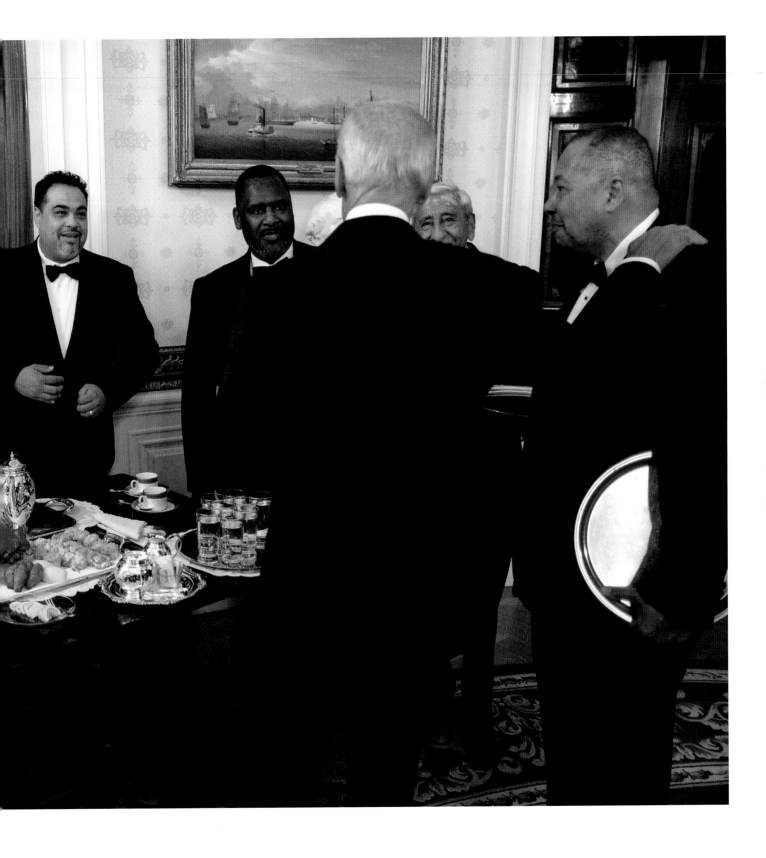

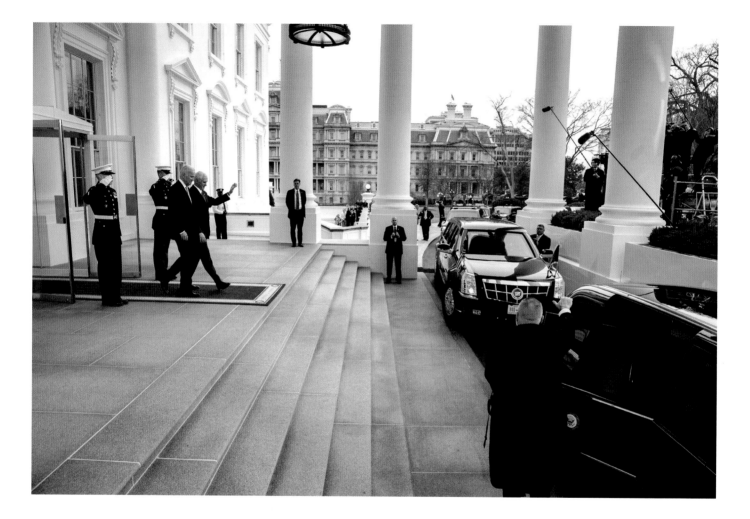

(ABOVE) Departing the White House with Vice President–elect Mike Pence, on the way to the U.S. Capitol for the inaugural swearing-in ceremony, in Washington, D.C., January 20, 2017.

(OPPOSITE) Waiting with President Obama, First Lady Michelle Obama, and Dr. Jill Biden at the inaugural swearing-in ceremony for President-elect Donald Trump and Vice President–elect Mike Pence, at the U.S. Capitol, Inauguration Day, January 20, 2017.

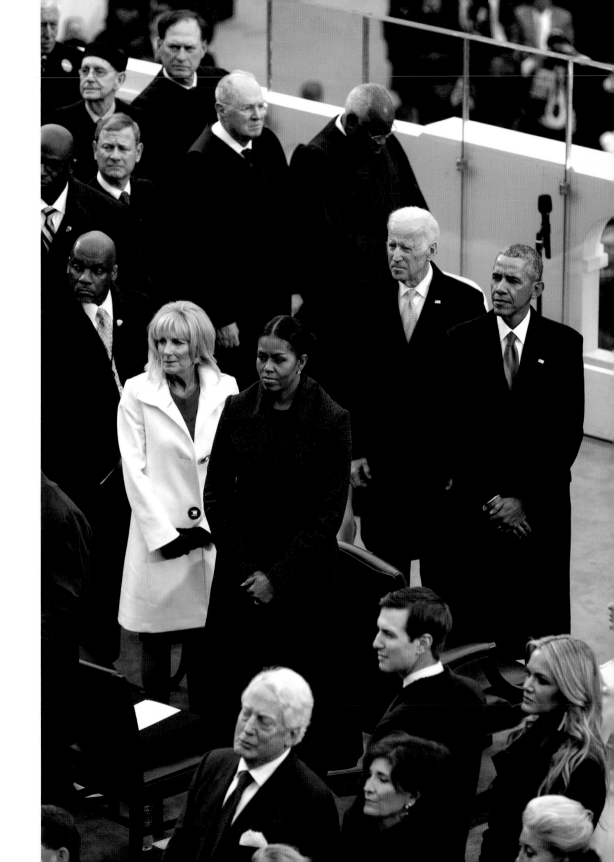

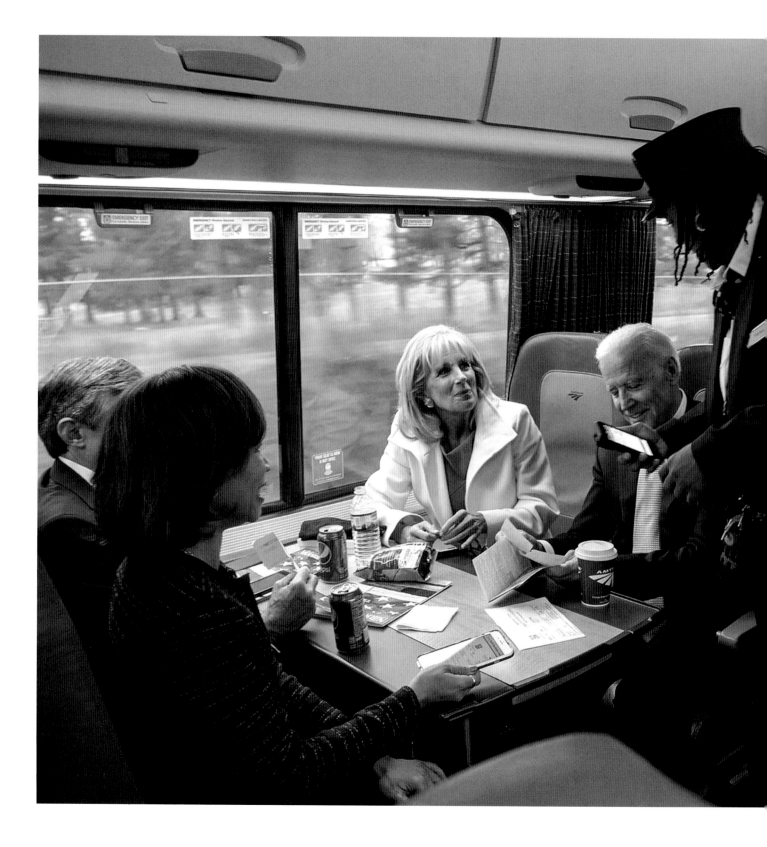

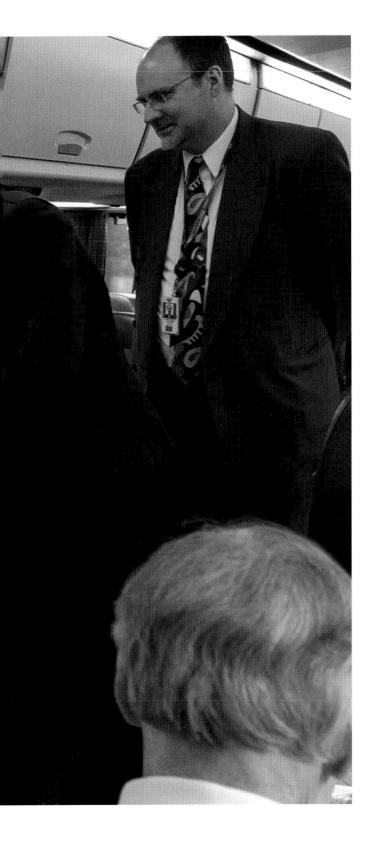

Traveling home to Wilmington, Delaware, aboard Amtrak, after the Presidential Inauguration, January 20, 2017.

A NEW BEGINNING

THE BIDENS LEFT WASHINGTON on January 20, after the inauguration. Like they had done so many times before, Joe and Jill boarded an Amtrak train at Union Station for the ride to Wilmington. In Delaware, crowds of people waited for them at the train station, and an even larger crowd rallied at the nearby convention center to welcome them home. But for most of the Vice President's staff, it was a farewell.

While many of my coworkers were moving on to new jobs or new cities, I drove to Alaska where my wife, reading the writing on the wall, had left her position at the State Department for a job in Juneau the month before. It was refreshing to wake up to a view of the mountains, take hikes to glaciers, and explore moss-covered landscapes in the temperate rainforest that arcs up the west coast from Washington State through British Columbia and into the largest national forest in the United States, the Tongass. Yet the pull of D.C. was still there. I missed my friends

and colleagues, but also a time when the people at the highest level of government were working to make life better for all Americans, and not just for members of their own party or their donors. It was a time when divisive rhetoric didn't come from the very top. Our administration appealed to people's better angels rather than spreading the division, hate, and fear that has come to define the nation's political landscape since Barack Obama and Joe Biden left office.

Working outside the Washington, D.C., bubble was a healthy change for me. I had gotten married in the final year of the administration and was finally able to go on a honeymoon. I worked in new roles that challenged my ideas and perspectives. But I watched with increasing alarm as the hateful rhetoric, erratic leadership, and sometimes just mean-spirited policy decisions were implemented. I became concerned about the safety and direction of our nation.

The current administration has cut government services, undermined the Affordable Care Act that had helped

millions of my fellow citizens gain access to health care, passed massive corporate tax cuts that overwhelmingly benefited the wealthiest individuals and corporations, and gutted environmental laws and regulations. I became convinced that 2020 might be the most critical election of my lifetime. Since then, Vice President Biden has called it the "battle for the soul of the Nation."

As other candidates started trickling into the race in late 2018, I speculated with colleagues in and out of the Biden orbit as my wife and I planned for the arrival of our daughter and a cross-country move, an uncertain time in our lives and in our country. We had watched as Biden had pursued a new cancer initiative, written a book, and taught at the university level. Then, on April 25, 2019, the Vice President announced his bid for the Presidency, and a few short weeks later took the stage with Dr. Biden in Philadelphia, Pennsylvania. There, he promised a return to ethical leadership in the White House and recalled the hope and

"AMERICA, FOLKS, IS AN IDEA, AN IDEA STRONGER THAN ANY ARMY, BIGGER THAN ANY OCEAN. MORE POWERFUL THAN ANY DICTATOR OR TYRANT. IT OFFERS HOPE TO THE TIRED, THE POOR, YOUR HUDDLED MASSES, YEARNING TO BREATHE FREE."

optimism of just a few years earlier: "America is unique in all of the world. America, folks, is an idea, an idea stronger than any army, bigger than any ocean. More powerful than any dictator or tyrant. It offers hope to the tired, the poor, your huddled masses, yearning to breathe free."

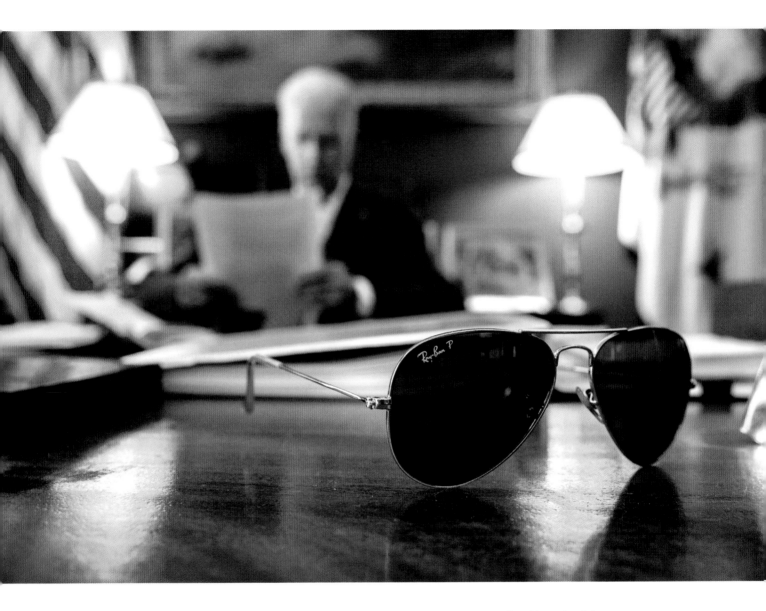

(**ABOVE**) Aviators at the ready on his desk, in the West Wing, April 16, 2014.

(**FOLLOWING SPREAD**) Official launch of the Joe Biden for President campaign with Dr. Jill Biden, in Philadelphia, Pennsylvania, May 18, 2019.

(**P. 256**) With Dr. Jill Biden before boarding *Air Force Two,* in Phoenix, Arizona, November 16, 2009.

ACKNOWLEDGMENTS

To the Vice President and Dr. Biden, thank you so much for allowing me into your lives for eight years. From sharing family meals to allowing me to capture historic photographs of the highs and lows of your incredible service to the American people, I will be forever grateful. To President Obama and First Lady Michelle Obama, thank you for your decency, graciousness, and commitment to the ongoing project of American democracy.

Thanks to Vice President Biden's staff, especially the scheduling, advance, and West Wing office teams. To Jay Carney and Annie Tomasini, who brought me in, and to Chiefs of Staff Ron Klain, Bruce Reed, and Steve Ricchetti for steering the VP's office. To Anthony Bernal and Lindsay Holst for your advice on the book's framing.

To my photo office family, who worked in close proximity to my incredibly messy office, especially Jordan Brooks and then Chris Mackler, who shared it with me: Al Anderson, Samantha Appleton, Nora Becker, Alice Gabriner, Tim Harville, Sonya Hebert, Kim Hubbard, Lawrence Jackson, Chuck Kennedy, Shelby Leeman, Amanda Lucidon, Rick McKay, Jared Ragland, Amy Rosetti, Janet Philips, Jenn Poggi, Jim Preston, Anna Ruch, Phaedra Singelis, Katie Bradley Waldo, and Dan Hansen and Nikki Brooks, who carried over from the Bush administration.

To my photo office boss, Pete Souza, for your advice and wisdom as you stewarded our office while also finding time to produce awe-inspiring photographs of President Obama and hang out with Bruce Springsteen.

To the U.S. Secret Service, Air Force, Marine Corps, and Army, for your support of the Vice President's team. To the Naval Enlisted Aides, thanks for the coffee, snacks, and friendship.

To my agent, David Black, thank you for the crash course in the publishing industry and helping me pull this project together. Additional thanks to Ayla Zuraw-Friedland and Gary Morris.

At Voracious / Little, Brown, I worked with Michael Szczerban, who saw the potential in this project and was often up after midnight with me, helping accomplish months of work in a few short weeks. Thanks also to Emma Brodie, Thea Diklich-Newell, Mario Pulice, Mary Tondorf-Dick, Betsy Uhrig, and Nyamekye Waliyaya.

To Mia Johnson, who designed this book and brought my pictures and words to life in a way I never imagined, thank you so much.

Special thanks to my colleague and friend Shelby Leeman, who badgered me for years to work on a book, helped edit thousands of photos down to those you see here, and carefully color-corrected each image.

To my parents, thank you for everything, especially for the values, compassion, and love you instilled in me.

To my beautiful, intelligent, loving wife, Sydney: I'm so lucky to have met you. You've been supportive of my work and schedule despite all the missed time together. I'm looking forward to a lifetime of adventures with you. To our daughter, Millie: I know that you didn't understand why Dad was on the computer for a month straight and not rolling around on the floor with you, but I'm so happy that you're in my life.

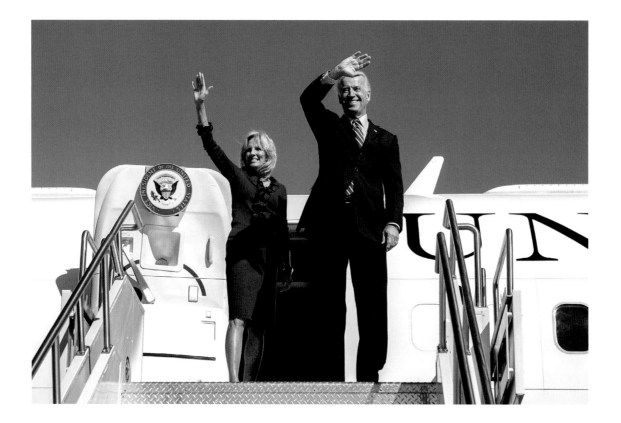

Voracious / Little, Brown and Company
Hachette Book Group
1290 Avenue of the Americas, New York, NY 10104
littlebrown.com

First Edition: September 2020

Voracious is an imprint of Little, Brown and Company, a division of Hachette Book Group, Inc. The Voracious name and logo are trademarks of Hachette Book Group, Inc.

The publisher is not responsible for websites (or their content) that are not owned by the publisher.

The Hachette Speakers Bureau provides a wide range of authors for speaking events. To find out more, go to hachettespeakersbureau.com or call (866) 376-6591.

Photograph on pp. 254–255 by David Lienemann / Biden for President

Photography/Artwork by David Lienemann
Design by Mia Johnson

ISBN 978-0-316-59323-6
LCCN 2020940652

10 9 8 7 6 5 4 3 2 1

WOR

Printed in the United States of America